# Cultural Literacy & Arts Education

*Edited by*
Ralph A. Smith

UNIVERSITY OF ILLINOIS PRESS
*Urbana and Chicago*

©1990, 1991 by the Board of Trustees of the University of Illinois
Manufactured in the United States of America
1 2 3 4 5 C P 5 4 3 2 1

*This book is printed on acid-free paper.*

The essays in this book originally appeared in the *Journal of Aesthetic Education,*
volume 24, number 1 (1990). Publication of that issue and this book was sup-
ported by a grant from the National Endowment for the Arts and the Depart-
ment of Education to the National Arts Education Research Center at the
University of Illinois at Urbana-Champaign (1987-90). The views expressed are
the authors' own and not necessarily those of the National Endowment for the
Arts, the Department of Education, or the National Center for Research in Arts
Education.

Library of Congress Cataloging-in-Publication Data

Cultural literacy and arts education / edited by Ralph A. Smith.
   p.  cm.
   Includes index.
   ISBN 0-252-01845-1 (alk. paper.). — ISBN 0-252-06215-9 (pbk.  :
alk. paper)
   1. Arts — Study and teaching. 2. Arts and society.  I. Smith,
Ralph Alexander.
NX294.C85 1992
700'.1'03—dc20                       91-9462
                                      CIP

# Contents

# Introduction

This book consists of the contents of a special issue of the *Journal of Aesthetic Education* (Spring 1990), which was devoted to the topic of cultural literacy and arts education. No changes have been made in the original essays, but the editorial and the editors' postscript have been combined and edited and now serve as the introduction.

The study of cultural literacy and arts education, of which the special issue of *JAE* and this book are the first products, was sponsored by the National Arts Education Research Center located at the University of Illinois at Urbana-Champaign, which was one of two such centers funded for a period of three years by the National Endowment for the Arts and the Department of Education. Particular thanks are due to Jack McKenzie, Dean of the College of Fine and Applied Arts, the center's director of management, and Charles Leonhard, Professor Emeritus of Music, its director of research, for their belief in the importance of the study of cultural literacy and arts education and their generous support. I also wish to acknowledge the encouragement of Warren Newman, director of the arts education program of the Arts Endowment during the period of the study. A large debt, of course, is owed to E. D. Hirsch, Jr., whose *Cultural Literacy: What Every American Needs to Know* stimulated questions about the meaning of cultural literacy for arts education. I further wish to acknowledge the research assistance of Penelope McKeon of the City Arts Institute of Sydney, Australia, and the editing skills of C. M. Smith, the associate editor of the *Journal of Aesthetic Education*.

Before discussing a number of ideas in the volume and their consequences for arts education, I will say a few words about the reasons for inviting essays on the topic in question. The purpose was not to feature a critique of Professor Hirsch's ideas, although a number of contributors do raise some questions, or to add to his list of facts, concepts, names, and titles. Rather, it was to draw attention to one important aspect of his analysis—his alarm at the serious slippage that has occurred in the background knowledge and information prerequisite for effective communication, a degree of social cohesion, a healthy economy, and a just democratic society. Professor Hirsch thinks that the principal reason for such decline is the overemphasis

in American schooling on skills at the expense of specific content and subject matter, a consequence, he believes, of the inordinate influence of John Dewey's philosophy and of progressive education. This claim is debatable, but so far as the teaching of the arts in the schools is concerned the observation impresses me as quite accurate. There has been far greater stress on the skills of creating, performing, and writing than on the mastery of a body of background knowledge; too much emphasis on what John Goodlad in *A Place Called School* labeled "playing, polishing, and performing" and too little on the study of works of art as cultural objects; too much concern for responding, analyzing, judging, and so forth, and not enough respect for the objects on which these skills are to be honed, that is, works of art and their special properties.

Professor Hirsch thinks the remedy lies in a better understanding of literacy itself, the development of which presupposes not only appropriate skills but also specific background information, a fact that is increasingly being demonstrated by schema theory research. The core knowledge Professor Hirsch has in mind provides indispensable reference points for those who share a culture. In the arts these reference points include works that may be notable not only for their artistic excellence and capacity to afford aesthetic enjoyment but also for the symbolic and communal associations they summon up. Such works, traditional and modern, from both the high and the popular culture, and from different civilizations, would be pointed out and discussed throughout what Professor Hirsch calls the "extensive curriculum" (essentially the early years of schooling) and the "intensive curriculum" (essentially the years of secondary schooling), the latter offering opportunities for the study in depth of selected works and the development of important skills. Professor Hirsch believes that his conception of the extensive curriculum, which characterizes the requisite background knowledge as quite rudimentary and in certain respects even superficial or highly simplified, can have an impact particularly on the elementary grades. Others can then concern themselves with the intensive curriculum, where the question is what counts as relevant background or contextual knowledge at the secondary level.

Several essays in this volume suggest answers to this question, while collectively the essays address the topic of cultural literacy from a variety of orientations, including the perspectives of the visual arts, literature, music, dance, and theater. The contributors were asked to reflect on the ways in which various kinds of context help to reveal rather than to obscure the character of a work of art (a question that was suggested to me by Peter Winch's essay "Text and Context" in his *Trying to Make Sense* [Basil Blackwell, 1987]). Each author was provided with a copy of Hirsch's *Cultural Literacy* (Random House, 1988) and his *Dictionary of Cultural Literacy* (Houghton Mifflin, 1988).

What follows does not summarize the various essays so much as point out some commonalities and divergences among them.

When it first appeared, Hirsch's book won general acceptance among the general population and school people but generated a storm of criticism in higher education and other educational circles. Several writers in this volume also express misgivings, although none repeats the most egregious accusation: that Hirsch intended his list for rote memorization by school-children. (Walter Clark, Jr., warns, though, that "in the hands of uninspired time servers [the list] could become a mechanical albatross to hang around the necks of uncomprehending students.")

The most vocal condemnations of Hirsch's proposals come from advocates of cultural pluralism, or multiculturalists. Hirsch, it is imputed, would impose an alien and discredited (because predominantly Western European, male, sexist, racist, and elitist) value system on children from diverse racial and ethnic backgrounds toward the end of achieving a cultural uniformity in which all people would think and feel alike. Because of the intensity of the concern about possible insult and damage to the native traditions of different groups in a pluralistic society, the relationship between the national culture and various subcultures—between the macroculture and microcultures, in David J. Elliott's words, or between the imperial culture and provincial cultures, in Francis Sparshott's—should receive closer examination so as to enable readers to decide for themselves whether Hirsch's ideas are as threatening as his detractors say they are. Such scrutiny may also shed some light on a parallel relationship that is of special interest here, namely, the one obtaining between the mainstream tradition that underlies Hirsch's notion of cultural literacy and the traditions of different art forms as they are taught in the schools.

The suspicion that Hirsch harbors disdain for the value structures of cultural subgroups is doubtless due to his call for social cohesion. Now social cohesion may be regarded as a value ideal or as a necessity for a nation's survival. It could be brought about by inducing the great majority of society's members to subscribe to a unitary value system. But a sufficient degree of solidarity can also be achieved through the sharing of a body of knowledge—which is probably closer to Hirsch's thinking. He talks, for example, about what every American needs to know, not what every American should value, prize, or cherish. His list is not composed solely of masterworks that everyone ought to venerate; it also contains seemingly trivial entries. Perhaps—and this is the first point to be made here—if we understood Hirsch to be more interested in the cognitive than the affective or normative side of things ("Cultural literacy," he says, "is descriptive; it tells us what educated people already know"), in information rather than in values, then the fear that resisting youngsters would have a macrocultural scheme of values forced on them might fade away. We may agree that

students' emotional commitments to their origins should be honored. Still, it is quite conceivable that people can become fully culturally literate in Hirsch's sense while maintaining undiminished allegiance to their subcultural traditions and preferences. To be sure, they may choose to loosen such ties. As Marcia M. Eaton points out—courageously, it might be added, given the prevailing climate of opinion—"Not all traditions are equally good, equally deserving of attention and respect. For one thing, not all traditions give respect to human beings generally."

A second feature we should note is Hirsch's emphasis on utility. Cultural knowledge is to be taught, not because it is intrinsically worth having or because it is simply superior, but because it is the most useful. In Sparshott's words, "Hirsch's primary claim is not that the knowledge he ascribes to the culturally literate is inherently better than other knowledge, but that it is knowledge that gives access to a publicly accredited world." Giving students useful information that will open doors for them in adult life should not be described as forcible imposition, and Hirsch should be cleared of any such indictment. The transmission of cultural knowledge may be best thought of in terms of teaching a second language (or greater fluency in one's own), as Eaton and Sparshott have recommended in their respective essays. Teachers should nonetheless proceed cautiously. Sparshott observes that "such teaching must be alienating, because what it exists to provide is the possibility of change. It provokes hostility if it presents its offerings, not as a second cultural language, but as what should have been the students' cultural language from the start."

Third, the "list" is not graven in stone. Hirsch expects that although some entries should probably be permanent, others may be added or subtracted according to procedures yet to be worked out. He only insists that change be gradual. A sudden wholesale replacement of the roster by another would produce cultural chaos and incomprehension. These are concessions to flexibility and change that should considerably soften the picture drawn of Hirsch as a rigid defender of the status quo.

Fourth, it might be said that at a deeper level Hirsch is less concerned with the precise composition and extent of the information that would qualify persons as culturally literate than he is with their empowerment. Education, from the elementary grades on, should be restructured so as to equip more young people than it now does for entry into the mainstream culture. Teachers must shoulder this task not only in the interest of social cohesion but also, and perhaps chiefly, for the purpose of placing in the hands of all students the best instrument for social mobility and private satisfaction. That instrument, Hirsch is convinced, is cultural literacy. So understood, Hirsch's suggestions are anything but undemocratic, and it would be disingenuous to oppose them on that count.

Even if the effort to exonerate some of Hirsch's ideas has established

their worth as a vehicle for thinking about arts education, there still remain two relatively minor aspects that should be examined because they may trouble arts educators. Reasons were given for stressing the cognitive and utilitarian slant perceptible in Hirsch's arguments for cultural literacy; but does this emphasis comport with the objectives normally pursued by arts and aesthetic education? Is Hirsch's view congruent with a humanistic outlook? Elliott, for one, appears not to think so. His essay opposes Hirsch's approach and projects instead a closely reasoned multicultural paradigm for music education and, by extension, for arts education generally and even for a conception of culture as a whole. Elliott posits self-knowledge and insight gained through an understanding of others and their diverse cultures and values as the most desirable goal of education. This is a decidedly humanistic objective, but it might be pointed out that it is not the only one. "Empowerment" also deserves that distinction. Culturally literate persons are ones whose education has enabled them to make their way through life with competence and assurance, comprehending and participating in society's major forms of communication. Their counterparts in the narrower (or "subcultural") realm of the arts would be individuals who, having been the beneficiaries of well-designed, well-executed programs in arts education, would move about the art world with intelligence, sensitivity, and discernment. Their broad knowledge and trained ability would have won for such persons entitlement to feelings of self-worth and self-respect, which are educational outcomes as legitimately humanistic as self-knowledge and insight.

Educators may also worry about another feature of Hirsch's definition of cultural literacy: the shallowness of the information that suffices as its base, the whole business of a "guided-tour" mentality, as Elliott puts it. These scruples are understandable. Often teachers and the general public alike take the "replicative use of schooling," to use Harry S. Broudy's term, as the only reliable indicator of educational effectiveness, and that involves the retention of detailed knowledge and the ability to reproduce it as learned. But Broudy argues that replicative capacities are needed only by people who make daily use of subject knowledge in their occupations. The rest of us get by with a faint residue of materials that nonetheless manage to be useful. John A. Richardson thinks that even passing acquaintance with some topics "can enhance our understanding of many other things." Yet Hirsch does not really endorse superficiality; he has merely set the minimum requirements for cultural literacy. Nothing has yet been said about the adequacy of such knowledge for other cultural pursuits, the manner and circumstances of its acquisition, and the preconditions for its retention—issues that will presently lead to a consideration of the learning theory underpinning Hirsch's recommendations for cultural literacy.

Needless to say, the sort of vague recognition of cultural concepts and

phenomena—a painter's name perhaps and a few associations—that might accredit persons as culturally literate would be of little help when standing in front of a work by that same painter. Much more precise and differentiated contextual knowledge would have to be brought to bear to ensure knowledgeable and appropriate appreciation of the picture.

Equally obvious is that information used in a shallow manner need not have been learned that way. Most likely each item on Hirsch's list was at one time appropriated in considerable detail, either through frequent exposure and repetition, as with things learned early in life, or through formal study later on. Clark analyzed the literary entries on Hirsch's list and estimated the periods of life during which they probably came into a person's possession. But it is a strange sort of possession. As Broudy explains it, much of the material we learn formally we soon forget. Forgotten, however, does mean lost: knowledge "tends to fold back into the allusionary base," or associative or interpretive store. Thence it can be summoned to consciousness when the occasion arises, and it is apt to bring all manner of associations with it. For example, when we recognize a word on Hirsch's list we may also be dimly aware of once having had explicit knowledge about its referent, information that now dwells just below the threshold of articulation but nevertheless guides us to a fuller interpretation than we would be capable of had we never studied the matter at all. This Broudy calls the associative or interpretive use of schooling, and he thinks it is crucial for cultural literacy.

We may now say that Hirsch's list is composed of those things that the culturally literate person can dredge up from the interpretive store. Putting them there in the first place is, Hirsch insists, largely the responsibility of the extensive curriculum and is a task that should be initiated vigorously in the early elementary grades. The intensive curriculum of the secondary grades would probe this material more thoroughly; but both strata are mutually reinforcing—the extensive curriculum facilitates in-depth study, while the latter lends enough thickness to the information to allow more items to be captured and anchored securely. Clark clothes these ideas in two metaphors, one economic, the other geographic. "Perhaps," he says, "we can see Professor Hirsch as urging the importance of providing the learner with the basic currency of cultural exchange at an early stage in his or her intellectual development. He is convinced the resultant activity will lead to an increase in currency, and also to increased intellectual 'backing.'" However, "the fullest backing of the currency comes only with time and effort." Alternatively, we may picture the knowledge taught as part of the extensive curriculum as tips of information icebergs—and as such, less important in the end. The tip does not exist for the sake of the body, whereas proper care for the latter—the substratum, the allusionary store— is "the best assurance that the learner will retain the tip."

The iceberg image may mislead us into thinking of the substratum as an undifferentiated mass; but it is not. Rather, it consists of "a scheme of places to which phenomena may be assigned, a mental sorting office," according to Sparshott; a collection of "interpretive schemes" with which the extensive curriculum is understood—a network of assumptions that is "loosely structured in a set of interpretive patterns"—according to Michael J. Parsons. Indeed, Parsons's essay is a needed corrective to Hirsch's somewhat oversimplified notions about the ways young children should be introduced to the extensive curriculum of cultural terms. The psychological context Parsons describes leaves no doubt that interpretive schemata evolve in children gradually and in stagewise fashion. This means that young students may not constitute materials as the curriculum planner had intended; they may not assort items to the correct places in their mental structures—hence be unable to recover and construe them correctly later on. Handed a generous supply of basic cultural currency, they may misspend it. In short, teachers and curriculum planners would do well to acquaint themselves with a psychologically appropriate developmental approach such as Parsons's to make sure that the items presented and the manner of talking about them are adjusted to the capacities of children in different age groups and developmental phases.

The main questions this volume was intended to address were: What would it mean for persons to be "literate" (that is, able to understand communications and have relevant experiences) in various art forms? What sorts of context should such persons bring to their encounters with works in these art forms and what would that imply for arts education? Readers should have no difficulty composing from the essays collected here portraits of individuals who listen to music comprehendingly, attend theatrical and dance performances with suitable background knowledge and expectations, are able to interpret the many-layered meanings of works of visual art, and approach literature with a mind unfettered by ideologically determined preconceptions. And so there is little to add on this point.

In other words, the impulse behind this issue was not primarily an interest in the direct contribution arts education could make to cultural literacy à la Hirsch or in soliciting suggestions for redesigning aesthetic education toward the end of feeding the master list. Patti P. Gillespie anticipated the undesirable consequences of such an approach for theater education, and what she says would apply to the other arts as well. If enlarging the extensive curriculum were the immediate objective of all arts instruction, then undue stress would have to be placed on introductory surveys as purveyors of the maximum amount of information, on cursory acquaintance with many works at the expense of intimate familiarity with a few, on contextual knowledge to the detriment of attention to artistic form. In sum, "adopting Hirsch's scheme would probably further shrink the role of aesthetics

in . . . education." These are good reasons for opting for an alternative view of the relationship between cultural literacy and arts education: arts and aesthetic education are more usefully confined to the intensive curriculum where they concentrate on the narrower range of cultural phenomena pertaining to each of the various art forms. But if such education is conducted properly, it will nonetheless make an inestimably valuable contribution to cultural literacy generally, not only through the sheer number of cultural concepts it would add to Hirsch's list, but through the more enduring availability of these items for recall and use, attached as they would be to the networks of assumptions and interpretive schemata the students developed in the course of undergoing arts instruction.

Jerrold Levinson reverses the relationship of inclusiveness by calling Hirsch's the "narrow" notion of cultural literacy because it is restricted to verbal literacy and envisioning a "broader" literacy that encompasses all major forms of communication, including the arts. The points and distinctions he makes in his discussion of musical literacy are also illuminating for the other nonverbal arts. Musical literacy, says Levinson, "can be taken in two ways, once in relation to the narrow idea and once in relation to the broad idea of cultural literacy. In relation to the first, musical literacy can be said to consist in the sort of factual information *about* music that a common reader is expected to possess and which enables him or her to understand discourse which takes music as its *subject*." It is the second way of taking musical literacy, however—that is, "as a component of a broad cultural literacy rather than as a minor element in narrow cultural literacy"—that is the more significant and fruitful.

Since there are arts that are nonverbal forms of communication, it is not surprising that the bulk of the contextual knowledge drawn on during comprehending listening and viewing in these arts is not in propositional form. As Levinson puts it, "Musical literacy, like reading literacy, is fundamentally contextual, but unlike reading literacy it is also primarily tacit, nondiscursive, not propositionally expressible or exhibitable." This does not mean that verbal discourse, like explicit teaching, has no place in music and visual arts education. It does, because it guides experience, and properly guided experience, Levinson insists, is the best way of building up background knowledge in the nonverbal arts. Nor would it be wasted effort to devise for these arts lists of names and concepts that knowledgeable percipients and listeners should be able to recognize. But it would be a mistake to think such a list as constituting or exhausting literacy in these art forms; individually and even collectively its entries may not be the most important components of contextual knowledge. Nor need we assume that students appropriated most of the items from discourse and should be able to demonstrate their knowledge of them by reciting definitions.

Clifton Olds's article on a painting by Jan Gossaert makes us appreciate

the breadth and scholarly sophistication of the contextual information that can be brought to bear on a complex painting—knowledge that we may presume many of Gossaert's contemporaries to have possessed and that we have to reconstruct painstakingly to arrive at an appropriate reading of the work. Yet we can never be quite certain that we have achieved the correct interpretation. Olds echoes Levinson in cautioning us not to take cultural literacy too literally because "'literacy' implies knowledge expressed in words. In that sense, all iconographic interpretations of art are, to one degree or another, speculative, since the verbal translation of nonverbal messages is inescapably flawed."

Thus far, contextualism and contextual knowledge have been presented in a favorable light as preconditions for cultural literacy and communication within society, on the one hand, and for the enlightened experience of art and hence for arts education, on the other. Some caveats are now in order. Gillespie notes that contextualism too zealously pursued may produce undesirable consequences for appreciating artworks and for arts teaching. This can happen when we follow the lead of critics who misplace their priorities by expending more effort on the context than on the work of art itself. Contextualism may also fail to do justice to artists who were ahead of their own era and therefore are not adequately treated in terms of it. "Contextual criticism," says Gillespie, "may . . . deny the unique (read, *supracontextual*) vision of an artist." Furthermore, the "fixed, historical explanations" of contextual criticism do not leave enough room for the new meanings that symbols and images acquire over time; such explanations may thus thwart fresh and vital contemporary experiences of artworks.

If Gillespie warns against contextualism carried to extremes, Ronald Berman invites readers to contemplate the dangers posed by a form of contextualism that currently has many followers in the academic community. Rather than researching the past in order to establish the appropriate environment for a literary work, these theorists supply a ready-made context and force the work to accommodate itself to it. It is a Procrustean procedure that can leave the artwork distorted almost beyond recognition. Berman shows what happens when Shakespeare's historical plays are subjected to this process, although he also deals with several more general questions about the interpretation of literature and the relationship, properly conceived, between a literary text and the circumstances of its origination. The prefabricated context or superstructure of literary theory that Berman exposes is the one crafted by "historicism or cultural materialism, the principal 'adversary' modes right now of seeing literature as a criticism of life." This adversary mode requires, first, that literature always serve some external end; it is denied independent existence. Second, it is claimed not only that literature invariably criticizes life but also that it casts its critique in political categories. Plays and other texts "are, essentially, frozen examples

of political relationships." Since these political relationships are understood as involving offenses against sex, race, and class committed by illegitimate powers, notably by governmental authority, they always create victims. In short, a framework that prominently features acts of victimization perpetrated by the state and reenacted in relationships among individuals— the characters in a play, for example—is projected onto a literary text. Those aspects of works that cannot be brought into conformity with the assumptions of the superstructure are discounted. No counterevidence can be forthcoming, either from within the work or from its actual historical context. Disregard for historical and literary facts and intolerance toward dissenting interpretations are perhaps the most worrisome characteristics of cultural materialism. Some of the proponents of this view have even professed antagonism to freedom of inquiry in the classroom. But why so much repression in association with allegedly literary studies? The most likely reason is that cultural materialists are interested in literature only as a tool to be used in delegitimizing the modern state; the interpretation of all literature as political is thus itself part of a political program.

Finally, there is Lucian Krukowski's lucid exposition of a fairly new conception of contextualism, the ideas of which are often couched in language that makes them inaccessible to the general reader. Krukowski's aim is to codify "an important controversy in recent aesthetic theory." In that debate the new contextualism constitutes the discipline's cutting edge. Now it might be said that education is a pragmatic enterprise, and teachers wishing to build a theoretical foundation for their professional practice are ill-advised to gather material from frontier skirmishes in philosophy; more settled opinion usually serves them better. But inasmuch as the new contextualism appears poised to become mainstream thinking in aesthetics, it is not too early to ask what changes it would imply for arts education as currently understood.

Krukowski elaborates the contextualist position in contrast to autonomy theories—with the curious result that Hirsch, the champion of contextualism (of an older variety), is assigned to the autonomist camp. There, despite his antiformalist leanings and adherence to an instrumentalist position on matters of value, he is grouped with formalists and believers in intrinsic value. This, however, is a minor point.

Traditional views of art, no matter how much they may vary in detail, generally hold that artworks can be identified as such because they exhibit a sufficiently large number of perceptual properties from a recognized set of artistic features to be certified as art. Contextualists do not think art should be conceived this way. They propose instead that "there may . . . be no class of phenomenally distinguishable objects which has exclusive claim to the status of art." Contextualism further denies "that there are specifically artistic properties that both identify artworks and guide our apprecia-

tion. The effect of this denial is more radical than at first appears, for the contextualist concern is not primarily with meaning or value, but with ontology—how the status 'artwork' is achieved and lost. It is clear, for this viewpoint, that if artworks cannot be identified through an examination of their unique properties, then the other considerations—meaning and value—also do not depend on any such properties."

The above quotations by no means capture the full import of vanguard contextualism, but they intimate what arts education would have to shed— a number of hitherto noncontroversial presuppositions and concepts. And perhaps this is a way for arts educators to get some bearing on the new contextualism: by trying to envision the excisions from arts education programs that the sharp scalpel of this theory would be likely to perform. Radical subtractions would have to be made from recent arts curricula— like those initiated through discipline-based art education (mentioned by several authors in this collection)—that aim at enriching students' knowledge base by calling on the resources of art history, art criticism, and aesthetics.

Art history would become irrelevant as a guide because, says Krukowski, "history teaches us very little." For this reason, "the contextual view . . . makes what past it needs out of the preferences of the present." Moreover, traditional art history relies heavily on masterworks as pinnacles of achievement in the development of artistic styles. But such works are not needed for the main business of contextualism (of which more will be said shortly). Indeed, Krukowski writes that "contextualists tend to deny that the institutional reverence and protection given artworks has any *theoretical* justification," and they ask us "to denigrate precious objects that we greatly prize." Courses in art denigration instead of art appreciation would therefore seem to be in order. Museums, and hence also museum education and museum field trips, might likewise lose their purpose and legitimacy.

It would appear that evaluative criticism would also have to be abandoned. Since the distinction between good art and bad art is no longer valid, judgments about such matters would be inappropriate. At this point the contextualist view may make good its claim to being more democratic, for artistic excellence is no longer expected. An additional thought is that while large numbers of people may try their hand at creating artworks, very few would probably earn a decent living from it. Art characterized as "expendable, disposable, replaceable" is not apt to have much monetary or career value.

This leaves aesthetics as an area for inquiry and possible application to arts education, and here contextualism comes into its own. Talk, debate, and philosophizing about art appear to be more important by far than the works that gave impetus to so much lively cognitive activity. One of the central interests of contextualist aesthetic discussion is, as mentioned be-

fore, ontological in nature: the manner in which, and the concepts through which, works gain and lose art status. The function of art is the other focal point. "In the contextualist view, the function of art is essentially cognitive. Artworks press our beliefs about them by resisting the categories we fashion for them; they thus force us periodically to discard both beliefs and categories for new and 'better' ones." This formulation of art's function may, however, raise doubt whether art has any place in the curriculum. Since students do not enter school with entrenched assumptions and notions about art, there is nothing an artwork could challenge, and so we may as well leave them alone. On the other hand, perhaps teachers are meant to give students the latest and "best" categories and beliefs about art so that they have something to discard later in life. Art teaching that builds a disposition to interrogate and dismiss assumptions about art may thus be a means of preparing students for attaining the overarching goal of boredom prevention. As Krukowski notes, "Avoidance of boredom is the value contextualist aesthetics offers as a replacement for the autonomist value of beauty."

But a number of questions crowd in. If escaping boredom is a central value, does it really matter how, through what sort of activity, this is done? (It should be remembered that in more traditional theories the outcome of commerce with works of art—whether it is called aesthetic gratification, insight, the experience of beauty, or by any other seemingly outdated name— is always thought to be more enriching or ennobling for the individual than the superficial pleasures provided by ordinary pastimes.) Is it reasonable to expect that many people would possess the intellectual equipment to chase away boredom in ontological discourse or the inclination to seek out an artwork solely for the purpose of having their assumptions and categories altered? And are these not grounds for concern that "art" will come to exist mainly as a nihilistic mind game played by an elite of intellectuals?

Krukowski is right to concede that the contextualist viewpoint may be "not quite benign," and he may even be correct in thinking it "prescient of our own time"—that is, one estimate of where we are and where we are likely to go. It is also possible that some aspects of his analysis have been misunderstood or misrepresented and that not all of the consequences for arts education that were projected as flowing from contextualism triumphant are likely to ensue. All this can be admitted without diminishing the value of the challenge Krukowski's essay poses to art educators.

The term "context," then, has a variety of meanings which we must sort out before deciding which sense of context and which idea of contextualism we want to incorporate into thinking about arts and aesthetic education.

# Reflections on Cultural Literacy and Arts Education

E. D. Hirsch, Jr.

> In the room the women come and go
> Talking of Michelangelo.

T. S. Eliot, through J. Alfred Prufrock, is contrasting the grandeur of Michelangelo with the insignificance of twentieth-century cocktail-party chitchat. Modern life, with its dreary social leveling, its getting and spending, and its decline into universal triviality is being contrasted with a more heroic age, when great art and great ideals of human conduct, exemplified by Michelangelo, were unimaginably more noble and magnificent than they are today. Could not a very similar contrast be drawn between the modern, utilitarian aims of education as conceived by modern industrial society, and the nobler aims of education that we might wish to aspire to, if we could, in humanities and the arts?

Art, like poetry in Auden's view, seems at first to be a domain "where executives would never want to tamper," leaving art education as another one of those "cultural" irrelevancies that executives might tolerate for cocktail-party chitchat, but do not really esteem. According to most proponents of art education, it is precisely the utilitarian, cost-benefit view of education which the teaching of poetry, art, and music purports to supplement and criticize. Purely utilitarian goals like good citizenship, economic usefulness, and social civility may touch the well-being of society, but poetry, music, and art purport to touch the well-being of the individual soul. What can the idea of cultural literacy, an avowedly utilitarian conception, contribute to a discussion of art education? Doesn't its admitted restriction to practical social and economic goals disbar its advocates from having anything useful to

E. D. Hirsch, Jr., is Linden Kent Professor of English at the University of Virginia. Among his numerous publications are *Validity in Interpretation, The Aims of Interpretation,* and, more recently, *Cultural Literacy: What Every American Needs to Know.* This volume, along with his *Dictionary of Cultural Literacy,* with Joseph F. Kett and James Trefil, and *A First Dictionary of Cultural Literacy* (for the elementary school years), with Michael G. Rowland, Jr., and Michael Stanford, have initiated a national cultural literacy movement, the home base for which is the Cultural Literacy Foundation, located in Charlottesville, Virginia.

say about education in the arts—beyond perhaps recommending a level of knowledge which would enable high school graduates to come and go talking of Michelangelo?

I'll start discussing that complex question by making a few observations about the general relationships between "mere utilitarianism" and "self-delighting, self-affrighting" education in the arts and humanities. Although my own exposures to discussions of intrinsic as opposed to utilitarian goals of education has been limited to hearing and reading high-minded defenses of the humanities, I believe that similar defenses are customarily proposed for education in the arts. Such talk usually trades in pious generalities. It takes a dim view of the merely practical utility with which it (vaguely) contrasts itself. Why do we tend to be so vague when we talk about the arts and humanities? J. K. Galbraith once observed that praise of nonutilitarian education

> comprises by a wide margin the largest part of the ceremonial literature of modern higher eduction. No university president is inaugurated, few speak, only rarely is a commencement address given, no anniversary is celebrated, and no great educator is retired without a reference to the continuing importance of liberal education for its own sake. In part this reflects the paucity of non-controversial topics available to men of high reputation for wisdom but slight specific information. It reflects also the deep conviction of the modern college president that any unsatisfactory educational tendency can be exorcised by sufficiently solemn oratory. (*Annals of an Abiding Liberal*, Boston, Houghton Mifflin, 1979, p. 78)

In the spirit of Galbraith's shrewd comment, I want to make some observations about utilitarian vs. intrinsic education before moving on to the narrower subject of cultural literacy and art education. In a broad sense, it is fair to say that educators in the arts and humanities have undersold the utilitarian importance of their own subjects, as if the very mention of practical utility might debase the spiritual value of their metier. Yet, surely it is both a spiritual and a utilitarian value to bind the members of a society together through common experiences in all domains of life including the domains of art—enough common experiences to enable the broadest possible communication and cooperation among its members. Additionally, we, as a society, also need to decide whether we wish to enable our citizens to come and go talking of Michelangelo, or may be willing to restrict the subjects of their common artistic experience to the television screen or the graphic design on a box of Wheaties.

Both an extreme pragmatism and an extreme antipragmatism come together in discussions of art education. *Les extrêmes se touchent*. From both a purely aesthetic point of view, as well as a purely utilitarian one, there is little to choose between two aesthetically admirable designs for a magazine

advertisement. For the pure utilitarian, both designs will do equally well as agencies of shared experience, and the pure formalist is equally indifferent to the content of the two designs so long as both are complex, harmonious, and strong. The advocate of social utility is indifferent to the content of shared experience so long as it functions to bring people together and enables effective communication and cooperation. The aesthetic formalist, as A. C. Bradley remarked, sees no inherent aesthetic distinction between the *Dresden Madonna* and a Persian rug. Both extreme positions are formalistic. The aesthete who finds value in the beauty and richness of design is no less a formalist than the pragmatist who finds value in the social utility of shared knowledge, and not primarily in its character and content.

While it is easy to dismiss either extreme kind of formalism, the advocate of social utility is a more desirable sort of formalist than A. C. Bradley's aesthete. The social formalist, while conceding that many different kinds of culture are plausible and admirable, nonetheless requires definite choices, so that definite strands of cultural content will predominate—in particular those strands that have been historically determined within a historical tradition. Thus the social utilitarian is only a semirelativist who says that French culture is right for the French and Swedish culture right for the Swedes. But by relying on the idea of concrete tradition, the pragmatist is able to make these specific social decisions. The aesthetic formalist, by contrast, speaks the language of abstract universality and has available, as a formalist, no principle of choice beyond the most abstract terms common to any and all cultures. That kind of tolerant universality is far from being a virtue which stands on a par with ethical toleration. Extreme aesthetic formalism is a copout in art education, because it does not make specific content decisions regarding the curriculum.

The direct *utility* of art education is not a subject to be avoided like a contagious disease. The best possible "intrinsic" education in art, literature, and music is closely allied to the goals of the social pragmatist. Art education, which elevates the soul of the individual, also contributes to social solidarity. Moreover, solidarity is not the same as uniformity. While solidarity does imply shared experience of art, it by no means implies that all shall think alike about art. The virtues of individuality and pluralism can only express themselves truly in a context of community and solidarity. To the goal of solidarity, art education, like humanistic education, has a fundamental contribution to make. No advocate of the arts should feel tainted or somehow impure in stressing the straightforward social utility of education in the arts.

Indeed, the subject of utility, both for the individual as well as for society, goes to the heart of what is valuable in the arts. A great deal of nonsense has been written and spoken about the *intrinsic* value of the arts—thereby distinguishing the aesthetic dimension of life from mere

instrumental aims like pleasure, goodness, and survival. But the concept of intrinsic value in art (and in art education) is an extraordinarily vague conception. It obliterates, in a simple contrast between the instrumental and the intrinsic, what is really a distinction between kinds of instrumental value. Education in sport, for example, is often contrasted unfavorably with education in humanities and arts, and it may be true that American education would be greatly enhanced if all school coaches were replaced with art teachers. But surely it would be incorrect to assume that the purely aesthetic dimensions of soccer or tennis can be isolated from the physical enjoyment of movement and the health-giving value of vigorous exercise. It is not even true to say that the purely aesthetic dimension of sport is an end in itself, in contrast to the physical pleasures and health-giving properties of sport viewed as merely instrumental values. The aesthetic values of sport, like the aesthetics of painting, are *also* instrumental values in the sense that they are satisfying to people and therefore *not* truly ends in themselves. They are ends for people. The most extreme and consistent aesthetic formalist was Immanuel Kant. But not even Kant could avoid the principle of human satisfaction. That he called in "disinterested" satisfaction by no means removed the instrumental implication of the concept of satisfaction.

My long-standing distrust of terms like "intrinsic" and "for their own sake," which are the standard terms of aesthetic discussion, make it easy for me to conceive of art education not as a "luxury," as seen by the philistines, or as an "intrinsic value," as seen by its aesthetic defenders, but as part of the continuum of instrumental goals that underlie the whole concept of education. To omit art education, as the philistines do, giving it a very marginal place in the curriculum, while at the same time saturating the curriculum with language, and science, and math, is to misunderstand the continuum of instrumental values—but no more egregiously than the aesthetes misunderstand that continuum. In fact, the philistines take their clue from the aesthetes. Again, *les extrêmes se touchent*. Those who defend art as being on a different level, on a higher plane, and therefore different in kind from other domains of experience and education are perhaps as culpable as the philistines for creating this sense of marginality in the public conception of art and art education.

Those who wish to promote and enhance art education in the schools fall under the same obligation as those who wish to improve education generally—the obligation to be specific. It is not enough to speak generally about the high humanizing goals of art education. It is not enough to desire simply to train the aesthetic sense of students, giving them an appreciation of design, seriousness, complexity, and harmony. It is incumbent upon those of us who believe in art education to decide which artists and works of art should be known in common by all students. While it is true that specialized art education should be made available to those who have special in-

terest and talent, it is also true that every student should have a developed aesthetic sense as well as an acquaintance with a specific range of works in the fine arts. But on what basis should decisions be made regarding the common core of art education?

It is in this area that the concept of cultural literacy can perhaps make a contribution. If the choice of core content in art education were to be made exclusively on abstract principles of artistic merit, then no committee could ever reach agreement about the core content of art education. We have only to look around us at the committees that have tried to decide what content should be shared in science and mathematics, not to mention literature, to realize that abstract principles will never be the basis of a concrete curriculum. The long, complex process by which works of art and literature, not to mention events in history and other domains of culture, are brought into our shared awareness, must no doubt include estimates regarding the absolute value and greatness of those works. But another factor in the selection of canonical works is pure historical accident.

The concept of cultural literacy recognizes the complex heterogeneity of cultural origins and thus provides a helpful basis for making curricular choices. The core knowledge that is to be shared in art education will, according to the principle of cultural literacy, not be made up exclusively of works deemed good according to transhistorical principles; it will also include what is known by historical accident. Among the many fine works of art that could be known by everyone, history has decreed that only a few shall be known by all. This central core does change, but it changes very slowly. While there may be lesser-known painters who were as great as Michelangelo and Rembrandt, it would be foolish to displace Michelangelo and Rembrandt. Nonetheless, a good case could be made for advocating significant changes in the received knowledge about art and the experience of art that is generally shared in our culture.

This brings me to what I conceive to be the great weakness of the cultural literacy idea as an agent of curricular decision. Cultural literacy is descriptive; it tells us what educated people already know. It does not tell us whether that knowledge ought to be changed. Cultural literacy is descriptive, and therefore can only improve culture in the sense that it brings a wider range of social classes into mainstream culture. In social terms, that by itself is surely an improvement of culture. But cultural literacy says nothing about how to improve mainstream culture itself. The task of art education in deciding upon a definite curriculum is simultaneously to raise everyone to a level of existing mainstream culture and to attempt to advance existing culture beyond its current level.

This second task is one of great difficulty, one for which we have no sure guides. Historically, it has been a task that has been performed by great publicists—critics who by the force of their speaking, writing, and reason-

ing have been able to win a new consensus to new monuments of cultural veneration. Between cultural literacy, which sustains and spreads mainstream culture, and the prophets of change there will always be some tension. But in the larger view, tradition and innovation in art education can be seen as two permanent necessities and two equally desirable aims, neither of which should be permitted total domination. The challenge to the prophets of cultural change is to be just as specific about the shared curriculum as are the proponents of cultural literacy. So far, the prophets of change have neither accepted nor risen to that challenge.

# Cultural Literacy and General Education

HARRY S. BROUDY

It may be advisable—perhaps even necessary—in considering the current debates on cultural literacy to make a number of distinctions. For example, What is a *great* book, poem, or painting? Are all great works classics? Is classical literacy the same as cultural literacy? How has the deconstructive movement affected the issue? What are the proper criteria for "literacy" in the expression "cultural literacy"? Finally, there is the problem of incorporating these definitions and distinctions in the curriculum of a school, especially a public school.

Related to these distinctions is the problem of evaluating the effects of formal instruction in the quest for cultural literacy. Are there uses of schooling that evade the SAT scrutiny, but which nevertheless may be highly relevant to the role of the school in the pursuit of cultural literacy?

## Classics, Texts, and Their Deconstruction

Familiarity with the classics and the educated mind are still tightly connected, for it seems obvious that if classics are the products of great minds, all minds would be improved by familiarity with them. In this context "great" is taken to mean ideas that capture important truths about nature, God, and man—what no educated mind can do without. Deciding which works meet this criterion and what the criterion really means must be left to the guilds of scholars in the arts and sciences. The public school can do little more than select from among them works that can be taught, not an easy task considering the host of variables that afflict all school programs and procedures.

Cultural literacy has a close affinity with liberal education which, in turn, is often equated with study of the Humanities. History tells us that

*Harry S. Broudy,* Emeritus Professor of Philosophy of Education at the University of Illinois at Urbana-Champaign, is a distinguished spokesman for art in general education. Among his recent works are *The Uses of Schooling, The Real World of the Public Schools,* and *Truth and Credibility: The Citizen's Dilemma.*

only selected portions of society have received such instruction.[1] It was not taught to the *hoi polloi* for whom the three r's plus vocational training were considered more than sufficient. However, in the late years of the twentieth century a quite different stratum of society has become impatient with the liberal arts version of general education. This group, sometimes termed "yuppies," are eager to struggle for success in the professions and business, especially big business. It is not that this group disapprove of the liberal arts. On the contrary, they are invoking implicitly an ancient Aristotelian view that a liberal education, i.e., the kind that cultural literacy denotes, is for *liberated* persons, viz., for those successful citizens who have been finally freed by age or circumstance from their political and occupational duties. In our times such a liberated state comes with retirement from a successful career rather than as an introduction to it. In other words, "liberal" education is not for the young.

I shall leave to the scholarly contributors to this project the exposition and appraisal of the movement that has come to be known as "deconstruction." If, as some deconstructionists would insist, there is no *real* text, only diverse interpretations geared to a myriad of cultural and psychological differences, what becomes of the notion of cultural literacy? Does it mean studying the texts or the evidence that there are none? Or does it mean both studying the alleged classic and following it with study of the evidence that it is no more than a classical illusion? It would be a stupid pupil indeed who would not wonder why so much effort should be expended in studying "great" truths that presumably don't exist or the illusion that they do.

About the best the school can manage in this impasse is to preach that the attempt to find the truth takes many forms and is approached by many different pathways; that it is this relentless *pursuit* of truth that is the text to be taught to all and which makes the effort to understand it worthwhile. This, one might argue, has always been the goal and justification of scholarship and cultural literacy. Surely educators can safely indoctrinate this "truth," namely, that inquiry rather than its results is the real value of the educated mind.[2]

There is a sophisticated heroism in this stance; a willingness to live and strive for truth that doesn't exist. It substitutes for naive passion a refined determination which, in the long run, might qualify as the goal of the educated mind. It just may be the best justification of the quest for cultural literacy in education, and there is reason for believing that the commitment of upper-class schools to a classical curriculum may have had just this goal in mind.

However, this stance is precisely what angers nonmembers of the white, male, Anglo-Saxon, economically comfortable culture. What is the school to do? Admit that the standard classical curriculum is based on a mistake that

the deconstructivists have revealed? Should cultural literacy for *all* consist of revealing this prejudice and finding a new curriculum that would avoid these errors? Or should the school—the public school—abandon the whole enterprise and stick with the more useful results of the empirical sciences? Should the scholars make available to the schools the "classics" of all known cultures or what is left after their deconstruction?

So between the strictures of deconstructivism and the expansion of diverse groups demanding study of their cultures, the prospects of the public schools satisfying the demands for cultural literacy are not bright. To be sure, as the academy institutes women's studies, studies of non-Western cultures and other neglected societies, the seedlings of new disciplines are sown, and with their cultivation "classics" in the new areas will be discovered and legitimated by the scholars. But legitimation does not necessarily mean uniformity or even agreement. Even disagreements require academic acknowledgment to become part of the organon of cultural literacy and the curricula devoted to their study.

Perhaps the task is not so intractable as I have made it out to be, if cultural literacy is not restricted to items listed in Hirsch's dictionary of cultural literacy[3] or restricted to a course in the classics. It might mean, for example, developing the noetic, moral, and aesthetic properties of objects that have portrayed a culture so vividly and impressively that they have become its trademark, so to speak. A work to become a classic must be a monument not only to the intellectual quality of a period, but also to its power to portray ideas and ideals in images that make their import vividly available to the senses as well as to the intellect. Plato's dialogues were more than exercises in logic, and Newton's speculations were about more than mathematical formulae. Both adumbrated systems of ideas that became portraits of a reality that had to be imagined as well as understood. To paraphrase Kant, ideas without images are empty; images without ideas are blind.

Classical studies, therefore, are not always comfortably housed in the standard university departments, which too often leach out either the moral or aesthetic components of classical works so as to maintain the intellectual purity of their own specialities. This is the price we pay for the scholarly development of a discipline and of the disciples who will become adept at preserving its specialized particularity. Classical studies, if they are to contribute to cultural literacy—if indeed they are not to be its main subject matter—must be studied in the intellectual, moral, and aesthetic dimensions concurrently.

Cultural literacy, therefore, may be defined as the ability to construe works that elucidate greatness by their concepts and inspire emulation by their imagery. They are works that have anticipated, so to speak, the argu-

ments of deconstructionists. On the contrary, it is because these works are so clearly the portraits of an ideal system of beliefs that not to have become familiar with them is properly regarded as a failure of education.

However, cultural literacy can mean the ability to construe the characteristics of a culture in terms of social organization, legal systems, religious beliefs, and kindred topics on which the social sciences concentrate their attention.

It may be useful, therefore, to distinguish between "classical literacy" and "cultural literacy." The former, as has been noted, refers to studies that have been a prominent component of the curricula of schools patronized by the upper social classes of Western nations. If, therefore, famous works and personages of this culture are taken as the criterion of cultural literacy, the members of non-Western cultures may fare poorly. However, college graduates who have absorbed good doses of sociological, economic, religious, and political analysis may or may not be able to identify who said something to the effect that one cannot step twice into the same river, albeit they can discourse on the cultural importance of rivers.

SAT examinations, like most of the tests administered in school, measure what has been retained of school lessons. They do so by asking the testee to reproduce an item as it was learned. We may call this a test of the replicative use of schooling. Instruction tries to make this replication as exact and enduring as possible. Unfortunately, as most SAT scores reveal, much of what has been negotiated successfully in course work cannot be recalled or recalled satisfactorily as the interval between school testing and life testing increases.

Nearly a half century ago, *The New York Times* conducted a survey to determine how much the American public had retained of their study of American history. It turned out to be so little that the American Historical Society became almost hysterical at the poor showing of testees who, presumably, had passed tests on the subject several times in their school careers. The test had asked the respondents to recall important names, dates, and events. I was moved at the time to remark that only professional historians or *idiots savants* would remember their answers to such questions ten or fifteen years later.[4] How many competent physicians who scored A in chemistry or English literature exams in college would care to retake college examinations in those subjects now? It should come as no surprise that the replicative use of schooling deteriorates unless regularly reinforced by use. However, we do not on that account stop asking college graduates to study easily forgettable facts and to retain them for frequent use. For example, most of us can give a ready and correct answer to $12 \times 12 = ?$ but not to $12 \times 13 = ?$. We do not, however, stop teaching the multiplication tables and rely on our deductive powers to perform simple arithmetical operations.

A quite different scenario is written when one asks adults to *apply* the concepts of chemistry, physics, mathematics, philosophy, sociology, and so forth. If by applying is meant understanding an idea's relevance to a problem, the results on tests are likely to be quite good, albeit the precise meaning of technical terms may have become fuzzy. Many of us can understand how an atomic bomb wreaks its horrors without being able to explain the technical details of nuclear fission. However, if by "apply" is meant the ability to resolve a difficulty by utilizing the scientific principles governing it, we do not do so well—unless such problems constitute our occupational duties.

Thus, relatively few motorists can apply their understanding of the operations of an internal combustion engine to fix a car that won't behave properly. Nor can many college graduates—male or female—repair a bulky refrigerator, television set, or microwave oven. Why, then, do we burden generation after generation with courses in theory which cannot be applied by most of the citizens who had negotiated the appropriate courses with good grades?

### The Other Uses of Schooling

An answer may be found in two uses of schooling other than the replicative and the applicative, viz., the associative and interpretive.[5]

By the interpretive use of schooling is meant the exfoliation of the meaning of a term or an idea. For example, a long, penetrating whistling sound in some towns *means* either that a tornado is approaching or has approached. If the sun is shining, no sign of a tornado manifests itself, and the whistle is silenced, it probably *means* that "it was only a test." Here the individual is asked to "interpret," i.e., deduce the meaning of a sound from what has been learned about the system of which it is a part.

"What does x mean?" is not quite the same query as "What is x?" or "How will x solve a problem P?" Interpretation often requires defining or explaining a situation of a term, and the means for doing so are the residues of a complex of learnings acquired in school. Sometimes we can identify the item as learned in school. Often, however, we attribute our ability to interpret situations to a complex of experiences that we may or may not be able to specify precisely, but which had been imbedded in this or that course.

The associative use of schooling is even less directly connected with specific content. It includes more than school experience, although much of what is studied in formal schooling suggests connections and ideas that were not specifically studied. What do the words "This is the forest primaeval" suggest? "Venus on the full shell?" "Napoleon?" "The Lake Country?" Very likely most of us have run across these or similar terms in courses at school at one time or another. Could we now pass an examina-

tion on the courses in which they occurred? Probably not, unless we had occasion to make a special study of them. Yet those encounters were not wholly forgotten, and given the appropriate contexts they return to consciousness.

The point of stressing the associative and interpretive uses of schooling is to suggest uses of schooling that are rarely if ever tested directly. Consequently, a good deal of the beneficial effects of schooling goes unmeasured and unnoticed. The relevance of these uses ofschooling is especially important in the evaluation of cultural literacy.

I opened the Hirsch *et al.* dictionary at random and landed on pages 184-85. There I jotted down the following entries: Swan Lake, swastika, symphony, Gilbert Stuart. What the cultural literacist would like to learn is how well I could identify these terms and what I could say about them. My own interest extended a bit further. I would like to identify the sources of my knowledge and possibly my ignorance.

*Swan Lake*: The name of a dance performed frequently by dance companies. Vague awareness of articles about various dance companies, ballerinas, and some gossip of goings on in the world of ballet.

*Swastika*: How could I not be familiar with this word? The sign of the Nazi horrors. Vague hints as to its origin and memories of reading an article about it.

*Symphony*: Obviously a reference to a large orchestra playing classical music, most of the time. Famous conductors; probably I could recall the names of a half dozen mentioned frequently in the news.

*Gilbert Stuart*: Stuart? A familiar name, but which one is this? Perhaps having something to do with art. American? English?

*Taj Mahal*: Easy, the famous temple, somewhere in India?

I wondered whether a SAT test on these terms would disclose my ignorance and whether my relatively vague answers would give me a decent score. I also wondered where and how my marginal familiarities had originated.

What, in short, would constitute a fair measure of cultural literacy? Is a sort of generalized familiarity enough? Should there be evidence of more extended professional knowledge? Would a traditional classical eduction at the secondary and college level be sufficient?

On the other hand, I was aware, but not too distinctly, that I had more familiarity with these items than I could state explicitly. I was responding *with* experience that I could not at the moment bring into the focus of consciousness, but which had been deposited in what may be called the allusionary base or store. Had I pursued these studies formally or as a part of a vocational or avocational interest, these allusions might well have been transformed or developed with more detail and precision.

One of the best-known and most thorough attempts to give a theoretical

justification for the interpretive and associative uses of schooling is Michael Polanyi's notion of tacit knowing, albeit he was not the first to explicate it.[6] Tacit knowing is distinguished by Polanyi from focal knowing. When, for example, we view two slightly different images of the same object in a stereopticon, the final image is known focally, i.e., in the center of the visual field. What about the two separate pictures? According to Polanyi, while seeing the unified picture, we have subsidiary or tacit awareness of the two separate images of which the unified image is the resultant.

We cannot simultaneously have focal and tacit awareness of the same object. In the act of comprehending an entity the bearings of the parts *on* the entity come into focus and thus are used as cues to the meaning of the entity.

The associative and interpretive uses of schooling provide many of the resources *with* which we think, perceive, and appreciate, but to which at any given moment we are not paying explicit attention. Thus, much of the schooling acquired by direct study tends to fold back into the allusionary base from which relevant items are summoned—not always consciously or deliberately—as the occasion demands. This store of associative material plays a strategic role in any definition of cultural literacy, except perhaps that which identifies the concept with the recollection of names, dates, events, and so forth.

As might be expected, capturing precisely what that value is and demonstrating its function is not a simple or clear-cut process. Consider, for example the following quotation:

> This gift which you have of speaking excellently about Homer is not an art, but, as I was just saying, an inspiration. . . . Now this is like the Muse, who first gives to men inspiration herself: and from these inspired persons as chain of other persons is suspended, who take inspiration from them. For all good poets, epic as well as lyric, compose their beautiful poems not as works of art, but because they are inspired and possessed.[7]

One may say with some confidence that this is a fair example of the species classical literacy within the class of cultural literacy. What is required of the reader to demonstrate such literacy? Is it the recollection of the dialogue from which the quotation is taken word for word? Is it enough to identify it as an excerpt from one of Plato's dialogues? Who was Ion? What is the point of the passage and against what notion is it directed? Could these queries be answered had not the respondents taken formal course work that included the study of the Platonic dialogues? Would reading these dialogues outside of school have been sufficient? What are the chances that the respondents would have read this or other Platonic dialogues had they not encountered them as part of some course in college?

These queries point up the role of schooling as the source of interpretive and associative resources—an allusionary store—even though the exam answers to these questions have been forgotten. The converse question might be: Would persons who encountered the names of Socrates, Ion, Homer in the Hirsch or a similar dictionary have been able to discuss the passage so as to convince us that they knew what it was all about?

### "Proofs" that Great Truths Are True

It may be apparent from the considerations raised here that the public school's role in developing cultural literacy calls for a theoretical stance that counteracts or at least blunts the arguments of deconstructivism. It includes study of great truths about the human quest wherever they are found and methods of testing the results by means not restricted to the replicative and applicative uses of schooling.

What is needed, of course, is proof that a given doctrine or idea is true and so important that it cannot be omitted from the education of each generation, despite the efforts of scholars to furnish such a proof and of deconstruction to improve it. Academic philosophers are noted for their ability to earn a livelihood and no little prestige for investigating problems that can neither be solved nor left alone. The history of philosophy is a running contest between arguments that there are eternal verities and logical surgery to show that such arguments are fallacious.

In such a situation the public school would be well advised to make a distinction between truth and credibility. The distinction is important because much, if not most, human behavior is grounded on credibility, on what one believes to be the case, on what the consequences of action *would* be, rather than on a logical demonstration of what the consequences *must* be. Faith is the ultimate ground of credibility because in the crucial gambles of life logic is of little help. That is why so much of the history of the human race is about quests for grounds for belief, all arguments from logic to the contrary notwithstanding Tertullian's dictum, *Credo qua absurdum est* is, oddly enough, not always absurd.

Tertullian (150-230 A.D.), of course, was not thinking about the odds on a horse or real estate gambles, but on the truth of the Incarnation. At this level, for the faithful, credibility replaces logic as the ground for belief and action. Cultural literacy demands familiarity with the historic commitments of the race on the basis of the so-called "great truths." Not all of these beliefs are religious. Virtually all metaphysical systems that end up with ultimate truths about the nature of God, man, and the purpose of life posit a system of reality for which the evidence is either lacking or to the unbeliever patently absurd.

When Plato reasoned his way to the conclusion that there is a level of intuition that reveals the reality of being, when the inhabitants of the cave turn around and see the reality instead of the shadows cast by the fires behind them on the walls of the cave, was he talking philosophy or religion? Cultural literacy must also include, therefore, the understanding of those ideas and ideals on which humanity has been willing to bet everything, including life itself. And by understanding is meant something deeper than a vague associative recall. It would entail as a minimum some of the history of these ideas and their progenitors, and one would hope that the fate of these notions in history would also be within the associative and interpretive store.

There is another ingredient in cultural literacy that it may be useful to mention, viz., the acquisition of aesthetic aptitude. We are familiar with the various modes of cognition that comprise schooling and their uses, but the common school curriculum pays far less attention to the aesthetic mode of comprehension than to the logical and linguistic ones. This is made manifest in the role of the arts in general education. To this day, despite recent efforts to make the arts fully validated members of the common school curriculum, they are still not fully accepted citizens of the republic of letters.

Although the schools may be committed to studying the classics or cultures, they cannot do so adequately unless the pupils acquire the ability to construe aesthetically the images that invariably accompany the ideas, ideals, and institutions. Indeed they are the most potent advocates of them. This means more than showing prints or playing records of various cultural periods or episodes. Literature is the only art that is studied systematically in general education, and even here it is difficult to ascertain to what extent such study gives appropriate attention to the imagery of the works and the appropriate modes of perceiving them.

How such aesthetic education is to be conducted and how the common schools can do so systematically is a perpetual subject of controversy. In recent years a project funded by the J. Paul Getty Center for the Visual Arts has aroused extensive and intensive discussion about how art education should function in general education. This is not the occasion for reviewing the development of Discipline-Based Art Education as formulated by Dwaine Greer and his associates to the dismay of many art educators.[8] The important point of the DBAE idea is that it makes explicit the connection of art education with the notion of cultural literacy. By making it necessary to ground art production and perception in the principles of aesthetics, art history, and art criticism and by training classroom teachers to give this art instruction, DBAE expects all pupils to become able to discern the images, the portraits of feeling that constitute the cultural heritage, whatever form it finally takes.

## Postscript

Cultural literacy, it may be agreed, is not a simple notion and the development of it not a simple formula or recipe. The differential components of cultural literacy illustrate not only its complexity, but also the need for understanding it before embarking on a crusade in its behalf. As a goal for education it poses the need for a curriculum that integrates a variety of disciplines that can never be taught as separate courses yet should not be the victim of inspirational but fatal comingling into an unstructured stew. How this can be done, however, still remains to be thought through by the curriculum designers of the public schools.

One attempt to accomplish this is worked out in a volume entitled *Democracy and Excellence in American Secondary Education.*[9] The book was a response to the rash of new science and math curricula as the aftermath of Sputnik. It tried to show that in a democratic society a public school must try to integrate the arts and sciences not by indiscriminate comingling of subject matter, but by a set of problems that utilize the results of many disciplines that cannot be taught as separate subjects. In a way it was a bid for making the secondary school an agency for the promotion of cultural literacy.

NOTES

1. Noel Annan, "See Gentlemen vs. Players," a review of *The Pride and the Fall: The Dream and Illusion of Britain as a Great Nation* by Corelli Barnett (New York: Free Press), *New York Review of Books*, 29 September 1988, 63-69.
2. Such, I take it, is the conclusion of a learned defense of the continued study of metaphysics against the onslaughts of the deconstructionists. Richard J. Bernstein, "Metaphysics, Critique, and Utopia" *Review of Metaphysics* 42 (December 1988): 255-73.
3. E. D. Hirsch, Jr., Joseph F. Kett, and James Trefil, *The Dictionary of Cultural Literacy* (Boston: Houghton Mifflin Co., 1988).
4. "History without Hysteria," *School and Society*, 14 August 1943.
5. For a fuller and more systematic treatment of this topic, see my *The Uses of Schooling* (New York: Routledge, 1988).
6. According to Cyril Burt, Stout was the first to set forth the account of this type of knowledge clearly in his *Analytic Psychology* (1896, bk. 1, chap. 4). Cf. also Michael Polanyi, *The Tacit Dimension* (New York: Doubleday, 1967), pp. 4-5; and Graham D. Martin "The Tacit Dimension of Poetic Imagery," *Polanyi Newsletter*, 8 April 1978.
7. In the Platonic dialogue *Ion*, Socrates speaks to Ion, the rhaposde; Benjamin Jowett translation.
8. Gilbert A. Clark, Michael D. Day, and W. Dwaine Greer, "Discipline-Based Art Education: Becoming Students of Art," in *Discipline-Based Art Education: Origins, Meaning, and Development*, ed. Ralph A. Smith (Urbana: University of Illinois Press, 1989).
9. H. S. Broudy, B. Othanel Smith, and Joe R. Burnett, *Democracy and Excellence in American Secondary Education* (Chicago: Rand McNally, 1964).

# Musical Literacy

JERROLD LEVINSON

> Hearing something new is embarrassing
> and difficult for the ear; foreign music we do
> not hear well.
> Friedrich Nietzsche, *Beyond Good and Evil*

The "cultural literacy" of which E. D. Hirsch's book speaks is that broad background knowledge of factual matters which underlies the possibility of effective verbal communication. Being culturally literate, then, is ingredient in being literate, *period*, i.e., a competent reader and writer of one's language. Thus Hirsch's "cultural literacy" is essentially verbal literacy in a new guise. To be verbally literate is to be able adequately to comprehend the majority of the verbal communications addressed to a general audience that are likely to come one's way and to be able to formulate similar communications of one's own in response; verbal literacy is the capacity to participate, usually as consumer but also as producer, in the public conversation of one's society. By recasting verbal literacy as primarily cultural literacy, Hirsch is drawing our attention to the vast role of factual knowledge, assumed in the culture and presupposed by common discourse, that goes into being able to read and write effectively, and implicitly criticizing the notion that reading or writing might be just algorithmic skills, like doing sums, involving formal rules but requiring no significant core of factual content.

This cultural literacy which, if Hirsch is correct, underwrites verbal (i.e., reading and writing) literacy I will call the *narrow* notion of cultural literacy. There is, however, a *broader* notion of cultural literacy to contend with. On this conception, being culturally literate involves *not only* narrow cultural literacy and the verbal literacy founded on this, but *also* the ability to comprehend adequately various *other* modes of communication, formulation, or

*Jerrold Levinson* is an associate professor in the Department of Philosophy of the University of Maryland. His most recent articles have appeared in the *Journal of Aesthetics and Art Criticism*, the *British Journal of Aesthetics*, and the *Journal of Philosophy*. A collection of essays, *Music, Art, and Metaphysics*, will appear shortly.

expression central in one's culture—for example, mathematical, artistic, so-cial, or behavioral ones. Being broadly culturally literate, then, is being com-petent in a number of going modes of discourse—verbal and nonverbal.

If we now consider "musical literacy," my chosen theme, we see that it can be taken in two ways, once in relation to the narrow idea and once in relation to the broad idea of cultural literacy. In relation to the first, musical literacy can be said to consist in the sorts of factual information *about* music that a common reader is expected to possess and which enable him or her to understand discourse which takes music or musicians as its *subject*. Thus, a person reading that "Beethoven, astonishingly enough, wrote some of his later string quartets while he was almost entirely deaf, and required an ear trumpet to hear even the loudest voice shouting in its bell" is aided in un-derstanding the passage by knowing that string quartets are a kind of music, that Beethoven was a composer of great merit, and that he worked in the early nineteenth century, when small-scale, unobtrusive hearing aids were unavailable. On a more sophisticated level, to understand a passage like "In the initial sketch for the finale [of Beethoven's Symphony no. 8], the basic ideas for the opening are evident: the major third in triplet rhythm at the opening, the consequent idea with a descending melodic contour, and the flat submediant as a harmonic interval,"[1] it is obviously crucial to know that a sketch here is an early version of a musical score (and not a charcoal drawing!), that a major third is an interval (one should not be asking "third what?"), and that "flat submediant" is the name of a note or position on a scale (and no flatter, spatially speaking, than any other note). This sort of musical literacy is obviously of importance, despite its limited scope, be-cause music is important in public and private life and in the history of human achievements.

But it is the second way of taking "musical literacy"—musical literacy as a component of broad cultural literacy, rather than as a minor element in narrow cultural literacy—that will occupy me from here on. What I will be interested in is *comparing* verbal (that is, reading) literacy with musical (that is, listening) literacy, as *both* aspects of cultural literacy broadly conceived.[2] How is the activity of reading with comprehension, whatever the subject, like and also unlike the activity of listening to music comprehendingly? How does what is required for the first to occur compare, either materially or structurally, with what is required for the second to occur?

I

Hirsch's main theme, as already suggested, is that verbal literacy is a thoroughly contextual matter. There is no such thing as understanding in a void, understanding an object or discourse without relating it to other things, either of the same kind or of a more fundamental kind. A back-

ground, a framework, a domain of reference, a set of givens, is presupposed in every act of comprehension. To be a literate reader, in particular, requires that one has accumulated a stock of cultural data which will be called into play by a given verbal communication, data which are needed to understand it but are not contained in it explicitly.

All of this, I will argue, applies in some form as much to musical as to verbal communication. No piece of music can really be understood in isolation, out of relation to anything else. We may say outright that the first pieces of music heard by anyone, of whatever inborn ability, are not understood but only registered, to one degree or another. Such exposures serve, of course, as the basis upon which any future understanding of those or any further instances of music will be erected, but they are not themselves occasions of understanding. Understanding in any medium is relational and always involves at some level connections to things not explicitly presented in the particular text, passage, event, pattern, or phenomenon to be understood.[3] These connections must be acquired, or laid down, through experience—even if there are dimensions of musical comprehension, to be sure, which rest on universal and innate human capacities.

A specific example will help us to fix the way in which Hirsch's basic insight as to what is at the core of reading literacy also applies, *mutatis mutandis*, to musical literacy—the ability to understand the majority of musical utterances in a given tradition. It should also help us to see at what point the analogy or parallel—of musical understanding and reading comprehension—gives out.

Consider a listener confronted with the first movement of Bruckner's Fourth Symphony (E-flat) for the first time.[4] What must such a listener be in possession of, cognitively speaking, if he is to grasp this music, on a primary level, as it unfolds before his ears on this or later occasions? To what degree do specific facts, background information, prior training, or earlier encounters underpin such a grasp? In other words, what is minimally needed for a listener to hear what Bruckner is "saying" in this piece of music?

In attempting to answer this question, I first offer a descriptive sketch of the comprehending listener which seems fairly uncontroversial; it will consist of a list of things such a listener will be doing, i.e., hearing or experiencing. I will then try to bring out what is necessary for such hearings or experiencings to occur, with particular attention to the role played by contextual knowledge. (In what follows, "CL" abbreviates "comprehending listener.")

(1) A CL hears the music as *tonal*, i.e., as constructed on the basis of a familiar set of eight-note scales, major and minor, and as having certain implied standards of consonance and dissonance—or stability and instability—both melodically and harmonically. (2) A CL hears the music as

*symphonic*, i.e., as a large-scale utterance, with regard to both span of time and number of voices or parts involved. (3) A CL hears the music as *Romantic* (or nineteenth-century) in style, i.e., as having certain distinctive features and ways of developing which that term denotes. (4) A CL hears the music as roughly in *sonata form*. (5) A CL hears the music as specifically *Brucknerian* in character. (6) A CL has an experience of the *connectedness* of the music—of its individual *motion or flow or progression*—rather than merely one of discrete, momentary sounds in succession. (7) A CL has a series of appropriate[5] reactions and registerings on the order of *tension and release*, or *expectation and fulfillment*, or *implication and realization* during the course of the music. (8) A CL hears the music's progression with some awareness of the *performance means* (or performing acts) involved in generating the sounds being heard. (9) A CL apprehends in large measure the *gestural and emotional* content of the music. (10) A CL has a sense of the *wider resonances*—in this case, mythic, religious, and nature-loving ones—attaching to the movement, rightly construed.[6]

The easiest way to corroborate the truth of this profile of basic musical comprehension, before pondering carefully what is minimally required to underwrite it, is to reflect on what a listener's situation is like where any of these factors *fails* to materialize. Suppose a listener does not even hear the music as tonal—due most likely to coming from a wholly different musical tradition, for instance, that of Japan, or India, or Indonesia. Then the alternating perfect and augmented fifths of the horn's opening call[7] will have no particular significance for this listener—neither will seem more strained than the other—nor, more generally, will the various modulations from key to key which ensue in the course of the movement be registered by him in any way. Stripped of its tonal character in the hearing of such a listener, Bruckner's movement retains only the sense it has as a pattern of changing dynamics and timbres.

Suppose, next, that a listener is capable of hearing the music as tonal, but fails to construe it as symphonic; he may take it, initially, to be a piece of chamber music for horn and strings (a nonet, perhaps), or else an orchestral piece, but one of short duration. Then he will, in the one case, be inappropriately disconcerted when the full panoply of voices enters some measures later, and in the other case, pointlessly puzzled by the clearly long-breathed character of the opening eighteen-bar statement. Categorizing the music as symphonic from the outset obviously allows the listener to avoid such unintended effects.

Next, consider the listener who hears the music as tonal and symphonic but not as Romantic in style, perhaps because of unfamiliarity with the difference between Romantic music, its Classical predecessors, and its twentieth-century successors. What will he be missing? Well, the expansiveness and rhetorical freedom of Bruckner's way of proceeding will not likely be

appreciated for what it is; a listener experienced only in the music of Mozart, say, will likely grow impatient, wishing for a conciseness and a pace of change that is not to be. Failing to situate the music as nineteenth-century music—and thus as prior to all "movie music" with its special burden of "enhancing" film narrative and audience involvement—could equally well lead a listener to hear in the Bruckner a bathetic or melodramatic charge which is not properly there.

What of a listener who does not grasp the movement as governed by the sonata idea? Such a person will be inert to many of the experiences that Bruckner has, so to speak, designed into his music. To grasp a sonata movement as a sonata is, in broadest terms, to take it as falling into three phases, a first concerned with exposition, a second with exploration (development), and a third with restatement and return (recapitulation). It is also to be sensitive to the turning points from phase to phase, to certain norms of internal connection (e.g., shared thematic material, key relationships) operating within and between these phases, and to the character of the whole as a kind of journey from a home base (roughly, the tonic) toward more or less remote lands (other keys, other guises of the basic musical materials) and, eventually, home again—exactly where you started out, in a sense, yet transformed by the journey.

A listener whose hearing is not at all informed by sonata expectations in processing Bruckner's discourse might, for example, very well think the piece is at an end at the close of the first part of the exposition (measures 69-74), with its hammered-out proclamation of F-major and momentary silence, save for sustained Fs on horns. He will, further, not recognize the slowing down of musical activity in measures 170-90 (immediately after a brutal four-measure fanfare in the brass) as the beginning of the exploratory, less structured phase of the music, calling for a different way of reacting. Nor will he, fifty measures later, experience the delicious wonder as to whether the horn call over tremolo strings at measure 217, clearly reminiscent of the movement's opening, is a sign that the return has begun or only a kind of teaser, heralding instead more extensive wanderings and transformations. (As it turns out, it is the latter, being in F rather than the E-flat essential to a true return; the *bona fide* recap does not occur for another hundred and fifty measures!) Lastly, he will not perceive in the final, blazing peroration (measure 550 to end) the almost superhuman force which, rightly heard, emanates from this long-delayed harmonic (and motivic) reaffirmation.

Instead of going in this way through the remaining marks on my list, I will assume the reader would agree to take them (or the majority of them) as intuitively plausible dimensions of basic comprehending listening. That given, the thing to note about them all is their implying a listening that is through and through *contextual*: for the music to be heard or experienced in

those ways is for it to be related to—brought in some fashion into juxtaposition with—patterns, norms, phenomena, facts, lying outside the specific music itself.[8]

Thus, to hear the movement as tonal (1) is to hear it in relation, however implicitly, to an underlying scale and range of chords; and hearing the specific moment-to-moment flow and connectedness (6) in a movement such as this can hardly be separated from hearing it tonally. To hear the movement as symphonic (2) is to compare it with a template of features applicable to other symphonies and drawn from them; to hear the movement as "sonata-ing" (4) is to bring to bear on the music as it unfolds a general schema of sonata form, with which the music can be seen to comply more or less, though in its own individual, and sometimes temporarily deceptive, way. To hear it as Romantic (3) or Brucknerian (5) in character is obviously to connect it with other works of music by the composer, his contemporaries, and his predecessors.[9] To hear the music not as disembodied tones but as the upshot of human actions applied to physical devices (8) means, among other things, gauging musical events with respect to the dynamic ranges of the various instruments (e.g., brass vs. woodwinds vs. strings), which ranges are not transparently displayed in the piece at hand. To have the right series of expectations, the right awareness of implications and realizations, the right sense of the rise and fall of tensions in the course of the movement (7), can come about only if one is perceiving the music against the backdrop of a host of norms associated with the style, genre, and period categories, and the individual compositional corpus, to which the movement belongs.[10]

This leaves only (9) and (10), a CL's appreciation of the "extramusical" content, if we may call it that, of Bruckner's musical essay. Can there be any doubt that this cannot fully emerge in the absence of connections made by the listener between sequences of sound and broad spheres of human life lying wholly outside the notes themselves? It is worth going into the generation of this latter content in somewhat more detail.

Consider the repeated

rhythmic figures so important to the movement's character. Where does the expressive punch of this figure, especially in its rising and forte enunciations (e.g., at measures 51-54), derive from? I suggest it cannot be other than from some association with human movement; the image of a compressed (e.g., crouching) body rising, slowly at first, then more swiftly, to full stature seems particularly apt, but surely some sense of physical rising is being tapped into. It is this that crucially funds the figure's uplifting, life-affirm-

ing quality. Similarly, the gay, carefree motives of the second thematic group (measures 75-86) unmistakably derive their expressiveness in part from their evocation of skipping and dancing movement.[11]

There are few beginnings more evocative in all symphonic music than the already noted horn mottoes over tremolo strings with which Bruckner's movement opens. Part of the magic of this opening, undeniably, owes to the connotations of the horn and horn timbre: the outdoors, the hunt, adventure, chivalry, and so on.[12] This opening passage, melodically and harmonically intact but with the horn's line taken instead by the bassoon, would be utterly transformed. The scoring of some passages of the movement, as has often been remarked of Bruckner's music, is suggestive of the organ, which was the composer's favored instrument: widely spaced harmonies, sustained pedal points, and even an effect like the opening and closing of a bellows, or, more pointedly, the swell on a manual organ (cf. measures 59-62). This perhaps contributes, in a subtle way, to the undertone of solemnity in much of Bruckner's music. A more direct invocation of the religious is to be found in a passage like that at measures 304-24, near the end of the development, which has the character of a slow-moving four-part Protestant chorale for brass. Lastly, it may even be the case that the religious, pantheistic dimension of the music is more clearly "there" for a listener informed about Bruckner's own pietism, his unassuming devotion and service to the church, and his simple appreciation of the goodness of nature.

I take it we have seen, then, how much of the "extramusical" content of the movement, which is there for musically literate listeners, presupposes cognizance in some fashion of various matters lying outside the given piece of music as a sonic event: the different ways human emotions embody themselves in gesture and stance; the sets of cultural associations carried by particular rhythms, motifs, timbres, and instruments; those aspects of a composer's life, work, and setting that enter into and qualify the precise meaning of the sequences of sounds he narrowly sets down in score. Neither the "extramusical" nor the "purely musical" content of this music can come across for a listener who brings nothing to it from his previous experience of related music and of the world.

## II

It is time, then, to ask what a listener needs to do in order that his listening be properly relational and contextual in the ways we have been exploring and so display the marks or indications of comprehending listening noted above. How does one become a CL, for this and other pieces in the tradition of Western classical music? What do all musically literate listeners to music in this tradition *know*, and on what level?

The obvious answer to this last query seems to be that a CL knows what

tonality is, what a symphony is, what Romantic style consists in, who Bruckner was, when he lived and what influences operated on him, what the rest of Bruckner's oeuvre consists of and what expressive gamut is inherent in it, how sonata form goes, what various instruments can do, what the possibilities of motion, gesture, and emotion are, and so on. This obvious answer is, in one sense, correct. But it also contains a suggestion that should be opposed, namely, that a CL knows these things in the way he knows that his telephone number is such-and-such or that Thailand is a country in Asia whose capital is Bangkok. That is to say, it is a mistake to think that the bulk of a CL's contextual knowledge, which underlies comprehending listening, is in propositional form, that he must come to this knowledge by explicit, verbally mediated instruction, and that he has, in principle, ready access to it in discursive dress.

A CL will, indeed, have knowledge of the sorts mentioned, and this will certainly inform his listening. The experiences and reactions we have posited as criterial of musical comprehension invariably involve a CL's relating sonic events being heard to structures and elements outside those current sounds; musical communications, like verbal ones, must be put in the right contexts by receivers if their meanings are to come through unobscured. But—and this is crucial—the relevant background knowledge of a CL may be largely *tacit*, not explicit, and he may often come to a lot of it in a largely *intuitive*, experiential, non-verbally-mediated way. In this, musical literacy parts company with reading literacy, which, naturally enough, requires its vast skein of background knowledge in verbally encoded form; it is that which makes its extraction, and subsequent publication as *The Dictionary of Cultural Literacy*, possible. But there can be, in the important sense, no "dictionary" of musical literacy—unless, of course, this were to consist of an extensive and representative collection of CD's! Understanding a piece of music is fundamentally *hearing it in an appropriate way*, in virtue of the experiences one has had and the resulting reorganization of one's mental space, whereas understanding a written text remains *grasping an articulate meaning*, even if this involves effecting an integration (as Hirsch insists) between the statements of the text and a larger body of knowledge discursively possessed.

A musically literate individual in the sense under consideration—that is, listening literacy—need never have digested a formal definition of concerto or fugue, need never have grasped the least fundamental of harmonic theory, need not know how many octaves and fractions thereof each orchestral instrument spans, need not be able to tick off the characteristics of Baroque style. He need only have an implicit grasp of these things—in his bones and ears, so to speak. His literacy ultimately resides in a set of experientially induced, context-sensitive dispositions to respond appropriately to musical events in specific settings, and not in items of recoverable

information in a mental dictionary of musical matters. Being musically literate is being sensitive to differences, departures, and digressions, relative to internalized norms of style, genre, and form. It is responding to secondary features of musical structure—timbre, tempo, dynamics, phrasing—in a way framed by awareness of the physicality of the instruments which make that structure sound. It may even involve, in some cases, appreciation of the individual answer to an old quandary carried by a given piece of music, a solution to an artistic problem implicit in its sequence of predecessors.[13] But in every instance, comprehension is essentially *appropriate construal*, and not—or not necessarily—*intellectual realization*, and must thus rest fundamentally on a history of aural absorption as opposed to conscious cogitation.

Consider our CL's grasp of sonata form. This may have been facilitated by explicit instruction in the lineaments of the pattern, as displayed in musicological analysis, but likely as not it was gained entirely from sufficient guided listening to a range of movements in sonata form—to which the Bruckner movement in question is then provisionally, and ultimately successfully, assimilated. Some internal operation of abstraction performed on a sufficient number of instances, if the gods are smiling, leaves a listener in possession of sonata form in a way that directly affects listening—which is not in fact invariably true of analytic education in what sonata form is. Similarly, our CL's hearing the movement as tonal, symphonic, Romantic, Brucknerian—even as specifically Wagner-influenced—does not entail that he has ever been exposed to explicit formulations of these characteristics, nor that he is able now to articulate such, even roughly. More likely is that he has simply managed to induce these categories unconsciously from the totality of instances of classical music—properly labelled, to be sure—he has been fortunate enough to absorb.

Again, knowledge of the human behavioral and emotional repertoire, of patterns of growth and development in the natural world, of the powers and potentialities of different sound makers, of the associations attaching to certain musical materials at certain cultures and junctures—all of which plausibly underlie one's capacity to identify and recognize various sorts of expressiveness in music—need never have come a listener's way in discursive, propositional form, nor need they now be so possessed. Admittedly, there are some kinds of information which play a role (as we have seen) in engendering comprehending listening—e.g., the chronological relation of Bruckner to Wagner, the religious environment of Bruckner's acts of composition, perhaps[14] the facts that fifths are characteristic of hunting horns and that chorales and organs are rooted in the church—which might have to be acquired and stored in an explicit manner.[15] But this ineliminably discursive element in the contextual background knowledge of a CL seems fairly marginal in comparison with that extensive repertoire of forms,

styles, and procedures, that framework of musical/extramusical connections which is tacit and internalized for a listener musically literate in the classical tradition. Not much, I want to suggest, that is required to have the kind of full hearing or experience characteristic of a CL need come from learning about music on a discursive level—from *reading* about music, in effect. Music histories, composers' biographies, analytical essays, liner notes are fine and often quite enriching, but they are not at the core of musical literacy; extensive and repeated *listening*, provided it is minimally organized in descriptive terms, is.

To become musically literate, one must have attentively experienced a good bit of music—as well as a good bit of life—and have appropriately categorized, organized, and abstracted that varied musical experience. Central to this process is the sorting of pieces into groups by composer, genre, period, national schools, etc., guided by titles and ancillary descriptions, so as to acquire and internalize, through listening and re-listening, the standard or normal characteristics of individual composers, genres, and so on. This then serves as backdrop against which the specific character of individual pieces of music, and their various shades of meaning, can stand out in proper relief. But a CL may not have this kind of contextual knowledge discursively, in even the vague way which is evidenced where *reading* literacy is in place. As long as the various musical norms are internalized by sufficient exposure to a representative selection of pieces, adequately tagged, then what defines these norms in an explicit way may remain inaccessible to the musically literate listener.

I don't mean to be denying that a CL may need certain bits of articulate information—e.g., the genre label of a piece, the name of its composer, the period of its composition—to *trigger* or *activate* the right perceptual sets and interpretive frameworks. The point is that *what is so triggered* is not fundamentally discursive in form and might not be verbally exhibitable by the subject. Such data, as I have already suggested, are at some point crucial in guiding organization of a CL's internal map of the musical landscape so that comprehending listening can take place, so naturally they are also instrumental in activating the appropriate region of the map, and an associated set of habits and sensitivities, as listening proceeds. Verbal labels function to organize the construing capacities and musical "memory banks" of a comprehending listener, but the resulting competence, in contrast to that of a comprehending reader of literate discourse, does not rest in any important way on articulate information.

Furthermore, even those labels (e.g., "trio," "serenade"), names (e.g., "Chopin"), and titles (e.g., "Russian Easter Overture") which initially play a role in seeing that the right collecting together of pieces relative to one another, and to extramusical experiences, occurs in the head of a listener who is in process of becoming musically literate, are not, after a while, *indis-*

*pensable* in most cases. Just the first few bars of an unfamiliar piece will generally suffice, assuming the listener has had wide enough exposure to music in the given tradition, for appropriate internal categorization of the music to occur in a number of respects, thus calling into play the right sets of schemata and associations, without the listener even being aware that this has occurred. Once one is musically literate in a tradition, the right frames of reference will in most circumstances be activated effectively either by the familiar sorts of verbal cues ("Chopin," "trio," etc.) or by onset of the music itself.[16]

To be musically literate thus requires internally classifying pieces as they are being heard in certain apt ways. And this, inescapably, means relating the given piece to a background repertoire of other pieces that have been heard and stored—whether as such or in condensed and abstracted form as archetypes, paradigms, and patterns of probabilities. It is this extensive background of what has been heard earlier, on other occasions, in addition to what has been internalized concerning relevant contexts external to music, which confronts each piece of music new to a literate listener, enabling it to be received in a manner that counts—though sometimes only after a second and third hearing—as understanding. Comprehending listening is a process of constant, largely unconscious correlation, and a listener without a "past" will be incapable of having it go on in him in the right way.

On my view musical literacy, like reading literacy, is fundamentally contextual, but unlike reading literacy it is also primarily tacit, nondiscursive, not propositionally expressible and exhibitable.[17] This is not, of course, to say it is innate; it must be acquired through experience, musical and nonmusical. The musical part of this experience, at least at initial stages, may have to be verbally guided to some extent, but it is the laying down of habits of response and construal, and not the laying in of descriptive information, that remains the real work of converting a musically illiterate ear into a musically literate one.[18]

My practical prescription, then, for attaining classical music literacy is *not* primarily to acquire more information about music on a verbal level— though a small amount of the cultural data needed to construe music aptly may not be otherwise absorbable—but to *listen* as widely as possible. To do so is progressively to fill out one's model of the matrix in which musical events take on their proper meanings. The set of contexts—formal, stylistic, historical, expressive, and instrumental—in terms of which a given musical discourse needs to be "read" if it is to be heard aright, are largely acquirable through listening alone, so long as minimal labelling is provided. Musical understanding, in sum, though as contextual a process as intelligent reading, is vastly more isolatable from knowledge propositionally possessed than is that latter activity. But this should not, after all, be surprising.

NOTES

1. Rey Longyear, *Nineteenth-Century Romanticism in Music* (Englewood Cliffs, N.J.: Prentice-Hall, 1973), pp. 77-78.
2. I am thus restricting my discussion of musical literacy to the reception, not the production, side of the musical situation—to listening, as opposed to performing. The latter is, of course, properly part of musical literacy, but it lies outside the scope of this article.
3. A possible exception to this might seem to be one's grasp of an abstract two-dimensional configuration as consisting merely in a grasp of the *internal* connectedness of the parts or elements of the configuration. But it seems likely that even such "formal" understanding, if we may so denominate it, would be nurtured by implicit comparisons to other configurative possibilities and underpinned by prior possession of certain plane geometrical paradigms (e.g., circle, square, line vs. area).
4. I choose this just as a representative, moderately complex piece of instrumental music. In this essay I shall have only such music in mind, thus leaving aside issues that music with text, and unequivocally representational music, would additionally raise.
5. To spell out in detail what standard of appropriateness is invoked here would be a large task. Suffice it to say that it is a standard established by the consensual assessments of earlier competent and experienced listeners. (I am trying to avoid characterizing this in a way which builds in the contextually informed hearing I eventually argue for. Such hearing, however, is in my view the ultimate ground of the appropriateness in question.)
6. It is worth noting that these various conditions or occurrences are not all logically independent of one another. To hear the movement as Brucknerian in character is *a fortiori* to hear it as Romantic, and to hear it as exemplifying the sonata principle is not separable from having the kinds of experiences of flow, tension, etc., mentioned under (7) and (8).
7. Strictly speaking, the alternating interval is a diminished sixth (*C-flat* down to E-flat, not *B* to E-flat), but this hardly affects the point I am making.
8. The case for the essential contextuality of understanding in the artistic sphere has been amply made by a number of writers, in different ways. See, for instance, E. H. Gombrich, "Expression and Communication," in his *Meditations on a Hobby Horse* (New York: Phaidon, 1963); R. Wollheim, *Art and Its Objects* (1968; New York: Cambridge University Press, 1980); N. Goodman, *Languages of Art* (Indianapolis: Bobbs-Merrill, 1968); K. Walton, "Categories of Art," *Philosophical Review* 79 (1970); M. Sagoff, "Historical Authenticity," *Erkenntnis* 12 (1978); P. Pettit, "The Possibility of Aesthetic Realism," in E. Schaper, ed., *Pleasure, Preference, and Value* (New York: Cambridge University Press, 1983).
9. Bruckner's symphony can, and certainly should, be heard as *Wagnerian*, in a broad sense. That is to say, Bruckner was clearly influenced by Wagner—he idolized him and dedicated his Third Symphony to him—and this is reflected in the brass-weighted scoring, the enlarged scale, and the greatly increased chromaticism of his symphonies. Certainly when understood as "passing by way of Wagner," the departures in Bruckner's symphonies relative to his predecessors in the symphonic tradition (e.g., Beethoven, Schumann) appear more natural and evolutionary than they otherwise would.
10. Leonard Meyer, in a series of books, has done the most to illuminate this thesis in detail. See *Emotion and Meaning in Music* (Chicago: University of Chicago Press, 1956), *Music, the Arts, and Ideas* (Chicago: University of Chicago Press, 1967, and *Explaining Music* (Chicago: University of Chicago Press, 1973).
11. We might remark in this case a plausible additional, minor contributor to the resulting character: an explicit reminiscence of the folk music of Bruckner's native Austria.

12. This is not to say the particular *interval* chosen (a fifth) is unimportant. Rather, this serves to reinforce the connotations spoken of, since for horn calls of the alfresco settings which are being traded on, the fifth is in fact traditional. (They are, in addition, "naturally" based, in that valveless horns—which preceded the orchestral instrument Bruckner wrote for—could not readily play notes outside the natural harmonic series.)

13. For example, how a symphonic movement might at one and the same time satisfy the felt demands of sonata procedure and the exigencies of fugal treatment, as in the finale of Mozart's *Jupiter* (an example I owe to Stephen Davies), or how a violin concerto's first movement might incorporate the usual cadenza and yet integrate it into the mechanics of the music in a noticeably smoother manner than usual, as in Mendelssohn's E-Minor Concerto.

14. I say "perhaps" because it seems plausible to me that one could have these sorts of knowledge in the ear, from a number of experiential sources, without having them enter one's consciousness in discursive form.

15. Possibly the clearest cases to be had in music of ineliminably discursive information being crucial to full comprehension are where specific referential relations, targeting particular earlier pieces of music, are present: parody, allusion, quotation, modelling, homage, repudiation, variation, and so on. However, none of these modes of reference, to my knowledge, figures importantly in the Bruckner Fourth.

16. For example, when a listener literate in classical music hears the rarely played (and unfairly neglected) Piano Concerto in F-Minor of Adolph von Henselt, without any identifying information, he will naturally, unreflectively take it as a concerto, as Romantic—as post-Lisztian, even. These inner categorizations carry with them patterns of expectation and response; the listener's mind is primed, as it were, to hear certain features or developments as significant and not others, to make certain background connections, thus perceiving certain resonances and not others.

Of course in some cases, the natural, unaided categorization, even of the musically literate listener, is the *wrong* one, and an explicit contextual datum may indeed be required to correct this, in order that optimally comprehending listening can occur. Thus, knowing a piece is an early Schubert work, rather than the middle-period Mozart one would likely have taken it for, changes the frame of comparison in a way which significantly affects one's perception of what transpires. But I would venture to say that cases of this sort, where an injection of specific propositional information is crucial to set things right for a musically literate listener, are relatively rare.

17. It could be thought that my way of putting the point, here and earlier, is too strong. One might understandably feel that any knowledge involved in, or presupposed by, musical understanding *must* be potentially exhibitable in the verbal arena, *must* be elicitable on request. Why? Because if not, comprehending listening, and the contextual competence behind it, will have no *public criteria*, and that can't be so. But this is, I believe, a false worry. Musical comprehension can be evidenced in having the right kinds of affective responses at the right points; by the character of one's reactions to alterations, rearrangements, truncations of the musical progression; in the way one plays, whistles, or otherwise attempts to reproduce given passages; and in the answers to simple questions designed to probe whether the sort of aural experience constitutive of comprehending listening has occurred (e.g., "Do you hear X as more similar to Y or to Z?," "Do you hear W as a continuation of V or not?"). Beyond that, however, there are no discursive descriptions of what he has understood and the contexts or schemata in terms of which he was able to do so, which a CL absolutely must be able, independently, to give.

On more extensive questioning and probing, of course, a CL may very well *come to* or *arrive at* a degree of explicit propositional knowledge, concerning both

the piece he has heard with understanding and the internalized norms underlying that understanding. But I think it would be a mistake to describe this as merely *articulating* on command what must have been already known in that form—in the back of one's mind, so to speak. To say the basic contextual knowledge possessed by a CL is generally articu*lable*, if we do, is not to say it is now articu*late*—in propositional form though unexpressed. Rather, to allow that a CL's understanding of a piece, and his grasp of the contextual framework underlying that, is often articulable, is only to say that such understanding or grasp can be *raised* to an articulate level for most listeners—or, more precisely, that articulate knowledge can generally be *achieved*, if one chooses, by reflection on and analysis of what one knows inarticulately. But that is *not* to say it was there all along, only unattended to. And so I am inclined to stick by my claim that the background knowledge underlying a CL's understanding of a piece of music—and 98 percent of what he so understands, for that matter—need not even in principle be propositionally formulable by him.

18.  It probably little needs saying that being musically literate in one tradition hardly constitutes being musically literate in another, any more than perfect comprehension in English translates into the ability to decipher Hungarian prose. But this much is true of the old nostrum that music is a "universal language," I think. Whereas the English speaker's mastery of his own language helps him not at all when first confronted with Hungarian, mastery of a given musical tradition will likely involve ways of taking and construing sound patterns that will transfer, to some extent, to an unfamiliar music. If we think of musical comprehension as divisible roughly into two phases, one of synthesizing hearable motion and continuity out of mere succession and one of hearing significance in what has been synthesized, then experience suggests that what one has learned to do on the first level in one musical tradition will carry over to a large extent to another (whether because of certain commonalities in the musical materials of any musical system, or because of universal constraints of human psychology, or whatever), whereas one's assignments of meaning or originality or expressiveness, rooted in different cultural and historical contexts, are as likely as not to be in error.

Thanks, to Stephen Davies and David MacCallum for helpful comments on several points, and to Karla Hoff for editorial suggestions.

# Theater Education and Hirsch's Contextualism: How Do We Get There, and Do We Want to Go?

## PATTI P. GILLESPIE

In the three years since its publication, E. D. Hirsch's *Cultural Literacy* has challenged Americans to rethink the meaning of education in a democracy.[1] In an effort to educate each child at his or her own level, Hirsch argued, schools have fragmented the curriculum, separated skills from subject matter, and caused "a gradual disintegration of cultural memory."[2] If we wish our schools to be a force for equality rather than inequality, Hirsch concluded, we must make radical changes in our educational philosophy and practice, changes aimed at restoring the contexts of our national culture.

Although Hirsch's best-selling book provoked a storm in some educational circles, it produced scarcely a raindrop among theater educators. Indeed, Burnet Hobgood spoke truly when he observed that the enterprise of theater education is seldom the focus of scholarly attention.[3] As a partial response to Hobgood's complaint, this essay will take as its subject theater education as it might be affected by Hirsch's proposals, especially in the areas of curriculum, production, and criticism. My interest in the subject comes from my work as a theater historian and my experiences as a teacher of theater, first in high school and now at the university.

In order to examine theater education in terms of Hirsch, I must try to explain how we arrived at current educational practice: that is, I will place our current practices in a context (itself an important word in theater studies). I will then examine these practices in light of Hirsch's claims about education in general. Finally, after suggesting some new directions for theater education based on Hirsch's proposals, I will consider in detail a single example, that of critical method, to discover how it might be affected by an acceptance of Hirsch's basic propositions.

Throughout the essay I will try to model as well as discuss a certain approach—the contextual—to criticism.

*Patti P. Gillespie* is Professor of Theatre at the University of Maryland. She is the coauthor of *The Enjoyment of Theatre* and *Western Theatre: Revolution and Revival*, has recently published in *Text and Performance Quarterly*, and has contributed an essay to *American Playwrights Since 1945*.

## Context in Theater Education

*Precedents in Western Culture*

Historically, theater and education have been inextricably yet uncomfortably linked.[4] Part of the price paid for allowing the linkage has been the neglect of questions about theater's nature and beauty in favor of those about its morality and usefulness.

In pre-Christian Greece, where there was no universal public education, theater's performance at festivals was a common and therefore unifying form of education for the residents of the *polis*. Its clear power as teacher, however, led Plato to distrust it and to ban it from his ideal state: "Poetic imitation . . . waters and cherishes those [unworthy] emotions which ought to wither with drought, and constitutes them our rulers, when they ought to be our subjects."[5] Aristotle's brilliant counterclaim, in *On the Art of Poetry*, did little to refocus the discussion from political to aesthetic principles, despite its reasoned explanation of the nature of the art *qua* art.

Theater's power to teach produced similarly ambiguous views during the middle ages. In the third century, Cyprian unequivocally condemned it: "The mimes are our instructors in infamy. . . . Adultery is learnt while it is seen."[6] In the fifth century, Augustine, although acknowledging redeeming qualities, also condemned it: "The theaters [are] sinks of uncleanness and public places of debauchery."[7] On the other hand, in the tenth century, Ethelwold, Bishop of Winchester, gave explicit directions in his monastic guidebook for performing parts of the divine service (to educate monks who were to become teachers), and Hroswitha, Abbess of Gandersheim, rewrote Terence in order to substitute for "the shameful abomination of wanton women . . . the praiseworthy chastity of holy virgins."[8] By the fourteenth century, great civic festivals, with church approval and often church support, featured religious plays that taught Biblical history and Christian precepts and served to bind the community through celebration of a common heritage.

The Renaissance witnessed drama's tie to formal schooling. Although public opinion about the value of *professional* theater remained severely divided, most thinkers agreed that theater *within schools* was an important educational asset. Thus, although the Synod of Nîmes (1572) forbade Christians' attending theater, it concluded that drama in schools was *useful* and could be "tolerated."[9]

There was even general agreement about the nature of drama's usefulness. Classical plays, for example, helped teach Greek and, more often, Latin: "Who more useful than Terence" in teaching Latin grammar, style, and pronunciation, asked Cardinal Wolsey in 1528.[10] New, specially written plays helped teach the vernaculars, those important reflections of the newly emerging nationalisms: "I love Rome but London better; I favour

Italy but England more; I honour the Latin, but I worship the English," explained Richard Mulcaster in 1582.[11] To foster both goals, Elizabeth I decreed in 1560 that during Christmas the children of Westminster would perform one Latin and one English play each year.[12]

In addition to their usefulness in teaching language and literature, plays could teach the life of Christian virtue: "Thus even as we play, we must direct morals towards piety, to conduct them through great images to great deeds and to plant in their hearts the love of Christ," explained Père Commire.[13] Moreover, all plays could teach oratorical skills, and all could improve personal bearing: "The art of acting is a trifling one, but for teaching oratorical delivery and suitable gestures and movements of the body, nothing is more calculated to achieve these aims";[14] and "it is customary to present plays . . . so that the youth . . . could cast aside unnecessary shyness, and also for the moulding of the tender and stammering mouth so that they may speak and express words clearly, elegantly, and distinctly."[15]

In developing a rationale for including theater as a part of their own curricula, Jesuit scholars well summarized the goals of theater in education during the late sixteenth century:

> To give the scholars that ease, that assurance, that happy mixture of boldness and modesty which forms the charm of well-brought-up youths; to introduce them to declamation and to complete the lessons in rhetoric; to strengthen and make flexible their memories by leading them to deliver long speeches no longer falteringly, but with grace and distinction; to arouse their intelligence and develop their taste by forcing them to understand their part and thus to make deeper literary analyses; to mould their hearts by obliging them to identify themselves, slowly and by meticulous study, with a noble character; to inspire in them generous sentiments, the love of church, country, and virtue.[16]

Finally, a major shift in educational philosophy during the Renaissance offered an added incentive for including drama. Rather than teach through compulsion, several Renaissance educators sought to lead students' learning through play. The impetus for this shift seems to have come from the renewed study of classical authors, for in support of this new pedagogy, Renaissance scholars cited no less authorities than Plato and Quintilian: "You must train the children to their studies in a playful manner,"[17] said Plato; "Pupils refreshed and restored by recreation bring more energy to their studies and a keener mind, whereas the mind as a rule refuses tasks imposed by harsh compulsion,"[18] echoed Quintilian. Thus, the first treatise on education in English, Sir Thomas Elyot's *The Book Named the Governor* (1531), cautioned schoolmasters not to fatigue the child "with continual study and learning wherewith the delicate and tender wit may be dulled or oppressed" but rather to interlace study with play and exercise, referring

specifically to the value of comedies by Plautus and Terence for such purpose.[19]

By the end of the Renaissance, then, the major themes of theater education as we now know it had been sounded: because theater was a powerful teacher that could teach either virtue or vice, it might be dangerous. Its social nature could make it a force for cultural cohesion. It could help teach other subjects, especially languages and literature. It could provide training in the skills of oral expression and rhetoric; it offered promise of personal development, including increased self-confidence and enlarged memory. And it could make learning fun, yet lasting and deep.

*Precedents in the United States*

Drama and theater education in the United States mirror this past. During its early years, *professional* theater was alternately condemned, tolerated, and embraced, considered (on the one hand) a powerful—and so dangerous—teacher and (on the other) a playful—and so perhaps frivolous—undertaking. *Educational* theater was hesitantly approved (or at least tolerated) on the grounds that it helped teach other, presumably more useful, subjects and that it encouraged desirable personal and social traits among students. From 1698 to 1903 its study and practice in American schools was either extracurricular or embedded within the study of language departments.[20]

Not until 1905 was theater production (as distinct from the study of plays) given curricular status in college; the rationale was that productions served as a laboratory in which students could test the skills and information learned in their classes.[21] The first accredited course in an American high school came in 1915 (although both art and music had been accredited before 1900).[22] Not until the 1920s was serious attention given to theater (or here, more properly, *drama*—see footnote 36) in the elementary school.[23]

Not only their late arrival but also the administrative locus of university theater programs influenced their direction. College programs typically began during the first two decades of this century, some as small units within departments of English (themselves recent break-aways from earlier programs of Rhetoric) and others within newly forming departments of Speech (themselves even more recent break-aways from English departments, which had quickly begun to neglect rhetoric in favor of *belles lettres*). Most did not then become free-standing units until World War II.[24] The American Educational Theater Association broke away from the professional association in speech in 1936 but held joint conventions until well into the 1950s.[25]

The ramifications of these early arrangements can be only briefly suggested, but three examples will serve to indicate their scope. First, New Criticism (which denied all claims to the relevance of context in literary

analysis) dominated departments of English from the 1930s into the 1960s. Second, most secondary teachers of theater had—and perhaps still have—as their major academic areas and their major teaching fields either English or speech (not theater).[26] Third, drama and theater trickled down into elementary school from college and secondary school and were early conceived, along with speech, as a kind of "oral English," with the attendant assumptive biases suggested by that phrase.[27]

Not until the 1960s did departments of theater tend to associate with departments of art, dance, and music, increasingly within formal divisions or colleges of fine arts. Before then, in both organizational chart and architectural arrangement, theater was closer to speech and literature than to music and dance. As a consequence, theater's critical paradigms and research questions more often mimicked those in literary studies and communications than those in the arts. Because of the growing importance of colleges in training teachers, this situation had major consequences for elementary and secondary, as well as collegiate, practice.

Lastly, theater education, especially at the elementary level, was influenced by developments in general education, which incorporated strong features of those theories called *progressive education* (after about 1918) and *life adjustment* (after about World War II). The likeliest explanation of the strength of this strand in theater education, especially at the precollege level, is that Winifred Ward, this country's pioneer in "creative dramatics" (see footnote 36), began her teaching career in 1918. Working with the public schools and teaching in Northwestern University's teacher-training program, Ward established "creative dramatics" as an important part of the education of both young students and their teachers.

By World War II, her students had established similar courses in twenty colleges and universities.[28] By war's end as well, Peter Slade and Brian Way in Britain were vigorously promoting the view that drama in schools should be about education, not about theater.[29] Their theories reached this country during the 1950s and 1960s and perceptibly shifted American practice still further in the direction of drama as developmental tool.[30]

### Contemporary Practice

Contemporary practice displays consequences of this history. Elementary schools take as their major goals the personal and social development of all students through drama. A recently drafted rationale for including drama and theater in the elementary school included the following: the importance of art as a way of knowing; as a way of understanding ourselves and others; as a stimulus to collaboration; as a means of acquiring basic skills like concentration and cooperation; as a means of learning other subjects; and as a means of acquiring global awareness, including an introduction to the heritage of many cultures. Only one item of the rationale treated theater

as theater: "Though 'pretend' play is natural for all children, they need the experience of making drama and seeing theater as part of a sequenced curriculum. . . . Children also need the opportunity to think like a theater artist and to respond to the theatrical event."[31] At the elementary level, plays are usually either improvised by the students or written especially for their age group. Standard plays (even rewritten for children) are seldom used.[32]

Theater education in secondary school focuses on introducing students to skills of production, especially acting and technical theater.[33] At this level, the assumption is that students will ready plays for public performance. The plays selected for presentation, however, suggest that recreational rather than cultural ends are paramount. For example, since World War II, not a single play by a recognized master of Western drama has appeared among the twenty most often produced high school plays, either for the entire period or within a single decade. Rather, heading the lists are *A Date with Judy* (the 1940s), *The Curious Savage* (the 1950s), *Our Town* (the 1960s), *Up the Down Staircase* (the 1970s), and *Oklahoma* (the 1980s).[34]

Some colleges consider the theater major a pathway to a liberal education; others view it either as preparation for the professional theater (and so offer a B.F.A. degree) or as preparation for graduate school in theater, which in turn leads either to the M.F.A. degree (for those intending to work in theater) or the Ph.D. (for those intending to teach in college). It is thus only at the college level, and for the first time, that the study of the history, criticism, and theory of theater comprises a serious component (roughly half) of the curriculum. At this level for the first time, too, the so-called classics of Western drama comprise a noticeable proportion of the public performances.[35]

The different practices of elementary, secondary, and collegiate programs are underscored by different vocabularies. Even the most fundamental words do not necessarily carry the same meaning. For example, *drama* in university parlance refers to the written text; *theater* to the performance (usually, but not always, of a text) by actors for an audience. *Drama* in elementary education, on the other hand, "is any informal dramatic enactment that is designed not for presentation, but rather for the experience or educational value. *Theater* is the more formal study of the discipline which culminates in dramatic interpretation by actors and technicians on a stage before an audience."[36] Indeed, *theater* is a controversial concept in elementary school, for educators differ on whether students should watch only or might also participate in formal performance.[37] (*Drama* is what the children do, *theater* is what the children see, is one recent formulation).[38]

Or, to take another example, *context* among university personnel is likely to conjure matters of historical background and to suggest a critical approach—that is, *contextual* as distinct from *formal* criticism. Among elementary educators *context* suggests rather concepts like "personal meaning"

(how a play's theme "may relate to your own life" and "may have enhanced your understanding of another person's point of view") and "cultural meanings" (how the play "enhanced your understanding of various ethnic groups in the community" and how geography "influences the kinds of characters and situations revealed in the literature of various cultures").[39] Thus, one cannot discuss the relevance of context in theater education without specifying *which* context is meant (that is, the context of *context*).

Several provocative conclusions suggest themselves from this overview of contemporary practice, but before moving to them, let us review briefly the reasons given by Hirsch for his indictment of American education.

## Cultural Literacy in Theater Education

According to Hirsch, the current educational crisis, signalled by the dramatic drop in standardized test scores among students at all levels of ability, stems from the failure of schools to teach reading. Students cannot read, he contends, because they cannot grasp the allusions contained in the writing; that is, they cannot grasp the context that the words are intended to evoke, and so they miss their meaning. They cannot grasp the allusions (the context) because schools have not transmitted the knowledge that educated members of the culture expect all persons to share: that is, students lack "cultural literacy." Schools have not transmitted this knowledge for three major reasons: first, they mistakenly assume that reading is a skill that can be taught separate from a content, itself dependent on a context; second, in a generous but mistaken effort to be democratic, they seek to teach each student according to his or her own ability, *using materials individualized for this purpose*; and third, from an equally well-intended but mistaken motive, they wish not to promote a set of materials and values that are politically sensitive because so clearly "class-bound, white, Anglo-Saxon, and Protestant, not to mention racist, sexist, and excessively Western."[40]

To his credit, Hirsch is not content with detailing the problems of American education; he suggests steps to reclaim students as members of a literate culture. Schools must abandon curricula that are "dominated by the content-neutral ideas of Rousseau and Dewey."[41] They must cease expressing goals in terms of skills to be acquired. Such a "skills model," Hirsch maintains, is "illusory,"[42] because recent research in artificial intelligence, cognitive psychology, linguistics, and reading agrees on "the knowledge-bound character of *all* cognitive skills" and agrees that "once the relevant knowledge has been acquired, the skill follows."[43] Schools must take as their primary goal the dissemination of information that society expects its educated members to share because research shows that "literacy is far more than a skill [;] it requires large amounts of specific information."[44] In particular, Hirsch cites the need to teach "intergenerational information"[45]

(that is, history) because *"80 percent of literate culture has been in use for more than a hundred years!"*[46] [emphasis in the original].

How does theater education look through the lens of Hirsch's criticisms? It is, of course, an almost paradigmatic example of what Hirsch finds wrong with American education: it is fragmented and discontinuous; that is, the college curriculum assumes nothing from high school, nor the high school from the elementary school.[47] It conceives its goals in terms of personal and social skills to be honed rather than information to be learned. It pays relatively little explicit attention to aesthetic issues at any level; "forming aesthetic judgments" is one of four goals in the most recent elementary and secondary curricula.[48] It pays relatively little attention to its own history, even at the college level—in the K-12 curriculum proposed in 1987, only two of seventy-one pages addressed the study of heritage.[49] Finally, it places little emphasis on cultural literacy (to borrow Hirsch's term) until college, at which time it is far too late: "Preschool is not too early for starting earnest instruction in literate national culture. Fifth grade is almost too late. Tenth grade usually *is* too late" [emphasis in the original].[50]

It is clear that, if we accept the validity of Hirsch's argument, the nature of theater education would change significantly at all levels, but most startlingly at the elementary and secondary.[51] The basic assumptions would change: theater education would become *primarily* neither a means of promoting personal and social skills, a craft to be learned, nor an art to be experienced; it would become rather a means of developing cultural literacy, of promoting national cohesion, of enhancing public discourse. Its basic goals would change: educational outcomes would be conceived not in terms of skills to be mastered but rather in terms of "diverse, task-specific information" to be acquired.[52] Curricula would not be "cafeteria-style"[53] but would be "a model grade-by-grade sequence of core information," having "a much stronger base in factual knowledge and traditional lore" than now.[54]

The acceptance of Hirsch would promote extensive rather than intensive education; that is, introductory surveys of drama and theater would be preferred to the "prolonged study of a few works,"[55] because cultural literacy depends more on acquaintance than intimacy: "The information essential to literacy is rarely detailed or precise";[56] indeed, "the paradox [is] that broad, shallow knowledge is the best route to deep knowledge."[57] Moreover, plays selected both for classroom study and for public performance would be more often drawn from the masterpieces of the West (even if rewritten for youth) than from the students' own experiences, from Broadway, or from the recent repertory, because the educational point is not drama or theater as art but drama and theater as part of a cohering national vocabulary that is shared by literate people. Similarly, improvisation, especially in the early grades, would draw from traditional lore (the Bible,

classical mythology, medieval tales) rather than from personal experience or social exploration, for the same reason.

Finally, adopting Hirsch's educational scheme would probably further shrink the role of aesthetics in theater education. Accompanying that shrinkage would be a changed emphasis: among the areas of interest basic to aestheticians (as identified by Crawford),[58] those concerning creativity, form, appreciation, and evaluation would likely receive decreasing emphasis in proportion to those inquiring after cultural context (the author, the age, the audience). This shifting emphasis in aesthetic education would, in turn, probably produce a similar shift within criticism.

## Contextual Criticism in Theater Education

Criticism takes as a major goal an increased understanding—and so increased appreciation—of a work of art. Criticism is therefore an important outgrowth of aesthetic education. In criticism, Hirsch's curriculum would promote studies of context over studies of form because a work's internal structure, its "intrinsic nature,"[59] would contribute less to an expanded cultural vocabulary than would the work's references to aspects of its own time and place.

Traditionally, the two major approaches to criticism have been the formal and the contextual. *Formal criticism* views the artwork as an object, "complete in itself," free from any environment;[60] it therefore focuses attention on the internal principles of the work: its form and structure, internal consistency, proportion, and "intrinsic nature." *Contextual criticism*, on the other hand, views the artwork as growing out of, and so reflecting, its place in time and space; it therefore focuses attention on the relationship of the work to its author, its age, its place in an artistic tradition, and, more recently, its critics.[61]

Although coexisting, these two approaches have alternated historically, with first one and then the other preferred. Thus, a strong preference for contextual criticism in the late nineteenth and early twentieth centuries produced, in reaction, both New Criticism and Neo-Aristotelianism in the early twentieth, schools of formalism ("that great block of aesthetic ice") that were maintained by the "powerful refrigeration apparatuses of English departments everywhere" during the 1950s and early 1960s.[62]

By the 1980s, contextual criticism was again dominant, but its practice was much changed. As developed and practiced in the late nineteenth and early twentieth centuries (when it was likely to be called *historical criticism* or *historicism*), contextual criticism had envisioned enriching aesthetic appreciation by locating a work of art within its social and artistic contexts. The act of criticism and the critic were considered pure, relatively objective. Early in this century, however, Marxist (and later Black and feminist and

other postmodern) critics observed that *critics* defined "art," "good art," and "bad art," that *critics* enshrined certain texts while ignoring or denigrating others, that *critics* established the canon.

Noting that almost all critics through history were white, male, and affluent, these postmodernists wondered in print if an act of criticism, like an act of artistic creation, was not influenced by context. They asked, in effect, "Does criticism derive from universal principles or is it, like art, embedded within time, race, gender, and class?" As a result of such questions, the postmodern conception of both context and contextual criticism has enlarged to include the critic and the act of criticism within the system that needs to be studied. Postmodern contextual critics, therefore, try to locate themselves in relation to the work as part of their written critical statements.

Supporters of contextual criticism, whether as traditionally or currently understood, cite the need to acknowledge—in each critical act—the fact that art (in this case theater) does not exist in a vacuum, that it is always written by someone and produced by someone who lives at some specific time during which art, politics, morality—indeed all culture—are viewed in some ways rather than other ways. A contextual critic would argue, then, that theater has a "range of referents" that extend "beyond the visible structures of the work into areas of social and artistic origination and influence"[63] and that these referents should be both acknowledged and probed for their explanatory power. More recently, such critics have urged that these referents should also be understood for their protective power: they can protect students from "the mystification of ideology."[64] By showing the specific circumstances that produce an outcome, the referents empower students to see problems as having cause (as neither universal nor inevitable) and so as amenable to remediation. This power has endeared contextual criticism to both Marxist and, more recently, feminist critics.

Primary among the dangers of contextual criticism is said to be its tendency to pull attention "too far from the unique characteristics of a work of art,"[65] with the result that some critics spend more time on the context than on the work itself. Contextual criticism may also deny the unique (read, *supracontextual*) vision of an artist; that is, artists often possess a vision at odds with that of their culture, and so cultural knowledge adds little to— and may even detract from—the meanings displayed in the artwork itself. Further, because contextualism seldom addresses the changing meanings that images and symbols acquire through time, it may neglect a work's vital, contemporary experience in favor of a fixed, historic explanation. Finally, because no historical moment can be fully recreated, critics necessarily create a partial and unsynthesized context that may cast unintended

emphases, and so unwarranted meanings, on the work itself, thus serving to distort rather than reveal it.[66]

Theater scholars have been especially sensitive to the charge that contextualism pulls attention away from the work of art, for two major reasons.

First, as we have seen, theater in education has long been viewed as a means to some other end: a way of developing personhood, of adjusting to society, of teaching other subjects (Greek), other skills (memory), and other values (Christian virtue). Wishing to assert the primacy of theater as theater, as art, some scholars have preferred a critical method that focused solely on the work, remaining skeptical of a critical method that threatened to look through the art to something beyond. As a theater critic, I would support their wish to focus on aesthetic issues, but I will shortly argue that their position is mistaken because they have themselves misunderstood the nature of the art of theater.

Second, theater scholars—and even more especially *drama* teachers— repeatedly encounter people who misunderstand the nature of drama. Because, in making plays, dramatists shape "the actions of men," using what seems to be ordinary language, many people lose sight of the art of plays. Drama, because it is so directly and clearly referential, is transparent and so is confused with life. Not that audience members rush to the stage to rescue Desdemona, but that students (and some critics) tend to ask of plays inappropriate questions.

H. D. F. Kitto clarifies this point well by comparing a play with a piece of sculpture:

> We are under no temptation to regard the pediment as anything but what it is: a work of art, a *mimesis* in stone. . . . if on looking at a pediment, we noticed that one warrior had no spear, we should not think of asking where he had dropped it, or whether he had forgotten it; we should at once ask ourselves why the sculptor had represented him spearless. . . . we do not find it so easy to remember that *Antigone* began with a pile of clean paper on Sophocles' table.[67]

And because we do not remember Sophocles' paper, we ask questions that are inartistic: How many children had Lady Macbeth? What did Hamlet study at Wittenberg? Such questions betray a profound confusion between a dramatic character (an artistic construct) and a real person, between life and art. Such questions will not lead us to see the *art* of Shakespeare.

In order to avoid this "documentary fallacy" (this confusion of the virtual with the real), some critics have proposed avoiding all questions that cannot be answered by direct reference to the text (the *dramatic*—written— text, not the *theatrical*—performed—"text," be it noted). They propose, in effect, to avoid contextual criticism altogether. Again, as a teacher I share the frustration they feel when they encounter someone for whom the art of the

drama cannot be made visible; but I will now argue that they have mistaken the nature of theater, that they have mistaken the part for the whole, the drama for the theater.

Paradoxically, however, as we move from criticism of drama as literary text to criticism of theater as art in performance, we find that some sort of contextual criticism is virtually unavoidable. Formal criticism of *theater* (as opposed to drama, i.e., literary text) is exceedingly difficult to undertake because of the nature of the object—a play performed by actors in front of a live audience. Because of the need to consider audience as a part of the theatrical event, some form of contextual criticism, however loosely conceived, is almost unavoidable in serious theatrical criticism: whereas a playtext may be studied in seclusion, a piece of theater requires that actors perform that text for an audience. Theater art happens at that intersection.[68] One therefore cannot understand what happens *in a theater* merely by understanding a text. An understanding of *theater* (as distinct from *drama*) requires an understanding of actor and audience, which are certainly extratextual—that is to say contextual—matters.

Some study of context, and thus some kind of contextual criticism loosely conceived, then, would seem to be essential, not only for artists of the theater but also for those who would watch and study it. Several examples can clarify this point.

A contextual-critical act is perhaps most visibly essential to the work of the design artists of theater. Most theater includes scenery, costume, and properties, each detail of which will carry meanings to the audience: it is impossible for any object on stage *not* to communicate something to those who see it. In order to create a suitable environment for actors interpreting the play, the designers must understand not only the play but also the requirements of an environment that will signal appropriate (and no inappropriate) meanings to the audience. In creating this environment, theatrical designers almost always select details from the real world (past and present) out of which they can create the virtual world for the performance. Selection requires knowledge, not only of what "is" or "was" but also of what an audience (however mistakenly) associates with and will accept as "is" or "was." Contextual criticism is therefore inevitable, for although formal criticism can lead to an understanding of text, it cannot lead to the necessary understanding of environment-as-perceived-by-audience, at least as currently practiced.

Actors and directors also practice some kind of contextual criticism, if less visibly than designers, because these artists must discover (or create) both meanings of texts and traits of audience through which those meanings can become accessible. At base, the contribution of actors and directors to production is to discover strategies for effectively signalling textual meanings to specific audiences.

In the case of a historical text, most actors and directors will want first to understand all allusions within the text; next they will seek to grasp the interplay of that allusion with its original audience; finally, they will envision ways of making the allusion accessible for a contemporary audience, that is, of reviving the allusion's original effect insofar as possible. To revive a historical performance, then, means more than "doing the play as written"; it means trying to recapture the original relationship between the actors-performing-the-text and their audience. To do their work, therefore, actors and directors must usually understand the play both in its original context and in the context of a contemporary production. Even those directors who seek to free themselves from artistic tradition (Peter Sellars comes most immediately to mind) must often know, in order to destroy, allusions.

Not only theater artists but also those who would enjoy theater and those who would study it must usually engage in contextual criticism at some level. To understand a piece of theater requires, at a minimum, some understanding of text and some understanding of audience, both the contemporary audience for which the play is now being performed and, for enriched appreciation of historical works, the audience which the actors-in-performance originally confronted.

Understanding audiences is, in effect, understanding certain kinds of people, those who are expected to attend the theater. In any age, the background that this audience brings to the theater is not only a knowledge of their real world (both past and present) but also some knowledge of the conventions of their art. If, as Hirsch claims, learning to read straightforward discursive prose requires cultural literacy, then "reading" a polysemous theatrical "text" will require a considerably more sophisticated level of cultural literacy. The more complex the play, the greater the "literacy" required of those wishing to experience it; the greater the "literacy" of an audience, the fuller their appreciation of performance.

In short, although theater artists may find (somewhat like Molière's M. Jourdain) that they have been speaking Hirsch all their lives, they are doing so (and here's the rub) before increasingly "illiterate" audiences. To follow Hirsch to his logical, pessimistic conclusion would be to give up doing plays altogether, for we will soon be doing polysemous works for audiences increasingly unable to understand monosemous ones. It would seem that if the art of theater is to continue, theater educators must assume some major responsibility for assuring a cultural literacy.

## Conclusion

As we have seen, education and theater have been linked historically, not because of a wish to teach the beauty of an art in order to enhance its appreciation, but out of a recognition of its power to teach. Historically, too,

theater educators have slighted aesthetic issues in education at all levels in favor of personal, social, and political ones. Were we to embrace Hirsch's proposals, we would continue viewing theater primarily as an instrument, this time as an instrument for ensuring cultural literacy. And so we would continue our relative neglect of aesthetic education.

Adopting Hirsch would be easiest at the highest levels of education, most difficult at the lowest, for two reasons. First, current practices at the elementary level are most distant from those advocated by Hirsch; college practices are closest. Second, the foundations of a shared cultural vocabulary must be laid in the earliest grades, for, in its absence, all subsequent schooling will be flawed and students will fall behind at geometrically increasing rates; by the college years, the urgency is gone.

In elementary school, a seismic reordering of philosophy, goals, and practices would result from substituting for personal and social growth those materials and techniques aimed at ensuring a shared national vocabulary. An entire generation of teachers firmly committed to the personal development of the individual child would have to become teachers of culture. At the secondary level, replacing recreational with cultural aims would mean a radical change in the philosophy of selecting plays for production; standard plays from the culture's canon would replace the trivial, if entertaining, fare of today. College programs would need a retuning rather than an overhaul, but even there some significant changes might be expected.

Even within the limited time we now devote to aesthetics and criticism in higher education, we would be pulled away from matters of creativity, appreciation, evaluation, and form in favor of still greater attention to context. This increased attention to context in criticism might have as a major consequence to cause us to think more profoundly about the nature of our art, especially the relationship among text, actors, and audience. In so doing, it might, paradoxically, refocus our attention on form, but this time form in the theater rather than form on the page.

A formal criticism, revised to take as its subject the *performed* play, would make possible, for the first time in theater, really, an equal status for formal and contextual criticism, to the enrichment of both: "Each, in its integral character, serves to heighten, through contrast, an understanding of its opposite. . . . When both universal and relative explanations of art are granted equal . . . legitimacy, each is able to maintain its strong focus—which allows its integral, salient characteristics to stand in sharp relief."[69]

## Context of the Conclusion

To the degree that it is successful, this essay manifests the contextual approach. Given by the editor of this issue the subtext of Hirsch's *Cultural*

*Literacy* and the question What is the value of contextual criticism?, I tried to approach the assignment as a contextual critic. The result has been, I hope, to show that a contextual approach, to its credit, offers a richly textured understanding of the complexities of any subject (or artwork). Another result, I think, has been to suggest the way in which contextual criticism expands (and complicates) the field of inquiry until the central focus ("What is the value of contextual criticism?") blurs against its background.

NOTES

1.  E. D. Hirsch, Jr., *Cultural Literacy: What Every American Needs to Know* (New York: Vintage Books, 1988).
2.  Ibid., p. 113.
3.  Burnet M. Hobgood, "The Mission of the Theatre Teacher," *Journal of Aesthetic Education* 21, No. 1 (Spring 1987): 57.
4.  Philip A. Coggins, *The Uses of Drama: A Historical Survey of Drama and Education from Ancient Greece to the Present Day* (New York: George Braziller, 1956), offers the most convenient summary of this relationship. A fuller treatment of society's ambiguous opinions of theater is Jonas Barish, *The Anti-theatrical Prejudice* (Berkeley: University of California Press, 1981).
5.  Plato, *Republic*, trans. Davies and Vaughan (1852), p. 606, quoted in Coggins, *Uses of Drama*, p. 13.
6.  Coggins, in *Uses of Drama*, p. 34, cites F. A. Wright, "The World and Its Vanities," in *The Fathers of the Church*. The original source is, however, *To Donatus Concerning the Grace of God*, VIII.
7.  Coggins, in *Uses of Drama*, p. 38, cites *De Consensu Evangelistarum*.
8.  Coggins, in *Uses of Drama*, p. 47, cites *Roswitha*, trans. by I. and J. W. Tillyard (1923).
9.  Coggins, in *Uses of Drama*, p. 106, cites E. K. Chambers, *The Elizabethan Stage* (1923), IV, 249.
10. Coggins, in *Uses of Drama*, p. 61, cites Foster Watson, *The Old Grammar Schools* (Cambridge, 1916), p. 17.
11. Coggins, in *Uses of Drama*, p. 63, cites *Elementarie*, 1582.
12. Ibid., p. 65.
13. Coggins, in *Uses of Drama*, p. 88, quoting from L. V. Gofflot, *Le Théâtre au Collège* (1907), IV.
14. Coggins, in *Uses of Drama*, p. 63, cites William Malim, *Consuetudinarium*, 1560.
15. Coggins, in *Uses of Drama*, p. 66, quoting John Bale (1495-1563), Bishop of Ossory, without citation.
16. Coggins, in *Uses of Drama*, p. 88, cites Gofflot, *Le Théâtre*, p. 308.
17. Coggins, in *Uses of Drama*, p. 59, cites *Republic*, p. 536.
18. Coggins, in *Uses of Drama*, cites *Institutio Oratoria*, I, 3, from *Quintilian on Education*, trans. by W. M. Smail, Oxford (1938).
19. As quoted in Coggins, in *Uses of Drama*, p. 72, without citation.
20. See John L. Clark, "Educational Dramatics in Nineteenth-Century Colleges," in *History of Speech Education in America: Background Studies*, ed. Karl R. Wallace (New York: Appleton-Century-Crofts, 1954), pp. 521-51.
21. See Clifford Eugene Hamar, "College and University Theatre Instruction in the Early Twentieth Century," in Wallace, *History of Speech Education*, pp. 572-94.
22. See Paul Kozelka, "Dramatics in the High Schools, 1900-1925," in ibid., pp. 595-

616; and Halbert E. Gulley and High F. Seabury, "Speech Education in Twentieth-Century Public Schools," in ibid., pp. 471-89.

23. Gulley and Seabury, "Speech Education," p. 480.
24. Patti P. Gillespie and Kenneth M. Cameron, "The Teaching of Acting in American Colleges and Universities," *Communication Education* 35, no. 4 (October 1986): 362-71.
25. See William P. Halstead and Clara Behringer, "National Theatre Organizations and Theatre Education," in *History of Speech Education*, pp. 641-73.
26. Charlotte Kay Motter, *Theatre in High School: Planning Teaching, Directing* (New York: University Press of America, 1984), p. 15, grasped well the situation: "By 1950 drama was well-established as an elective course in most high schools. It was usually associated with the English department."
27. Gulley and Seabury, "Speech Education," pp. 474-75, 480-81.
28. R. Baird Shuman, ed., *Educational Drama for Today's Schools* (Metuchen, N.J.: The Scarecrow Press, 1978), p. ix.
29. Coggins, *Uses of Drama*, p. 243.
30. Through their influential books, Peter Slade, *Child Drama* (London: University of London Press, 1954), and Brian Way, *Development through Drama* (London: Longmans, Green, 1967).
31. National Arts Education Research Center, "Drama/Theatre K-6 Curriculum Guide" (Draft distributed in mimeograph, 1 June 1989), pp. 1-2 and, for the quotation, p. 2.
32. The NAERC draft seems interested in changing this situation, beginning at the fourth grade level. Under "Goal IV, To Appreciate Significant Works of Theatrical Literature" is found: "The assumption is that shortened, adapted versions of plays will be available for the children to read aloud or to improvise from" (p. 34).
33. See, for example, National Theatre Education Project, "A Model Drama/Theatre Curriculum: Philosophy, Goals and Objectives," American Associations of Theatre for Youth and Theatre in Secondary Education, 1987 (Mimeograph). John Allen, in *Drama in Schools: The Theory and Practice* (London: Heinemann, 1979), p. 72, concludes that "primary education is child-centered and secondary education is subject-based."
34. Patti P. Gillespie, "The Thespian Play Survey: 40 Years in the Middle of the Road," *Dramatics* 57, no. 1 (September 1985): 32-37, and "Current Trends in High School Productions," *AATSE Journal* 1, no. 1 (Winter 1987): 6-8.
35. National guidelines for each degree program are now available from the National Association of Schools of Theatre.
36. NTEP, "Model Drama/Theatre Curriculum," p. 7, which prefers *drama* to *creative dramatics* or *child drama*. Creative dramatics was the older term and is somewhat more inclusive than drama; child drama is the usual designation in Britain. All three words refer roughly to the same practices: "Their work [is] implicit in the goals and objectives of this currculium" (p. 7).
37. Way, in *Development through Drama*, for example, argues for watching only, see especially pp. 1-9; Viola Spolin, *Improvisation for the Theatre* (Evanston, Ill.: Northwestern University Press, 1963), for example, included children in performance with good result.
38. NAERC draft, p. 1.
39. Ibid., pp. 2, 49-50.
40. Hirsch, *Cultural Literacy*, p. 21.
41. Ibid., p. 19.
42. Ibid., p. 144.
43. Ibid., pp. 60 ff, and, for the quotations, 60, 61.
44. Ibid., p. 2.
45. Ibid., p. 7.
46. E. D. Hirsch, Jr., Joseph F. Kett, and James Trefil, *The Dictionary of Cultural Literacy* (Boston: Houghton Mifflin, 1988), p. xiv.

47. Allen, in *Drama in Schools*, p. 71, expresses considerable frustration over the same situation in Britain: "The fact that I cannot . . . discuss continuity of drama training from primary to secondary school is a serious criticism of our system."

48. NTEP, "Model Drama/Theatre Curriculum," p. 7; and NAERC draft, p. 2.

49. NTEP, "Model Drama/Theatre Curriculum," pp. 58-59.

50. Hirsch, *Cultural Literacy*, pp. 26-27.

51. That theater education would be a powerful weapon in the war on cultural ignorance cannot be questioned by anyone who makes even cursory examination of *The Dictionary of Cultural Literacy*. Subjects of plays appear regularly in sections like "The Bible" and "Mythology and Folklore." Names of playwrights and plays figure prominently in "World Literature, Philosophy, and Religion," "Literature in English," and "Fine Arts"; common quotations, in "Proverbs" and "Idioms." From *Hamlet* alone Hirsch cites ten quotations, familiarity with which educated persons presumably share. From the *Oedipus complex* in "Anthropology, Psychology, and Sociology," through the names of planets in "Physical Sciences and Mathematics," to *vulcanization* in "Technology," the common language of Western theater and drama overlaps the language of national literacy.

52. Hirsch, *Cultural Literacy*, p. 61.

53. Ibid., p. 20.

54. Ibid., pp. 141, 140.

55. As called for by Bruce E. Miller, "Artistic Meaning and Aesthetic Education: A Formalist View," *Journal of Aesthetic Education* 18, no. 3 (Fall 1984): 97.

56. Hirsch, *Cultural Literacy*, p. 14.

57. Hirsch et al., *Dictionary*, p. xv.

58. Donald W. Crawford, "Aesthetics in Discipline-based Art Education," *Journal of Aesthetic Education* 21, no. 2 (Summer 1987): 231-36.

59. Miller, in "Artistic Meaning," pp. 85-99, argues for an intensive, formalist curriculum as a means of giving students access to "unfamiliar modes of consciousness," a proposal clearly at odds with Hirsch's. Albert William Levi, "Kunstgeschichte als Geistesgeschichte: The Lesson of Panofsky," *Journal of Aesthetic Education* 20, no. 4 (Winter 1986): 81, succinctly contrasts formal and contextual criticism. "Intrinsic nature" is his language.

60. Aristotle, *On The Art of Poetry*, trans. Ingram Bywater (Oxford: The Clarendon Press, 1920), p. 35.

61. Levi, "Kunstgeschichte," pp. 79-83, offers another useful differentiation.

62. Frata Katz-Stoker, "The Other Criticism: Feminism vs. Formalism," in *Images of Women in Fiction: Feminist Perspectives*, ed. Susan Koppelman Cornillon (Bowling Green, Ohio: Bowling Green University Press, 1972), p. 313.

63. E. Louis Lankford, "Principles of Critical Dialogue," *Journal of Aesthetic Education* 20, no. 2 (Summer 1986): 61.

64. Nicholas Wright, "From the Universal to the Particular," in *Exploring Theatre and Education*, ed. Ken Robinson (London: Heinemann, 1980), pp. 88-104, and, for the quotation, p. 103.

65. Lankford's language, "Principles of Critical Dialogue," p. 61.

66. Lankford makes many of these same points, in ibid., pp. 61-62.

67. H. D. F. Kitto, *Poesis: Structure and Thought* (Berkeley: University of California Press, 1966), pp. 1-32, and, for the quotation and subsequent sample questions, pp. 14-15.

68. For an opposing, but distinctly minority, view, see Paul Campbell, "The Theatre Audience: An Abstraction," *Southern Speech Communication Journal* 46, no. 2 (Winter 1981): 139-52, 157-62.

69. Karen A. Hamblen, "Commentary: The Universal-Relative Dialectic in an International Perspective on Art," *Journal of Aesthetic Education* 18, no. 2 (Summer 1984): 100.

# Literature, Education, and Cultural Literacy

WALTER H. CLARK, JR.

It seems proper for someone who comes to Professor Hirsch's book from a different orientation to provide a word or two of self-introduction. The author of this article is someone whose own thinking has inevitably been shaped by undergraduate education of the fifties, with its emphasis on "core" and "distribution." As a result he shares Hirsch's belief in the importance of a common body of knowledge, partly because he believes that some knowledge is worth more than other, partly because he accepts Hirsch's argument that a shared body of knowledge facilitates communication. Graduate studies made him aware of Dewey and the American pragmatists, more in their emphasis on the importance of active learning than in their emphasis on "work" and "society." Among contemporary philosophers he is most drawn to Gilbert Ryle, not so much for his attack on the Ghost in the Machine, as for his concept of minded behavior. He is not aware of the direct influence of Rousseau, of which Professor Hirsch speaks, but he definitely belongs to the school of those who regard the mere amassing of information with suspicion—assenting to Whitehead's dictum that "knowledge doesn't keep any better than fish." Feeling that controversy is healthy for educational theory and armed with what he thinks of as benign skepticism, he regards Hirsch's proposals as worthy of serious consideration and discussion.

Over the course of his teaching career the writer has developed certain concerns which overlap some issues raised by Hirsch. It seems to him, for instance, that one unfortunate effect of today's undergraduate curricular diversity is a separation of living and learning which deprive today's undergraduates of some experience of intellectual community available to their predecessors. The larger the institution and the greater the curricular diversity, the less likely that any student will encounter fellow students who are

*Walter H. Clark, Jr.*, a professor in the Department of English, University of Michigan, is the longtime codirector of that university's New England Literature Program. He has contributed essays to this journal, to *Orion Nature Quarterly*, and to a book of readings titled *Teaching Environmental Literature: Materials, Methods, Resources.*

doing the same reading and writing, responding to the same teacher, wrestling with the same intellectual issues. Anyone who feels that much of a student's learning takes place outside the classroom cannot but regret the dilution of opportunities to expand upon and digest lecture and reading materials in the residential situation. In such circumstances, Hirsch's charge that much of today's student culture is taken up with ephemera compels attention.

The writer also has a concern for the preparation of teachers. Since the major part of a high school teacher's subject preparation takes place in college, it would seem sensible to trace the implications of reform at the secondary level for college and graduate education. Although Hirsch does not speak to the issues of upper levels of education, I shall assume that he would assent to the proposition that his proposals have relevance for them.

Since I intend to address the main body of my remarks to the teaching of English Literature, I found it useful to isolate references to literary texts from the rest of the list. The following one hundred and twenty-five texts are the entirety of those listed (though by no means all those implicated) in Hirsch's five-thousand-item list. They consist of literary items alone. I have condensed some dozen references to particular books of the Bible into a single entry and have ruled out movies and musical comedies, while including fairy tales and Mother Goose rhymes.

### LITERARY TITLES IN "THE LIST"

*Aeneid, Aesop's Fables, Alice in Wonderland, Antigone, Antony & Cleopatra, Babbitt, Bartlett's Familiar Quotations,* "Beauty and the Beast," *Bible* (King James Version), *Black Boy,* "The Boy Who Cried Wolf," *Candide, Canterbury Tales, Catch 22,* "Christmas Carol," *The Cid, Confessions of Rousseau, Confessions of St. Augustine, Crime and Punishment, Death of a Salesman, Diary of a Young Girl, Divine Comedy, A Doll's House, Don Quixote,* "Elegy Written in a Country Churchyard," "The Emperor's New Clothes," "The Fall of the House of Usher," *Gone With the Wind, Grapes of Wrath, Great Expectations, The Great Gatsby,* "The Grinch Who Stole Christmas," *Gulliver's Travels,* "Gunga Din," *Hamlet,* "Hansel and Gretel," "Hey Diddle Diddle" (text), "Hiawatha," "Hickory Dickory Dock" (text), *Huckleberry Finn,* "Humpty Dumpty" (text), *Hunchback of Notre Dame, The Iliad, The Invisible Man,* "Jack and Jill" (text), "Jack and the Beanstalk," "Jack Be Nimble" (text), "Jack Sprat" (text), "Dr. Jekyll and Mr. Hyde," *Julius Ceasar, King Lear,* "The Land Was Ours," *The Last of the Mohicans, Leaves of Grass,* "The Legend of Little Jack Horner" (text), "Little Miss Muffet" (text), "The Little Red Hen," *Little Women, Macbeth,* "Mary Had a Little Lamb" (text), *The Merchant of Venice, Metamorphoses* (Ovid), *Metamorphosis* (Kafka), *A Midsummer Night's Dream, Moby Dick,* "A Modest Proposal," *Native Son,* "The Night Before Christmas," "O Captain! my Captain!" (text), "Ode on a Grecian Urn" (text), *The Odyssey, Oedipus Rex, Oliver Twist, Othello, Paradise Lost, The Pilgrim's Progress, Pinocchio, Pride and Prejudice,* "The Princess and the

Pea," "Puss-in-Boots," *Pygmalion, The Red Badge of Courage,* "Rime of the Ancient Mariner" (text), "Rip Van Winkle," "The Road Not Taken," *Robin Hood, Robinson Crusoe, Romeo and Juliet, Roots,* "The Rubaiyat of Omar Khayyam," "Rumpelstiltskin," *The Scarlet Letter,* "The Secret Life of Walter Mitty," "Simple Simon" (text), "Sleeping Beauty," "Snow White," "Stopping By Woods on a Snowy Evening," *A Streetcar Named Desire, The Sun Also Rises, A Tale of Two Cities, The Taming of the Shrew, The Tempest,* "There was a little girl" (text), "There was an old woman who lived in a shoe" (text), "This Little Piggy Went to Market" (text), "The Three Bears," "The Three Little Pigs," *Through the Looking Glass, Tobacco Road, Tom Sawyer,* "The Tortoise and the Hare," *Treasure Island,* "The Ugly Duckling," *War and Peace,* "The Waste Land," *The Wizard of Oz, Wuthering Heights,* "Wynken, Blynken and Nod" (text).

As one looks over this list certain patterns appear. About a quarter of the list, some thirty items, consists of Mother Goose Rhymes, fairy and folk tales; the sort of thing that children learn at home before beginning school. It would be interesting to know what percentage of children today have this material in repertoire by the time they start first grade. If the memorization of Mother Goose Rhymes in the past has been a part of language acquisition, to what extent is this so today? If the children of today are unfamiliar with Mother Goose when they arrive at school, should we try to teach it in the early grades or instead try to discover what common literary denominators mark their language acquisition years? One suspects that television programs ("Sesame Street" is on Hirsch's list) would be the place to look for common ground. The problem is not an easy one. Hirsch emphasizes the dangers of ephemera. Still, in terms of cultural significance it seems much more important to retain Shakespeare and the Bible than nursery rhymes. The nursery, after all, has been replaced by the day-care center, and the rhymes address an agrarian way of life now vanished.[1] To what extent, one wonders, does the old practice of parents reading aloud to children continue? If it is falling by the wayside because of cultural changes (television, the two-job family), how do we respond? Should we alter tactics (method of delivery) but not strategy (the inculcation of traditional cultural literacy) or instead acquiesce in a radical shift of cultural literacy? This is not an easy question, and a virtue of Professor Hirsch's proposal is that by taking the position he does, he provides a stage for such questions.

The consideration of nursery rhymes and folk tales by no means satisfies my curiosity as to how the items on the list are acquired or what it means to have acquired one. Turning away from literary examples for the moment, I choose items from the list at random and try to reconstruct their coming into my possession. Where did I first encounter such terms as "narrator" or "national liberation movements," for instance? (p. 190) The first, no doubt, in secondary school, though not until I myself began to teach did "narrator"

seem much more than an academic bangle. "National liberation move-ments" is a serviceable, if unexciting, concept in my vocabulary today. I must have picked it up from newspaper or magazine. Doubtless it would mean a great deal more to me if I were writing modern history. Some of these terms came rapidly, but without incident, others; such as "narrator," seem not to have "set" until I had what I thought of as a serious use for them. But such instances are doubtless insufficient to bear the weight of generalization. My acquisition of "Nazi-Soviet nonaggression pact," for in-stance, extended over a period of years, beginning with childhood exposure to newspaper headlines and continuing on to reading a biography of Adolf Hitler, assigned in a high school history class. Here the purposes of the teacher fed my own. The spectrum of acquisition seems to extend from simple recognition, without real understanding of a term's meaning, to comprehension adequate to explain it with respect to a complex web of his-torical cause and effect. At some early point in the temporal spectrum of my understanding it must have functioned as a kind of token or banknote, which I was capable of recognizing when it came to me and "passing" in certain simple situations. As I grew more familiar with the significance of "Nazi-Soviet nonaggression pact," it was as if I were more and more in pos-session of the specie which backed the note and capable of "passing" it in an expanding variety of circumstances. (As Ryle might say, "I acquired greater know-how with respect to using what I knew-that.") It is particular-ly the questions about what it means to know, or even be familiar with, these terms that makes Hirsch's list so rewarding and frustrating to con-sider.

If the reader will accept a metaphor from economics, perhaps we can see Hirsch as urging the importance of providing the learner with the basic cur-rency of cultural exchange at an early stage in his or her intellectual development. He wants to see a common currency of information in general possession and circulation. He is convinced the resultant activity will lead to an increase in currency, and also to increased intellectual "back-ing." I do not, incidentally, see Hirsch as arguing single-mindedly for the importance of information. Were that the case I would draw upon John Passmore's excellent discussion of information and capacity in *The Philos-ophy of Teaching*, which treats those complicated matters in illuminating detail.[2]

This brings me back to further discussion of titles of texts culled from Hirsch's master five-thousand-item list. My own unscientific assessment of the level at which students might be expected to have minimal under-standing of the significance of a title—less than that of someone who has read the work, but more than just recognition of the title—works out as fol-lows. About one fifth of the items can be assigned to the preschool language acquisition stage. This, combined with kindergarten through the sixth

grade, accounts for about a third of the texts; grades 7-12 for a bit more than a third, and college a bit less than a third. Perhaps the assignment of a relatively large segment of the list of titles to the college years is extreme. One would like to believe that a well-prepared student arrives at the university with almost all of Hirsch's items well in hand. But when we consider the *Confessions* of Rousseau and Augustine, *Don Quixote*, *The Cid* (where is *The Song of Roland*, by the way?), those plays of Shakespeare not discussed in high school, and the fact that the Bible is ordinarily a closed book at the secondary level, this may seem more justifiable. The list contains twenty-two works translated from eleven different languages, eleven Shakespeare plays, and a roughly similar number of specific biblical books. Altogether these account for more than a quarter of the listings, and I assign more than two thirds of them to the college years. Living authors, in contrast, account for only five of one hundred and twenty-five items. According to my assessment, about half to two thirds of the literary items on Hirsch's list would be acquired in some minimal way during the years of primary and secondary education. Although it must be kept in mind that the preschool items, numerically large, are actually negligible in terms of total wordage, quite the opposite is true of works assigned to the college years. It should be further pointed out that the process of reading complex literary works inevitably tightens one's hold on items already acquired at primary and secondary levels.

What is the point of these observations? It is to emphasize that the process of literary enculturation starts before enrollment in primary school and continues outside, as well as inside, school during primary and secondary years, and finally to say that processes of acquisition which seem negligible in the period before college may be picked up and amplified during the college years. Simply to address Hirsch's list to primary and secondary school teachers is not sufficient, in my view. It should somehow be gotten into the hands of the media, as well as to those responsible for college education and the preparation of teachers at all levels. One way to encourage this might be to make it a basis for testing of those about to receive teaching certificates.

How shall we prepare those who are going to use Hirsch's list? Might it be that they need no special preparation at all? Could we simply hand them the list; assume them to be already familiar with most of the items on it; tell them to keep it in mind while teaching their classes? Such an approach would of course be better than doing nothing at all! But Hirsch's remarks about how we read have relevance here, "The explicit meanings of a piece of writing are the tip of an iceberg of meaning; the larger part lies below the surface of the text and is composed of the reader's own relevant knowledge" (p. 34). The fact of the matter is that no teacher training program could get away with teaching the list as mere list. The body of the

information iceberg must be dealt with as well as the tip. Not only does the tip exist for the sake of the body, if we accept Hirsch's use of reading schemata, but acquisition of body is the best assurance that the student will retain the tip, as Whitehead's remark about knowledge and fish suggests. The implications for transmission of the list seem fairly clear. The set of explicit meanings of its items constitute the tips of icebergs on which each learner is to "grow" his own substratum. The implications for the preparation of teachers would seem to be equally clear. The teacher cannot escape responsibility for this process and therefore, to the extent possible, must have a substrate of his own. Another way to put this is that the teacher should be able to go below water line with most items on the list, and to go considerably below water line with some items, including not only the teacher's area of academic specialty but also a random sprinkling of other items. Finally, both teachers and teacher training programs still have to confront the issues implicit in Hirsch's reference to "relevant information."

The question might be asked as to the preparation necessary for someone capable of dealing with Hirsch's list of texts at the high school level. Should he have read all one hundred and twenty-five? The requirement does not seem unreasonable when we consider than an average beginning English major will already have read between half and two thirds of the texts. More to the point, perhaps, is the question as to the most efficient ways of acquiring the depth of understanding we would expect a high school English teacher to have. Some study of a foreign language? Some rudimentary familiarity with one of the literatures from which foreign language texts in Hirsch's list are drawn? Some experience in close reading of poetry? Sufficient experience with drama to assist students in mounting plays? Broader reading in one or more of the novelists (Dickens, Thackery, Austen, for instance) on Hirsch's list? Considerable writing experience? Some sense of the history of English literature and of the English language? These areas of competence sound very much like what we would expect an English major at most liberal arts institutions to acquire. Perhaps we might make an additional stipulation that *The Iliad, Odyssey,* and Bible be required reading, though I suspect ability to manage the list does not demand it.

But more should be required of high school English teachers than an undergraduate English major and in-depth comprehension of the list. Teachers need to have some understanding of the strategy by which they are operating. Insofar as Hirsch's list is concerned, this means at the very least familiarity with the book, *Cultural Literacy,* in which he not only sets forth his list but also defends and explains it. Teachers ought to be familiar with his use of the analogy to schemata in reading theory. They need to consider the analogy, analyze the respects in which reading theory carries over to the general question of knowledge. They also need to consider what it means to "know something," since a student who has learned items on

the list will be presumed to know them. Issues having to do with degrees of knowledge or qualities of knowledge should be examined, because the student's ability to recognize texts, or other items on the list, may indicate no more than a superficial, inadequate knowledge. The list and its purposes need to be placed in a broader context of education. This should not be done for teachers preparing to use the list with secondary students. Rather, the circumstances of their preparation should be arranged in such a way as to allow and encourage them to do this for themselves. Only in this way will they have the necessary breadth of understanding to make use of the list in a strategic, as opposed to tactical, sense.

There is another aspect of preparing teachers to use Hirsch's list. This has to do with their understanding of society and their role as teachers in society. The mere fact of the production of the list serves as an indication that a state of affairs in learning which may have been satisfactory a generation ago is no longer so. These teachers-to-be need to consider Hirsch's analysis of the sociology of knowledge in the present-day world and to carry it further. What are the criteria for generating lists such as this one? What are the justifications? To what extent does evidence support Hirsch's claims; to what extent subvert them? What principles ought to govern the addition and dropping of items in future editions of the list? What are the particulars of the relations between high and demotic culture; between items on the list that have endured and should continue to endure, and items that will one day be candidates for exclusion? Without an understanding of the epistemological and sociological significance grounded in conviction, a list such as that of Hirsch may not prove very useful to classroom teachers.

Perhaps the best way to prepare to teach the list is comparable with what one might describe as the best preparation for drawing it up; namely, a broad liberal education, reading in neighboring and distant areas, broad culture, familiarity with current events, a lively professional life with a variety of stimulating contacts, service to profession and society. The meaning of the items on Hirsch's list cannot but be different to a colleague of his own age from what they are to a high school senior or an undergraduate preparing to teach. The fullest backing of the currency comes only with time and effort. And here I feel impelled to put in a word on behalf of experience, for the fact that is what education is all about, striving, as it does, to make good the gap which age sees and youth imagines. Deliberate circulation of unbacked currency represents a justifiable attempt to stimulate an intellectual economy, despite the counterbalancing danger that it may simply serve to encourage intellectual deficit spending. For Hirsch's list to become an integrated part of the social and philosophical curriculum of education schools, the ideas behind it must be accepted by those responsible for the ideology behind the curriculum of those schools. Of course a

prophet is vulnerable in the hands of his priests. No less than John Dewey, and perhaps more, Hirsch should anticipate the possible fate of the ideas and perceptions which led him to develop his list. All too easily, in the hand of uninspired time servers, it could become a mechanical albatross to hang around the necks of uncomprehending students.

It remains to say a few words about the undergraduate English department and graduate education in English (the Ph.D.). English departments, which are partly responsible for the problem Hirsch is addressing, could be part of the solution. Emphasis on scholarly publication in a field that cannot expand in the ways that the sciences do, could benefit from greater concern for teaching and general education. We all recognize problems in the preparation of college freshmen, but how many of us have taught at the secondary level? Let us reward, rather than handicap, job candidates with secondary school teaching experience. Let us offer students at the doctoral level a course in which the epistemology and the cultural purposes of instruction in English literature, as well as questions of pedagogy, are given the most serious consideration. Let there be more scholarly writing of the sort Hirsch undertakes here. Let one of the tests of critical theory be usefulness in the teaching/learning process. And finally, let us remember that only a tiny fraction of our students are preparing to follow in our footsteps as academics. Bearing in mind the contents of Hirsch's book, we may ask whether the course offerings of the undergraduate English major make the best possible use of student energies.

NOTES

1. I recently checked with a day-care center operator on these points. In her experience, children three and older generally know Mother Goose Rhymes. She sees them as important in language acquisition as well as learning to retain information sequences. To her it would be a great loss if other material were to replace Mother Goose Rhymes.
2. See John Passmore, *The Philosophy of Teaching* (Cambridge: Harvard University Press, 1980), chaps. 3-6.

# The Visual Arts and Cultural Literacy

JOHN ADKINS RICHARDSON

It was a long time ago, in a world that now seems far away. Humanity's spoor had not yet marked the dust of our lone moon, and on this well-trod planet certain thresholds barred footsteps taken by those "of color," even from halls of political franchise and temples of learning. Too, much of what passed for devotion in those temples was worship of Mammon and the meditations of his apostles altogether banal in their narrow vocationalism. So aware of this were professors of the liberal arts and their disciples among the journalists and other commentators as to make foregone yet another of the perennial reformations of the educational fundament.

Thus, at the very beginning of the seventh decade of our century, I found myself the junior member of a group charged with the establishment of new general degree requirements for a large Midwestern university. Upon convening as a committee, we were asked for our personal views of what the criteria should be for inclusion of course material. Senior members spoke with enormous confidence and impressive eloquence. I recognized the greatness of thoughts from Newman, Arnold, Carlyle, Dewey, and even such minor contemporaries as Paul Goodman and Arthur Bestor,[1] lofting majestic clouds of rhetoric in the room where we had been brought together by our president. Inevitably, my turn came last, and my contribution was clearly judged the least as well as the most flippant. In point of fact, I meant it to be a joke, for I was ill prepared to present a serious philosophic statement to the very kinds of people who'd only recently adjudicated my orals for the doctorate. "It seems to me," I said, "that the best measure of our undergraduates' general knowledge is whether or not we would be embarrassed by what they might say at a literary cocktail party in Manhattan or Belgravia." This comment was somewhat better received than might have been expected, largely I suppose because the reference to a fashionable lo-

*John Adkins Richardson* is Professor of Art and Design at Southern Illinois University, Edwardsville. Among his works are *Modern Art and Scientific Thought, Art: The Way It Is,* and, with Michael J. Smith and Floyd W. Coleman, *Basic Design: Systems, Elements, Applications.* He is a frequent contributor to this journal.

cale in nineteenth-century London mitigated the callowness with which the remark was otherwise bedewed.

Needless to say, mine was not the criterion that reigned supreme. And, like most such curriculum-making bodies, we found ourselves by circumstance compelled to approve a number of things that academic integrity, refined judgment, and our own best reason should have forbade. We were in surprising agreement, considering that the academic disciplines represented by the seven members of the committee ran the gamut of plausible diversity from nuclear physics to American literature. But despite our congeniality of mind, none of us was as certain about anything we believed in as most of our supplicants seemed to be about *everything* they proposed, no matter how far-fetched. It was, of course, to be expected that departments whose salary bases resulted in large measure from massive enrollments in required courses would be strenuous in arguing for the continuation of the same provender they'd been dishing out in the collegial cafeteria of knowledge. Too, it was easy to anticipate that self-proclaimed noncomprisers would march forth under banners emblazoned "innovation" to proclaim crackpot schemes of every sort. From the very outset we expected to tolerate some of the less expensive and probably more harmless of these.

Much to my personal dismay, the president of the university was highly enthusiastic in support of an experimental two-year program proposed by the School of Design. Both he and the Dean of Design took it for granted that I, as someone with a sympathetic interest in visual organization, could be counted on to champion their cause. I did, indeed, end up trying to translate the intentions of the designers to the committee, most of whom perceived the whole enterprise as nothing less than a boondoggle and probably an outright "scam" being perpetrated by academic charlatans. It was, of course, a good deal more than that and was undertaken sincerely, too, by comparatively capable people who had absorbed from experiences of their youth at the Institute of Design and Black Mountain College a set of beliefs that amounted to an explicit philosophy of general education. Where liberal arts curricula reflected the literary and hierarchical conceptions of the Enlightenment, the Design School's philosophy was associated with the technological idealism of the Weimar Republic and the ameliorating social conscience of the New Deal. By the early sixties, much of this had been reinforced by an acquaintanceship with the visionary, Buckminster Fuller, and the ecology movement.

The students in the experimental program were volunteers set off in a sort of Bauhaus-inspired enclave where they took "integrative" sequences of courses graded by—and I am not making this up—"Initiatory, Secondary, and Tertiary Diagnostic Traces (Primarily Nuncupative Type)," that is, largely oral interviews at the first, second, and third stages. Since enor-

mous stress had been placed upon the conceptualization of knowledge through visual display and direct experiential, "holistic" operations, I was astounded to read that among the topics included at the sophomore level was a section called "Solid State Physics." Scarce wonder that the president was impressed! But when the committee perused the syllabi and related course materials in this science sequence we were quick to see that what was being studied had, in fact, nothing to do with the crystal lattice, its dislocation, or with energy bands and so on; what the students were dealing with was the same Newtonian mechanics involving "solid" objects in standard inertial fields of the kind all of us had studied in high school. The material itself was worthwhile, but the terminology was at once pretentious and very, *very* misleading. This single revelation about course content, however, did go a long way toward explaining why 44 percent of the 240 design students received grades of *A* in the course of study. That amazingly lopsided curve was bound to outrage the General Studies Committee and, when the group asked the Dean of the School of Design whether he thought such a distribution of grades was satisfactory, he admitted that it was not. A general sigh of relief around the conference table. The Dean continued: the curve was imperfect because not *all* of the students attained the highest possible mark! His rationale for this statement—which produced one of the very few instances of dignified older men actually spluttering in furiously strangled incoherence that I have ever witnessed—was that his school had established an absolute standard of attainment and a specified body of material to be mastered. He and his colleagues had brought to bear upon the problem of communicating the information a number of unique pedagogic techniques and remedial measures; when the techniques—which were, indeed, of considerable ingenuity—were perfected, every student would achieve an A.[2]

The designers' were the most appalling of the pseudointellectual posturings we encountered, but they had as well the most potential for making some sort of weird contribution to the educational experience of at least a few unconventional learners. It was probably true, as my colleagues on the committee asserted, that the students in the design experiment did not match the performances of the conventionally trained when they entered into competition with them during the third year of general education. On the other hand, to me the designers' worldview seemed less marked by banality than did the outlooks of similar mediocrities that make up every student body. Quite a few of them seemed to have been transformed from ordinary rustics of an unassuming sort into shallow dilletantes with an inclination toward trendiness, but I felt that nothing could ever turn a single one of them into anything as contemptibly complacent as many of their peers. In this connection, I offer for the reader's diversion a "true-life" anecdote that, while bitterly amusing on its own account, has also a more

profound and immediate pertinence that will not become too apparent until much later in the essay. I beseech your patience, then.

While on my way to lunch I happened to find myself walking within earshot behind two young men whose conversation (and holstered calculators) told me that they were majoring in one of the applied sciences. They had just come from an English literature class of some sort, and one of them was exasperated. He resented being required to study poetry. But, even more, he considered the teacher an ignorant fool who was not worthy of even slight respect. Apparently, it had become obvious to both of the men that their instructor knew no calculus, was unfamiliar with the concept of "factor analysis," and had even misunderstood the term "Mach Number," when spoken, to be a reference to falsification of some particular datum—as "mock chicken" is not genuine fowl. It was, said the grumbler, impossible to respect anyone that ignorant of the "real"—that is, physical—world. It interested me that the second student reacted to every complaint with a sort of detached reasonableness, objecting in the same way to every criticism, saying that none of these things justified disregard of what the professor of English had to offer. This was "irrelevant," that "had no bearing," and something else was "beside the point." Actually, I was growing quite fond of this fellow. He was consistent in his tolerance of those of us who wouldn't know an independent variable from a stochastic perturbation. So I was especially interested in his closing remarks. "Just let me tell you something," he said. "The other day I happened to see a list of faculty salaries broken down by departments. Do you realize that most Ph.D.s in humanities and the arts make less than forty thousand dollars a year? *That's* the reason you shouldn't pay any attention to that sonofabitch!"

Now, I grant that this is a level of philistinism no mere pedagogy could override. Yet, it is the kind of thinking that would have offended the students emerging from that design program twenty-five years ago. And I know from interviews done at the time that such materialism would not have seemed so very awful to many of those in courses of study tailored for marketing and civil engineering majors. So far as the indoctrination of liberal values was concerned, those design professors were onto *something*, something that cannot be explained away by what one might suppose to be an inherent tendency of design majors to be less materialistic than others. For this general education experiment handled people majoring in many disciplines. Moreover, at least some of those who went through the program are champions of it still today.

As purest chance would have it, I talked with a couple of students I had previously known from the program at a national convention of ophthalmologists during autumn of the year just past. No, none of us is an M.D. My father was an "eye man," but an optometrist. Partly because of his inter-

ests, however, I was there to give a speech on the relation of ocular deficiencies to certain kinds of artistry. The two ex-students were there out of general interest in the topic. One of the two is now in the office of the State's Attorney, the other a medical administrator of some sort, and each felt their devotion to public service could be traced back to that general education experiment conducted by the School of Design and its general education staff. I became convinced that, at least in this admittedly insignificant sample, the content of the somewhat bizarre curriculum to which they'd been subjected *seemed* in some very peculiar fashion to bear upon the cultivation of attitudes many of us would consider admirable. That, no doubt, explained the design faculty's zeal. But, then, similar fervor was everywhere to be encountered, even in the Schools of Business, Engineering, and Agriculture. Too, it could be that products of these areas also had positive characteristics attributable to their nonmajor studies that I was blind to because of bias or sheer fatigue. For me at any rate, dealing with these matters became a bore. Few things are more enervating than continued exposure to unflagging enthusiasm, particularly when it seems to be misplaced.

Faculty spoke with a sort of terrible intensity about the immensely humanizing qualities of every curriculum with which they happened to be connected. Rarely, however, did these academics exhibit personally the merits they claimed students would be likely to induct from exposure to the education they proposed, a trait that made me skeptical about sonorities university people are forever putting forth under the rubric *Educational Objectives and Goals*. A philosopher of education for whom I have considerable regard had once described such things as being "incantations in the form of summarizing slogans," and now personal experience confirmed his characterization.[3]

My facetious remark about assessing an education according to whether the professors would be embarrassed were it known that their graduates had received so much as C from them seemed to be a far more pertinent comment than I had intended at the time I made it. So, when I came to write a book intended for the purposes of general education, I attempted to establish a comparably realistic goal. *Art: The Way It Is* first appeared in 1974 and was originally conceived of as a text for junior colleges. As it happened, between the conception and birth—which, like most art books, required a gestation period of about twice what it takes to make a child—the character of the market had undertaken a marked change, and the work turned out to be well suited for university freshmen, or so adoptions indicated. Whatever the case, it was only in Canada and the United Kingdom that the book caught on as a community college or senior high school text. Otherwise, it has been most widely used in the United States by four-year colleges and universities. The first chapter is called "Who's Putting on Whom?" and is

forthright in proclaiming that an acquaintance with art is neither practical nor necessarily adjunct to a happy and fruitful life; it does, however, recognize the social-class bias favoring such knowledge:

> There is real utility in knowing a little about the arts if one wishes to advance in the corporate structure from the lower to the executive levels. . . . What most laymen are apt to want is just a bit of polish. And that is the most an author dares hope to achieve. True, the attempt to apply a bit of polish often leads to something that is not so superficial. But I cannot promise to do more than gloss surfaces for there are basic difficulties in dealing with a thing so all-encompassing as art.[4]

Now cometh forth E. D. Hirsch, Jr., with a principle to support my presumption. His notion that even a superficial acquaintance with certain things can enhance understanding of many others is, I think, entirely true. And those who dispute this on the grounds that a cursory reading of serious matters is so empty of purpose as to be dangerous are likely to be in the way of peril when asked to prove their own firm grasp of the very same material. Which is not to say that complainants mightn't be thoroughly competent to raise objections, as often as they are not. But whether they are or no, one thing in all of this is certain; when any of us sets out to convey matter of even slight intellectual complexity we must, perforce, rely upon the integration of associated concepts.

Let us take as an instance something that does *not* replicate material from *The Dictionary of Cultural Literacy* by Messrs. Hirsch, Kett, and Trefil and address ourselves to the significance of a great natural disaster, the Lisbon Earthquake of 1755. This event had repercussions far exceeding its immediate horror and devastation, and all sorts of historical transformations have been attributed it, particularly those attendant upon the diminished importance of conventional religious practice in European intellectual life. Democratic rebellion against the privileged orders of society, Romantic ructions in opposition to Classical models of artistic perfection, even the prestige of scientific skepticism and philosophic Positivism have been ascribed to disillusion that resulted from the destruction of religious confidence at 9:40 a.m. on November 1, 1755, when virtually the whole of Lisbon, Portugal, was leveled in a matter of moments. As it happens, November first is All Saints Day when attendance at mass is required. As many as 70,000 and no fewer than 30,000 died in this earthquake, most of them at religious services.[5] Voltaire, in *Candide*, used the event to oppose panglossian optimism, and Goethe said it had loosed "the Demon of Fear" upon the land. Just ten years later the first horror story, Walpole's *Castle of Otranto*, appeared. After the terror of the earthquake, the kind of artistic vision that had infrequently titillated eccentrics like Piranesi before, became epidemic in what we call Romanticism.[6] Goya, Géricault, Turner, Delacroix, Blake, and hundreds of

lesser artists created works that were full of morbid, fearsome apparitions. Of course, Romantic art is not ghastly in the whole; there are glorious celebrations of wondrous nature as well. Jacques Barzun has made a great point of the all-encompassing character of the Romantic temperament.[7] He is right. Still, the new art was far more gruesome than what preceded it— once the standard iconography of Christian martyrdom has been exempted from consideration—and those majestic escarpments, breathtaking cascades, jungle depths, and desert wastes also carry in their strangeness what Edmund Burke called the sublime effect of such visual objects "as are great in their dimensions."[8]

One does not have to be very knowledgeable about the specifics of the Lisbon quake to see its probable ramifications; as a matter of fact, one does not have to know the precise date of the event. And, if one is aware of one or two of the artists and the sort of work they did, it is easy to estimate the interrelations overall. Thus, if one is at all interested in the historical connections here involved, it is easy enough to seek out the particulars. And, then, it may be revealed that Giovanni Battista Piranesi (1720-78) did his famous etchings of prisons, known as the *Carceri d'Invenzione*, in two versions, the first published in 1750 and the other, darker, more frightening states in 1760.

My point is, of course, that knowing the Lisbon earthquake exterminated numerous good worshippers on a holy day is already a very considerable revelation. And knowing only a little about the art and literature that came afterwards is surely of more than passing import. It is not a great Truth, perhaps. But, like so many influential events, it is interesting to speculate upon and consider in relation to one's own faith and one's own view of history past and the moment present. Obviously, it is not the kind of information that could be counted on to reform boors or revise the values of a materialistic society. But it can provide a toehold for ordinary ascent up from lesser to greater knowledge.

How much does one need to know about the artists to know something of value? Well, to know no more than that they are painters or sculptors rather than dramatists or musicians or jurists is something in and of itself. But merely to know that John Constable is "an English landscape painter of the late eighteenth and early nineteenth centuries, known for pastoral scenes," is to be aware of a bit that is correct and a little that is, perhaps, misleading—particularly when given the literary connotations of the term "pastoral," with its generally bucolic overtones. Certainly, John Constable was in love with the English countryside in somewhat the same way as his friend William Wordsworth was, but what characterizes his painting style is the particular approach he made toward the problem of *rendering* nature, and it is not very informative to speak of his works in terms of subject matter. After all, the countryside as it is depicted in Holland during the seven-

teenth century by Jacob van Ruisdael, in New York by Asher B. Durand and Thomas Cole around 1840, or by China's fourteenth-century Taoist, Fang Ts'ung-i, is not very different in its essential components from what Constable shows us. The medieval monk from Kiangsi province was as intrigued by the essence of natural beauty as were these other painters. It requires only a glance to see that his conceits are not European, and barely more is required to distinguish the differences between the Hudson River School painters and the Englishman. But when we turn to European artists who come after Constable, the situation is quite different. Theodore Rousseau and Constant Troyon have their distinctive traits, of course, but often enough the path they and other painters of the Barbizon School took through Fontainebleau Forest was in the very direction Constable had set when he began doing *plein air* sketches on the banks of the River Stour in 1802. Today, our very notion of what a standard, picturesque landscape consists of is pretty much a description of what Constable began. His recapturing of transitory, fleeting effects of nature and his invention of means to convey apparently spontaneous impressions of such things as shifting clouds, rippling streams, and the flicker of rustling tree leaves by employing *alla prima* sketchiness and masterful scumbling of oil pigments make John Constable's oil paintings masterpieces of fine art.

I should not, in these remarks, care to give the impression that subject matter has no bearing upon the character of a work of art. We would be surprised to encounter a Constable depicting an alley in the slums of Limehouse, surely; his world constituted a norm opposed to urban life. Too, there is definitely something in the idea that the nineteenth-century landscape represents, as Arnold Hauser said, the displacement of man from the center of art "and the occupation of his place by the material world."[9] I myself have written on the degree to which Realism and even French Impressionism mirror Positivism and imply a criticism of the social mores of the Second Empire and Third Republic.[10]

Still, despite all that one can say in support of the importance of subject content in the art of Romantics and Realists, it is the sheer appearance of the work that is the basis of its importance. More to the point of our concerns here, that is true of *all* forms of visual art. To speak of "visual literacy" would be to utter an oxymoron. Everyone realizes that poetry is made of verbal units, music of nondiscursive sounds, and paintings of visual sensations that may or may not have some illusory effect. It should be obvious, too, that visual art is peculiar in consisting of physical entities and that this fact alone imposes the most severe kinds of restraints upon its nature as a part of the cultural continuum. The implications of that fact are not, it seems, well understood or appreciated even by professional intellectuals whose attentions are absorbed by mounting exhibitions and performances.

Consider merely the matter of ownership of a work of art. Some years

ago I and one of my colleagues attended the auction of an estate with the object of picking up one or two artworks for the university collection. Partly because of the bidding skills of my companion, David C. Huntley, at present the Director of University Museums at Southern Illinois University, Edwardsville, we were able to purchase a superb impression of the tiny Rembrandt etching of 1634, *Christ and the Woman of Samaria: Among Ruins* (sometimes known as *Christ and the Woman at the Well*) for less than a tenth of its real value. The print, then, became the prize item of the university art collection. It was stolen from an exhibition, along with some other pieces, by accomplished thieves, and it has never been recovered. Assuming that it has not been destroyed and is still intact, this impression of the Rembrandt still exists and is, in fact, in the possession of someone, somewhere. There are other impressions of the work, fortunately, though not even the Rijksmuseum's is superior to what we once owned. Still, one of the positive features of traditional etching is that it produces multiple originals of a single aesthetic conception. And yet, it is conceivable—only just conceivable—that some criminal mastermind of the kind popular melodramas feature could contrive to steal every existing impression of the Rembrandt. If these were subsequently destroyed, the work would then cease to exist except in memory or as a photo-reproduction.

To take our melodramatics a bit further, pretend that Basil Slinksnard, billionaire archenemy of society and masochistic aesthete, determines that the most exquisitely debased pleasure he can conceive would derive from the extermination of a specific masterpiece. Now, were he to choose a famous painting, the problem would be a relatively simple one, though its resolution might pose all kinds of practical problems so far as overcoming security measures is concerned. However difficult the task, all that Slinksnard's minions have to accomplish is the destruction of a specified work of art. But what if it were a symphony Basil wished to erase? Then the task would be insuperable. For it would require not only the elimination of every manuscript and score but also all of the recordings and every musician who knew the work or who could, from some recollection and trial after error, reconstruct it. On the other hand, no human being could own the piece itself, because musical works exist as works only in performance. One may possess an original score, but that's not the work. One may have every record, tape, or other transcription of some concerto, and still it cannot be said that one does in fact "own" the work. Even the composer who has created but a single score in manuscript cannot be said to be in possession of a musical work, at least not in any real sense. In somewhat the same way, a dramatic work exits only as it has been performed upon the stage or, strictly, is being undertaken by actors.

Literary works, in general, have an immortal existence; they need not necessarily take the form of print, since perfect recall of the words is suffi-

cient for them to remain intact. Of course, should every printed copy of *War and Peace* evaporate, it is unlikely that the whole of Tolstoy's novel would remain, even in the collective consciousness of readers of Russian who have memorized its greater portions. But the book is clearly not a manuscript or printed volume in the same way that Max Ernst's *Day and Night* or Giorgione's *Castelfranco Madonna* exist as individual, physical entities with notably singular properties.

That fine-arts works are members of the class of objects that may sometimes be counted as precious commodities gives them a special cachet among some of those whose cultural and intellectual interests are otherwise stunted but simultaneously limits their general cultural significance. The ephemeral transcience of musical performances has a somewhat similar effect upon that art.

It's all very obvious, surely. But, so far as cultural literacy and pedagogy are concerned, literature does hold a position of sovereignty. Not only is the commonality of written language universal among civilized peoples, but the power of verbal communications cuts across the entire sensorium of humanity. The deaf can read, the blind hear words spoken, those who are both unsighted and also immune to auditory sensation can deal with literary works through the tactile indicators invented by Louis Braille. Even though literacy itself may be somewhat overrated by modern, industrial nations, it does have a unique capacity to reach very nearly everyone.[11] That is one of the reasons that the substitution of Marshall McLuhan's electronic media and direct, "hands-on" experimentation for the printed word and spoken lectures was invigorating for the people in our 1960s School of Design experiment but was ineffective in terms of giving them the fundamental base of core material identified with a liberal arts education. To use design theorist Moholy-Nagy's words: "Teaching focussed on learning for learning's sake will always bypass the ultimate objective. . . . Choices are easy if the goal is clear. Knowledge should not be suspended in a vacuum; it must be in relationship with socio-biological aims."[12] As I noted earlier, I believe a genuine truth is embodied in what the designers, the Instrumental "Progressives," and Social Reconstructionists assert in this regard.[13] Unfortunately, the intensification of learning that accompanies their kind of participatory involvement runs completely counter to the dominant ideology of the entire industrial world. There is not so much as a whisper of doubt in my mind that the enculturation Hirsch and myself would like to achieve in the schools and in college education is in service of an essentially hierarchical, capitalistic, and elitist social system. Karl Mannheim was right about that during the 1930s, George Counts in the forties, Paul Goodman in the fifties, Ivan Illich in the seventies, and Jacques Derrida had it pegged again more recently. I have news for their supporters; *they lost.* The system won, and it will continue to win so long as scientific technology and the resulting

political economy prevail. It seems evident to me that the system itself is not necessarily racist, sexist, or even inhumane. In fact, it isn't even capitalistic—at least not in the strict sense. But it demands for its dynamic a culturally literate group to operate it in a decently just and responsible way.

Being culturally literate presumes a knowledge of things other than letters, rightly enough. One must know music and art as such even to think about them in any meaningful way. That requires some direct experiencing of artworks and the media used to create them. Primary school and secondary school art education programs are ideally suited to associating the cultural contents of the works with the experience of creating them. Some of the knowledge that will be essential to understanding is of a surprising kind, I think. When I first began teaching at the college level in New York State, just after the Korean War, I was annoyed to find exam papers from graduates of Catholic schools ensigned at the top of every page with the initials J-M-J—for "Jesus, Mary, Joseph," I learned. A minor parochialism, the cause for which did, as it happened, abet the study of art history. It was obvious that these students had been inculcated with the essentially fundamental iconography of Medieval and Renaissance art. Well, they would be, wouldn't they? These depictions are the art of their religion. The Jews, Protestants, and others were no match for graduates of Saint Mary Magdalene or The Academy of the Blood of the Holy Sepulchre when it came to identifying Saints Barbara (tower), Catherine (wheel), Agatha (severed breasts), and so on. Today, even Roman Catholics aren't so well versed in these matters. And you will be surprised to learn that quite a few freshmen have no idea whatever about "those round things behind the heads" of sacred figures. Go ahead, check it out. Ask. I did; it's one of the reasons I included a section on halos in *Art: The Way It Is*. Halos, along with the Lisbon Earthquake, might well be added to the dictionary of things Americans (and others) ought to know. Why, in an age of increasing skepticism, young people don't know about Christian symbols is obvious; the youngsters don't go to church or look at religious pictures in *Life* magazine the way I did. Normally, a public school wouldn't teach about sacred imagery, since it can be foreseen that not all will understand that teaching about a subject is not the same as indoctrinating pupils with a belief in the thing. Even Christmas cards nowadays are frequently nonsectarian to the point of being irreligious. (I myself buy the "Season's Greetings" type.) In any event, this is grist for the mill of the newly historical art education, in spite of predictable obstacles that will be raised against it.

Objections to teaching about Christian symbolism in art are not completely nitwitted, even when viewed from the most open-minded and liberal angle. What, after all, could possibly be more ideological than showing pictures of Jesus and the other holy figures? Those works are even quaintly sexist in a very obvious and special way, albeit one that has come

into art-historical consciousness with remarkable belatedness in Leo Steinberg's recent study of the representation of the genitals of Jesus in Renaissance art.[14] It would do a world of good if we could teach people what the semiotisists want to, namely, that the social world of humankind is nothing but a collection of signs—some verbal, some gestural, many as concrete as public notices and marble statuary. That, ultimately, is what cultural literacy is really about, the status of certain signifiers in our communication with one another. I realize that the term "semiotics" has a slightly tarnished quality in many quarters of the academic world today, partly because of the sins of structural linguists and so-called "post-structuralists," whose analyses have too often been inanely arbitrary or trivially self-evident. Their excesses are not my fault; the one thing they do seem to have in their favor is cognizance of how misunderstanding is built into our relationships because of the way that communication is effected through signs and the way feelings are affected by the significances these have for us. Obviously, a study of the contents and forms of images and explanations of them is directly pertinent to the work of the aesthetic educator, even when the connections may be marked by an unseemly *chic*.

To some extent all of us must accept the biases of the social order, no matter that these may in some measure be offensive to our sense of what is right. One may do all that is humanly possible to eliminate gender references from an essay in English, but when she speaks in a Romance tongue, the presence of nouns feminine, masculine, and neuter is pervasive. "Castrating" an entire language and all of its literature in obedience to a sense of equal treatment is impossible, so we accede to necessity while by no means foreclosing the chance for certain reformations. So it is with education overall.

Earlier, I reprised a conversation overheard between two engineering students on the campus where I am now employed. Now, I wish to return to that conversation within a different frame of reference. The man who was most vocal in his dissatisfaction with his English professor was, in point of fact, behaving far more reasonably than was his cynically pragmatic but apparently phlegmatic companion. In my opinion he had every reason to lament the limitations of the instructor who, in his way, was as insulated from the deeper meaning of our culture as the young man who measured intellectual worth according to its monetary value. I cannot forbear remarking yet another educational prescription from the early 1960s that is pertinent to the present circumstance as well as to the contentions of the fledging engineer whose gripes I overheard.

C. P. Snow's famous lecture *The Two Cultures* was delivered in 1959 and received a good deal of attention in this country during the years just afterwards. Many of the faculty who appeared before the general education

committee of which I was then a member alluded to it, and several made direct reference to ideas they believed were contained within it. Nearly all of these people were humanists, and only a few got it right, despite the fact that Snow was a famous novelist in a relatively conservative, typically British tradition. The few scientists—actually one biochemist, a physicist, and a mathematician, as I recollect—who mentioned it understood that it had rather little to do with the situation here and that it was not, as the humanities professors assumed, a demand for more literature in the curriculum.

Snow's main concern was with the kinds of learning that were needed by those who walk the "corridors of power," and he contrasted scientific knowledge, not with the arts and humanities in general, but with the curiously literary culture of Britain's "Establishment." His "two cultures" essay questioned the purported values of a traditional classical education for leaders of government who make policy in a world where human destiny is held hostage by the future of technology. It has many times been pointed out that not much has changed in the three decades since the speech appeared in pamphlet form. But then, the problem in the United States is not the overvaluation of Tacitus, Virgil, or Edmund Burke to the detriment of the laws of thermodynamics. Recently, at least, it has been said that our leaders are apt to have formed their ideas of ethical will and technological progress from such prototypes as motion picture Westerns and the voyages of the starship "Enterprise." On the other hand, if we are truly concerned about correcting infirmities in the cultural grasp of the citizens for whose educations we are collectively responsible, we should probably be devoting some attention to the very kinds of weakness Snow had spotted in Whitehall and my engineering student in the person who was teaching him about English poetry. Humanists, too, should know about such things as Ernst Mach's determinations of the speed of sound and about x or y axes. Perhaps not those particularities, but surely there is always plenty in the general culture that has contingent relations with the arts. Tomorrow morning I am going to attend a mathematics course and make a few comments on Albrecht Dürer's use of the *Mensula Jovis* in his 1514 engraving, *Melancholia I.* This is a "magic square" of sixteen differently numbered cells. The continguous ones add up to thirty-four in every direction, and the four cells in the center do, too. It's a Neoplatonic device that was reputed to turn evil into good—a neater trick than transmuting lead to gold, certainly. Dürer's interest in the numerology of the square was associated with his investigations into alchemy, astrology (at the time a branch of astronomical study), the theory of the humors, and the mathematics of architecture and perspective. I had dealt with this in an art course one of the math students took, and so I've been invited to address a class dealing with set theory,

making extra work for me but providing some evidence that it is not impossible to achieve some small advance in the direction of cultural literacy through the use of visual art.

I assure the reader that making reference to things like science and technology when one teaches about the arts and letters will not always enlist the interest of the philistines. I have plenty of anonymous comments from students on "Evaluation of Teaching Effectiveness" forms that will attest to how boring many of these auditors find "nonessential" material from physics, mathematics, literature, and philosophy when it crops up in classes that are "supposed" to deal with art history and criticism. Not left behind in their hatred of such impertinences are the art majors themselves. As some of my readers will know, young artists are not among the most energetically sedulous pursuers of information about their art as it was practiced in the past. It is also true that perhaps the first of the two engineering students would not be any more taken with my treatment of Frederick Church than he was with the English professor's discussion of Hawthorne, but at least he could not raise the same *kinds* of objections to mine. The fellow who had the final word will presumably tolerate anything to the extent that passing a required number of courses with a sufficient grade point average will produce higher income for him than he might otherwise secure.

My emphasis, in these remarks, upon college general education may seem to be misplaced, since it is the intention of Professor Hirsch and his collaborators to modify the general education conducted in primary and secondary schools. That is appropriate, surely, but it depends in large measure upon the capacities of the college graduates to carry out a program they are clearly not equipped to convey at present. Indeed, one might have a few qualms about the universality of the "canon" made explicit in the *Dictionary of Cultural Literacy*.

While composing this piece, I happened to mention to a colleague, who is one of the most intelligent, well-read, and productive research scientists I know, that it was interesting, not to say astonishing, just how hard it was to turn up something in Hirsch's list that I didn't know at least a bit about. My intended point was not that I was particularly well informed, but that a breathtaking chasm must have opened up in the general knowledge during the past decades. The evidence is, I'm sure, incontrovertible that this woman is generally more knowledgeable than I about all sorts of things beyond her field of expertise—molecular biology—including political history, entire zones of literature, and anything in music that you'd care to mention. Yet, what she said was: "Well, I didn't know the source of the term 'marathon' for a 26-mile race, did you?" Quite probably those of us who deal on a more or less regular basis with such things as the Persian Wars are taking for granted quite as much as I did in supposing that

"everyone" knows what a halo is. Moreover, we are making assumptions about peers and not only about students.

## NOTES

1. The names of Paul Goodman and Alfred Bestor will be known to many of my readers, surely, but it is perhaps instructive to recall the consternation that greeted their pronouncements in the years on either side of 1960. Goodman was a neo-Marxist antagonist of the public school system, which he indicted as being the principal ideological support for an exploitative and sexually repressive socioeconomic system. His theories of pedagogy carry "permissiveness" virtually to the point of an amiable sort of anarchy; indeed, it is not too much to say that Goodman is an early herald of the so-called "Woodstock Generation." Arthur Bestor, one the other hand, was the epitome of academic respectability and responsively liberal education. A professional historian, he spoke for those who felt that the professional "educationists" in charge of mass schooling of the American public had subordinated intellect to multitudinous other concerns. See Paul Goodman, *Growing up Absurd* (New York: Random House, 1961) and Arthur Bestor, *Educational Wastelands* (Urbana: University of Illinois Press, 1953).

2. Readers familiar with the history of design education will understand that much of what was done in the 1960s was based on the thought of theorists opposed to competitive activities in the marketplace and also in the classroom. Most of us would suppose that if nearly half of a group of students can master enough material to earn an A, the standards must be too low or the material of a somewhat elementary nature. But, then, most of us begin from the assumption that the mediocre invariably outnumber the gifted. The head of the School of Design seemed not to labor under such a prejudice. Or did he not? For he did suggest that we should revise our credit hour system to permit those showing special ability to go beyond what was regularly offered to secure extra credit for additional work. In other words, everyone gets an A but some people get more As than others! Small wonder that Laszlo Moholy-Nagy considered design an attitude rather than a profession.

3. I have this remark in notes on lectures from James E. McClellan, Jr. He is a penetrating critic of the Establishment puffery of the age, among other things. See James E. McClellan, *Toward an Effective Critique of American Education* (New York: Vintage Press, 1968), and *Philosophy of Education* (Englewood Cliffs, N.J.: Prentice-Hall, 1976), as well as his other works.

4. John Adkins Richardson, *Art: The Way It Is*, 1st ed. (Englewood Cliffs, N.J.: Prentice-Hall, 1974), p. 14.

5. The ironic circumstances of death being visited upon so many at worship made the event particularly disturbing to complacencies of faith, naturally, but it was a great loss of life regardless of the theological implications. To get some notion of the relative dimensions of the tragedy, we may contrast it with the San Francisco earthquake of 1906 that resulted in only 700 deaths. By far the most devastating earthquake of modern times was in China, July 1976, when 750,000 were said to have died (although the government, three years later, reduced this official estimate to 242,000).

6. See Kenneth Clark, *The Romantic Rebellion* (New York: Harper & Row, 1973), pp. 45-95 and elsewhere.

7. See Jacques Barzun, *Classic, Romantic, and Modern* (Boston: Atlantic Monthly Press, 1961).

8. Edmund Burke. *A Philosophical Enquiry into the Origin of Our Ideas of the Sublime and Beautiful* (facsimile of second edition, 1759) (New York: Garland Publishers, 1971), p. 285.

9.    Arnold Hauser, *The Social History of Art*, vol. 2 (New York: A. A. Knopf, 1951), p. 707.

10.   See, for instance, John Adkins Richardson, *Modern Art and Scientific Thought* (Urbana: University of Illinois Press, 1971), pp. 24-32.

11.   It has been discovered that most Americans today use their ability to write almost exclusively for making lists and writing brief notes. It is well known that literate peoples rely on written records to the extent that they do not have memories the equal of those from preliterate, "traditional" societies. Any open-minded Westerner who has lived in Africa can tell stories about some unlettered native cook who was able to recall everything on a thirty-item grocery list along with the price of each purchase. In a similar fashion, nonliterate peoples invest their histories in the memories of sages. The most famous demonstration of the uncanny accuracy of Africa's tradition of oral history is Alex Haley's *Roots*, a journalist's report that verified the consistency between written records and African mnemonics. I am not a mindlessly romantic Naif; history recorded in archives is less subject to error than what a succession of wise men recollect. Nonetheless, the gift of literacy is a blessing that is mixed with some misfortune for the receiver.

12.   Laszlo Moholy-Nagy, *Vision in Motion* (Chicago: Paul Theobold, 1947), p. 21.

13.   These forms of educational liberalism are linked in more than merely circumstantial ways. Bauhaus educational philosophy was deeply influenced by the ideas of John Dewey and also by the Sociology of Knowledge, the political/educational theory of Karl Mannheim. Mannheim's thought was a major component of George Counts's Social Reconstructionism.

14.   Leo Steinberg, *The Sexuality of Christ in Renaissance Art and in Modern Oblivion* (New York: Pantheon, 1984).

# Contexts of Dance

FRANCIS SPARSHOTT

Peering uneasily over the frontier, the Canadian observer considers the work of Professor Hirsch and his colleagues apprehensively. Granted that a community exists to the extent that it shares a common set of schemata and references, the citizen of a neighboring country wonders what he would have to learn before he would fit in. As it turns out, the list of things that literate Americans know, at the back of *Cultural Literacy*, holds few terrors. I got all but about half a dozen names. (Who, or what, is Sojourner Truth—or is it Truth Sojourner? Or Maya Angelou?) I do not think this would have worked the other way round. The list does not suggest that the average literate American would do well on what literate Canadians know. I find Montreal and Toronto, but not a great deal more. Well, that is what it is to be an imperial power: everyone has to know (and does know) your stuff, you don't have to know (and don't know) ours.

Aside from the odd unfamiliar name (and a lawsuit: I did not know the Brown decision, though I guessed it would be civil liberties), the list has its surprises. Apparently literate Americans have heard of Natty Bumpo rather than Natty Bumppo, surely one of the most memorable spellings in world literature. And why and in what connection do they know about Paul Laurence Dunbar? And why do they know about Niagara Falls, N.Y., a fairly ordinary metropolis, rather than about Niagara Falls, Ontario, or just plain Niagara Falls, a notable cataract? I am rather saddened to find that their purview encompasses Bob Hope, but not the Smothers Brothers—how could anyone not know about the Smothers Brothers? I find it downright depressing that they know "You may fire when ready, Gridley," and "Damn the torpedoes," and "Win one for the Gipper," but not "rule of law" and nothing (except Peace Corps and peaceful coexistence) with peace in it.

What do literate Americans know about the dance? Not a great deal.

*Francis Sparshott* is University Professor at Victoria College, University of Toronto. Among his recent books are *Off the Ground: First Steps to a Philosophical Consideration of the Dance, The Theory of the Arts, The Cave of Trophonius, The Hanging Gardens of Etobicoke,* and *The Concept of Criticism.* He has contributed several articles to this journal.

"Ballet" and "ballerina" are in there, but no ballets and no ballet dancers. Pavlov's dog is remembered, but not Pavlova. No Balanchine, no Baryshnikov, no Nureyev, no *Nutcracker.* Cecil B. De Mille gets in, but not his daughter Agnes, though *Oklahoma!,* which she choreographed, is there. No other kind of dance gets much of a look in. Isadora Duncan draws a blank. Americans know about Graham, Billy, but not Graham, Martha. In fact, the only dancers I could find were Fred Astaire and Ginger Rogers, as a single entry. No "modern dance"—and no "postmodern" anything. But also no square dance, no hoe-down, no Virginia Reel. (Elsewhere in the arts, we find Louis Armstrong but not Duke Ellington, the Beatles but not the Rolling Stones.) In fact, it looks rather as if the literate American discovered or defined by Hirsch and his colleagues knows absolutely nothing about dancing or the dance except that there is something called ballet, and he knows about that because his granddaughter wants to grow up to be a ballerina. And, oh yes—didn't there use to be that couple who were in movies back in the thirties?

In short, it's a great idea, but will it play in Peoria? Not likely; literate Americans have heard of Akron, Ohio, but not of Peoria, Illinois.

Who gets to say what literate Americans know, or need to know, or are better for knowing? One answer we are given is that the news media make the fundamental decision. What the newspapers and the television newscasts think it is both necessary to mention and feasible to mention without explanation is the primary determinant. But what kind of person gets to make that sort of decision, and how well are such people informed about what needs to be explained? I really do not know. As I have suggested, a shadowy sort of profile may be teased out of the list in the Appendix to *Cultural Literacy,* but I do not know what it really represents. I suppose Hirsch and his colleagues would insist that it does not matter. The important thing is that in any cultural community there should be some such common core of assumptions about the range of what a person can be expected to know, and that within that community there should be an educational system that furnishes every prospective citizen with the means of mastering that range.

Notoriously, there has recently been controversy about the way the mainline media and the educational establishment implicitly define cultural literacy. Hispanic Americans, Black Americans, women have argued that what is central to their concerns and self-esteem has been treated as peripheral by the organizations that believe themselves to be in a position to say whose knowledge is to be counted and whose is to be disqualified. For a newspaper to decide that something is not worth mentioning, or that when mentioned it needs to be explained, is a political act. And that applies to arts and sciences no less than to social groups and their concerns.

For the last ten years, as a philosopher professionally employed to teach aesthetics, I have been reflecting on the status of the art or arts of dance

among my professional colleagues. A lot of them know a lot about dance; few of them allow this knowledge to affect their professional practice. This curious reticence, we have seen, extends to the avowals of the culturally literate. A lot of people buy tickets to dance performances; a lot of people spend a lot of time performing this or that kind of dance as recreation or display; a lot of young people study the theory and practice of dance at universities, many of which have "physical education" requirements that are thus conveniently met. But none of this is near the center of literate consciousness, it seems.

It is not only dance that suffers from such aversion of the gaze. It is only in the last year or two that rock music has appeared in the mainstream media, although for more than twenty years it has actually occupied much of the attention of literate Americans. Apparently people have known more than they were supposed to know. The excuse here would be that rock music is inherently coarse, basely sexual in appeal, and generally beneath the notice of educated people, though the pundits who deliver these judgments have shown themselves suitably ignorant of all aspects of what they were talking about. But the apparent invisibility of dance has no such excuse. Two of the key figures in the development of modern dance as we know it, Duncan and Graham, thought of themselves, and were thought of by others all over the world, as representatives of things that were important in America and Americanism, and for the last fifty years the history of modern dance has been an American history. But it does not exist in the world according to Hirsch.

I would suppose that people generally get to know what they think they need to know. And we need a very good argument if we are to convince them (or ourselves, if we are honest) that they are wrong about what they need to know. Most familiarly, we might point out the existence of nonevident but real constraints that limit the choices they would make if they knew of the possibility of them. In a word, they need to know about opportunities. But those who would advise them need to know what they consider to be opportunities. Wealth, power, erudition are not self-evidently good.

The United States is not an effective cultural community. The argument of Hirsch and his colleagues supposes that there is such a potential community, defined in a sort of loose interaction between the mass media on the one hand and the "educational" establishment on the other—I put "educational" in quotation marks because I am actually referring to the schools and the bureaucracies that govern them, whereas the word "education" traditionally implies claims about the value of what is taught and learned. To what extent this potential community could be realized in the United States (or any other industrial nation) as it is or might be is obscure, since a consensus is defined by its implicit exclusions. As I remarked above,

as a Canadian with colonial status in the American cultural empire I am supposed to know what Americans officially know, but they are not supposed to know what I know. That is just what it is to be a colonial. Hirsch's argument converts massive parts of the United States into internal colonies. A Hispanic American is supposed to know what the people Hirsch defines as culturally literate know. But the culturally literate person is not supposed to know what members of the excluded minorities know, what they think they need to know. Hirsch shows little sense that the forging of an American cultural community might need to go both ways.

Hirsch may well be right, of course. Proponents of official culture identify it as the common property and heritage of "our" civilization, as emancipation from restrictive prejudices. The counterargument I have sketched is not ignored but considered and rejected as spurious. I am only repeating that the grounds for that rejection are not such as to convince anyone who is not already convinced of the advantages of standing at the imperial center.

I have been chewing over these commonplace generalities because to anyone interested in the cultural contexts of dance the discussions about cultural literacy are important. The exclusions noted in the original list of what literate Americans needs to know—the *Dictionary* ranges more widely and is less sharply characterized, though I have not gone through it with a critical eye—show that dance goes *against the grain* of official culture even when it is recognized and adopted by the appropriate institutions.

Who has the right to expect what from whom? Hirsch's primary claim is not that the knowledge he ascribes to the culturally literate is inherently better than other knowledge, but that it is the knowledge that gives access to a publicly accredited and recognized world. But such access is always limiting as well as enabling. Unless one is born and bred in a social stratum where indoctrination in the official culture is pervasive and hence automatic, there is an enormous price to pay for the enormous benefits of belonging. For whom, and to what end, is that price worth paying? Even within the official culture that question has an acknowledged place, because that culture has or used to have a Judaeo-Christian component, in which one is allowed to ask: "What shall it profit a man, if he gain the whole world and lose his own soul?"

Our present situation, as Hirsch and his associates see it, is one in which there are many subcultures within which alternative values and practices are sustained. The situation envisioned as "cultural literacy" is one in which a particular set of valuations is paramount, with its own set of facts and schemata. But the present situation is favorable to dance, not only because the dance world incorporates a diversity of artistically powerful and emotionally compelling traditions of ethnic dance, but above all because the built-in ignorance and contempt for dance as such is compatible with, and

tolerates, the dance world itself, within which knowledge and skill are nurtured and maintained, as a sufficient enclave.

For the rest of this article, I will take it for granted that dance is worth knowing about, and I will say some general things about what, on that assumption, a culturally literate person might need to know about dance. I will adopt the general standpoint of cultural literacy, that what one needs to know is to be considered in the light of America as a cultural universe, with its official valuations in place.

Dance is in a curious situation in the public consciousness of the arts. Traditionally, it is the least known of the arts, least securely established in the cultural hierarchy. The ordinarily cultured person in a medium-sized town has read plenty of books, seen some paintings and seen reproductions of very many more, seen photographs of the world's great buildings, listened to recordings of the world's great music (and in the old days would probably have a piano and be able to play some in its original form and much more in transcriptions). But such a person might never have seen a dance performed by a dance artist. And pictures can't show dances; they can only show poses, which are misleading at best.

Though traditionally inaccessible, dance actually lends itself better than any other art to television—except perhaps opera. Opera and dance are already audiovisual spectacles in motion. Televised dance and opera have notorious defects, but in principle they are available. In fact, excellent series of programs of and about dance and dancing have been made by U.S., Canadian, and British television and publicly presented on this continent, and no doubt there are similar series in other countries. In a typical format we see and hear a choreographer talking about a dance he or she is preparing, we see the dance being invented and rehearsed, and the program ends with a stage performance of the dance itself. An attentive viewer can learn a lot about what choreography is about, what dancers have to learn, the difference between working on a dance and presenting it to an audience, as well as acquiring acquaintance with a respectable repertoire of dances.

These television programs, made with the assistance of people in the dance world if not actually by them, show in effect some of what well-informed people think is the important contextual knowledge that the dancegoer should bring to the theater. First, there is the basic readiness to attend to the ways in which movements are put together so as to be danceable and a sensitivity to what is possible and what is not as well as to what is effective and what is not. Second, there is the double awareness that dance is strenuous and demands great skill and trained strength, but also that that is not what a dance is actually about. Third, most important, there is the awareness that people who make dances are very serious about dancing and dancemaking, that they give thought to what they are doing, they are not just waving their arms and legs. Fourth, also important, the fact that

the series is shown on network television (even if "only" on an educational or public network) testifies that we ourselves can also be expected to take dance seriously as an activity in the public realm.

What, in general, does one need to know in order to come to terms with dance, to understand dance practices and appreciate dance performances? One thing one needs to know is the placing of dance—of different kinds of dance—in relation to official culture. This is a complex matter, and one is grateful here for the precisions of Hirsch and his colleagues. At a certain level, it is enough that one's mind should not be a complete blank, that one should have the sort of sense of where dance fits in that (for instance) a hazy awareness of which television networks show dance programs at what hours would suffice to provide. Literacy is not an either/or affair, and one may be in possession of much knowledge that one has never thought about.

In a sense, the concept of cultural literacy itself is a large part of cultural literacy. The culturally illiterate as Hirsch and company see them are, I would think, first and foremost people who do not expect themselves to be able to assign a place to cultural phenomena on the basis of accessible cues—much as a political imbecile is first and foremost one who is not aware of the feasibility of making political judgments at all.

The basis of cultural literacy is the possession of a scheme of places to which phenomena may be assigned, a mental sorting office; and to know that one might have one is perhaps enough actually to have one. One must know that significances and values are assigned. And I would agree with what I take to be Hirsch's position that one must have some awareness of how they are assigned at this or that level of official culture.

It is also necessary that one have at one's disposal an indefinitely large set of facts, names, and classificatory schemata. It is probably not possible to make useful generalizations about how much one needs for what purpose—as a voter, as a potential dancegoer, or in any other capacity. In the case of dance, if one is potentially a dancegoer, one's classificatory schemata will include schemata of expectations. It is astonishing how people expose themselves to performances in the arts without knowing in the least what to expect—without having the minimum knowledge on the basis of which one could intelligently decide whether to expose oneself or not. And the relevant schemata of expectation are essentially matters of cultural history. So, to be culturally literate in the matter of dance, one must first be aware that it may help if one knows what to expect; then, that such knowledge is to be got, and how to get it. Getting to know what "every American needs to know" is one manifestation of cultural mobility; there is a sense in which the awareness that mobility is possible comes first.

What is the first thing one needs to know about dance? One answer, as we have seen, is enshrined in the practice of TV series. But those series

make a set of assumptions that are embodied in the format and context of the program themselves. They are art programs, supposing a certain level of public support and endorsement. Not every form of dance gets into such a program. One needs first to know what is excluded, what is the choice on which the programs are based. This is never explained. Dancemakers who have programs made about them, with the sort of support that the credits for the program will recount, must have attained a certain level of competence and professional and public recognition, and I expect the viewers are aware of this fact, even when they do not know (and have no faith in) the procedures by which such selections are made. Most viewers no doubt will suspect a conspiracy, but a conspiracy among those who have first conspired to make themselves the effective decision makers. But there are other kinds of dances which will never make it on TV—or rather, which will make it only on news programs, or as parts of variety shows, or in travelogues. The viewer will be aware of this, but will be fully conscious of it only in the light of some classificatory schema. The relevant schema here will distinguish between three kinds of dances. There are ethnic dances, danced as part of a way of life in which they play a structural or ideological role; there are social dances, which groups of people dance together just as a means of endorsing their togetherness; and there are art dances, which are danced in studios and theaters and belong to the same world as concert halls and art galleries. These three kinds of dance belong to three quite different compartments in life. One kind has to do with the art world, a complex enclave in our society with its own institutions and viewpoints. Another kind of dance belongs to the practices by which we identify ourselves, in nostalgia or in everyday life. The third kind of dance has no conscious meaning and makes no ideological claims: we dance them for fun, as recreation, and (traditionally) as part of the mating game that takes up so much of the attention of the young.

In practice, these three kinds of dance overlap, or may turn into each other. An ethnic dance may be taken up as an art form, a person may join an ethnic dance group just for sociability and exercise, and so on. Also, an important point in view of the special interest that this journal exists to serve, skill and artistry can be, and often are, shown and cultivated in any of the three kinds of dance. But only art dance involves the special challenge and mystique of art. And to understand art dance one needs to know the current presuppositions of the art world. One needs to know what it would be to experience dance, or anything else, *as art*.

The fact that any kind of dance may be danced skillfully and artistically and with concern for such aesthetic values as beauty, grace, elegance, and so on, suggests that our threefold schema needs to be understood against a common background, a sort of generic notion of what dancing is. I suppose the generic notion is that of nonfunctional movement of the human body,

considered in two ways: as something a person can do and as something a person can watch. A psychoanalyst acquaintance of mine, to whom I was mentioning my recent interest in the philosophical aspects of dance, answered in a way that showed that for him the very paradigm of dance, its truest form, was the ineffectual limb movements of the newborn child. I would not have thought that that was really dancing at all, and I still don't, though I can see why a psychoanalyst might think as my friend did; but it reveals the basic idea, that people are dancing when they are moving to no practical purpose. The generic idea of dance is two-sided, and comes to the fore in two contexts. As something to do, there is educational dance, where in principle one is simply getting a workout (or fulfilling a P-E require-ment), and there is no artistic constraint or interest beyond a general re-quirement of a certain aesthetic quality. As something to see, there is the show dancing in vaudeville performances or as interludes in TV shows, where again there is no artistic constraint or interest beyond the display of stripped and/or bedecked bodies in aesthetically enjoyable movement. Is the awareness of this generic idea of dance in its double aspect something that we should include in what the appreciator of dance needs to know? Possibly, but one might conjecture that this (or rather, the phenomenon I am trying to point out; I am by no means sure I have identified it correctly) is the commonly shared background in our civilization against which all facts and schemata are to be understood. In another civilization, the generic idea of dance might well be something that the culturally literate would have to acquire.

Given the threefold schema, what does the culturally literate person need to know about the three kinds of dance? What about social dance? The sort of thing one should know here is, precisely, who is expected to know what. Who should join, who should abstain, when does it matter and when does it not matter; what should one know, what is it better not to know?

Consider the case of what I shall call "disco dancing," the kind of freeform dancing done by young people at parties and recreational oc-casions for the last twenty years or so. The conventions governing this sort of dancing are complex and subtle and apply in quite different ways to people in different age groups. How one conducts oneself at such a dance shows important things about one; what one knows and how one knows it is itself important. I am deeply ignorant in this area, like the philosophers (Plato, in fact) who were said by Isocrates not to know how a gentleman folds his cloak. Some cultured people would say that it is essential to cul-tural literacy not to know such things, in the same way that T. W. Adorno used to parade his ignorance of popular music. Is this perhaps one case where we can rely on my principle that people generally get to know what they feel they need to know and in these social matters are unlikely to be wrong? The kind of dancing that comes to my mind when I use the phrase

"social dancing" shows a lot about who I am; perhaps cultural literacy here is knowing what one should admit and not admit to knowing in this or that social group.

Perhaps one ought to know the sociology of social dancing, so as to know what to pretend ignorance of. A shrewd person might pick the essentials up from the media, if they once got the idea of looking—though recent commercials for light beer in Canada, like most beer commercials, seem designed to obfuscate the issue. But this seems to be just the kind of knowledge that the idea of cultural literacy seems designed to exclude.

What about ethnic dancing? What does one need to know about that? Well, that there is such a thing, that it can be and is cultivated artistically though not in the context of the art world, and that it can be bound up with the pride and identity of the subcultures that practice it and sedulously keep it alive in an imperial context. To come to terms with ethnic dancing one also needs, I think, to understand that its significance is not only deep but variable: the dance of a culture may be related to that culture in all sorts of ways, and one needs at least to be aware that something may be going on that does not meet the eye. As with other areas of cultural literacy, what is basic is that one should understand that there is *something to be understood* here, that one should be sensitized to possible meanings.

Ethnic dance is on the present view essentially related to provincial or colonial status. Those who identify with the metropolitan culture of the imperial power cannot be expected to know about ethnic dances. But in these days of rampant democracy and global-villagism (and, in Canada at least, "multiculturalism") it is part of cultural literacy to have some idea of what ethnic dancing is about. (Yes, McLuhan's phrase "global village" is listed among the shibboleths that culturally literate people must pronounce—but "multiculturalism" is not.)

Arguably, culturally literate Americans might be expected to know more. Navaho and Sioux Indians are on the list of things they know; but, in general, one might expect them to carry in their minds some sort of ethnic map of the States, what distinctive cultural groups maintain their identity, and how, and where they live, and how they relate to each other and to the official culture in terms of which cultural literacy is defined. Anyone interested in dance will certainly be vividly aware of the strength and variety of ethnic dance that exists in the nation. However, ethnic dance being by definition divisive, one could argue that knowledge of ethnic dance traditions in America is part of general culture rather than integrated with dance as a mainstream practice or an official art.

Our present concern is chiefly with dance that is conceived, performed, and presented as art, rather than as a recreation or an affirmation of personal or cultural identity. What contextual attitude or information does that require? First and foremost, a general understanding of what it is to con-

ceive and perform and appreciate something *as art* rather than as anything else. Second, an understanding of what specifically it means to do and view something as art in the relevant times of the producers and of the present day. Third, an understanding of what "dance as art" is taken to be at those relevant times. And fourth, an understanding of what constraints and suppositions dominate the specific kind of dance one is concerned with.

The essential context of dance-as-art, then, is that of the art world, and immediately the concept of a work of art. The dominant idea is that a dance of the sort in question is to be *looked at* as an object for appreciation—and, more specifically, to be looked at in the way one looks at and listens to a dramatic performance or listens to a piece of music being played. That is different from the sympathetic or satiric interest with which one watches one's fellow dancers while one takes a breather in a social dance; from the sort of lateral appreciation of oneself and one's fellows in a dance in which all are joined; from the self-immersion in a ceremony in which one participates and in which dance is a component. It is very complicated, involving measures of absorption and of critical distancing, of attention and self-loss, in ways that are familiar and controversial at the same time—it is being subject to just those controversies that is most characteristic of our transactions with works of art as such.

The isolation and clarification of the concept of a work of art as such is, notoriously, the work of the dominant intelligentsia of the seventeenth and eighteenth centuries and is part of the self-definition of the modern era in our civilization, in which the ideas of "science" and "history" and "nature" and "philosophy" as well as that of "art" took on the forms and interrelations that they have today. In regarding something "as art," then, we are (however nonchalantly) adopting some form of a culturally specific and historically developed stance. I suppose it is this stance that children are being indoctrinated into when their schools march them into art museums and subject them to lectures by earnest guides—a procedure much wondered at by the onlookers.

In the development of European theater dance, the crucial transition is that from the court ballets in which royalty and nobility joined, marshalled by a professional ballet-master and joined by professional dancers, in a palace to which a loyal and admiring populace were admitted for the occasion, to a dance expertly performed in a theater *by* professionals *for* a public some of whom might be connoisseurs but who would not normally consider such dancing as within their social scope even if it had been within their capacity. And it is part of the understanding that some of the audience would indeed be connoisseurs, interested in and able to appreciate fine points of technique, but many would certainly not be connoisseurs.

An essential part of the mindset with which art is to be approached, especially the performance arts in which the artists themselves are the

medium of display, is that the performers are not being ridiculous when they behave ridiculously. Actors, singers, and dancers make movements and sounds that no one would make "in real life," and, although it is essential to the art that this should be so, it is of course essential that the audience should not regard the performers as people who in real life are doing things that no one would do in real life. The dying tubercular heroine in an opera is not playing the part of a woman who is singing on her deathbed. Plato in his *Republic* assumes that most people who see plays will, at some level, succumb to this mistake, and Tolstoy in his *What Is Art?* pretended to do so. To appreciate ballet, clearly, we have to disengage our everyday expectations about how people manage their bodies. We all learn to do this—in fact, before we set foot in the theater we know we will have to do it and are willing to do so—but for some reason the learning is fragile, as is shown by the abundance and popularity of dances in which balletic movements are satirized.

The first contextual requirement, then, is that we should be aware that there is such a thing as an "art" stance, that we should be prepared to adopt it and know when to do so, and that we should be able actually to adopt an appropriate form of it.

Readiness for and understanding of the art stance amounts to a "thin" idea of art. But there is more to art than that. To deal appropriately with works of art, a more substantial idea of what art is about would be appropriate—one equally general in its application to anything that we would normally allow to be an artwork or an art performance.

Contemporary introductions to aesthetics generally agree in effect that a threefold schema can be applied to any artwork. One can look for properties and significances of three sorts: formal or material, mimetic or referential, and expressive—that is, signifying some sort of subjective attitude. Would-be appreciators of a work of art may miss its point if they are not alert for and attentive to significances of all three kinds. It is often argued that works of art have a further and deeper significance, their relation to the various ways human beings exist in the world, which are said to be not really reducible to any or all of the basic three "dimensions," but sensitivity to that aspect can hardly be said to be part of what all lovers and connoisseurs of art bring to their appreciation, and it would be stretching the concept of cultural literacy to include it. One can, however, say that it is essential to the appreciation of art that one bring to it some sense of art making as serious work, as opposed to self-expression or amusement or self-advertisement. The seriousness of art as an activity is certainly an essential part of our understanding of what art is. Other demands are made. One needs to be aware at some level and in some fashion of the relation of artworks to the social organizations in which they are produced and enjoyed: not that one must have any particular view on this matter, but that

one must be aware that it is a matter on which views may importantly be held. And one must be aware, in some fashion and at some level, of the expectations that govern the relation of artworks to the traditions of production: the demand for originality, the prevalence of genres and influences. This whole mass of relationships is largely constitutive of what art as art is and holds equally of all arts. One can indeed deny that some of these considerations are truly relevant or important; but one cannot reasonably deny that they are all part of what is deemed central to art by some of those who speak with most authority.

Within dance itself, as a theater art in America, what is most useful as background—apart from simple immersion in the dance world? I suppose the first thing one needs to know is the ideological and social difference between ballet and modern dance, since the latter began in ideological opposition to the former. Modern dance has presented itself as stemming from American democracy and female emancipation, artistic integrity, and opposition to established authority; it defined as its enemy ballet, the product of European decadence, the child of first French and then Tsarist autocracy, the crippler of women.

Then, of course, one has to acquaint oneself with the artistic self-image of ballet, classical tradition, and austere discipline, the only enduring heritage of dance art that has detached itself from personal quirks and established itself as a pure artistic method of dance in our civilization.

Having got these basic ideologies straight, one has to get some idea of the state of "peaceful coexistence" and mutual influence that constitutes the situation today.

Historians of the music-going public in nineteenth-century Europe have diagnosed a split between a hedonistic upper class, comprising the aristocracy and the business world, which went in for opera and for virtuoso soloists, and a relatively austere upper class, comprising the bureaucratic and professional circles, which favored chamber music and other music that defined itself as "serious." If that is true, it seems clear that the ideological split between ballet and modern dance corresponds to a form of the same division: ballet belongs with opera and opulent first nights, modern dance goes with uncomfortable seats and self-conscious virtue.

Now we face a problem. Given the plausible division between the two principal modes of art dance in America, and its apparent social implications, is this something culturally literate people ought to know? Or, if it is not true, that they ought to believe? Ought they even to think about that sort of thing, or would they do better to avert their gaze from it, on the principle that there are some things one does better not to ask? Or should one, on the contrary, deliberately conform to it, cultivating a taste for the kind of dance that corresponds to the social group one wishes to be aligned with?

Hirsch writes rather as if no such problem could arise, at the level that interests him, because such divisions would occur only within a basic consensus. But since, as we have seen, he thinks of that consensus as one that altogether excludes art dance (except for "ballet" and "ballerina," for the little princesses), he is no help here.

However these things may be, one cannot make much of the art of dance in America without at least knowing that ballet and modern dance are different. But to equip oneself for general spectatorship one needs to have some sort of supplementary schema, because "modern dance" as I have presented it does not cover much of what one is likely to see. I am not sure what the best schema would be. Perhaps one might contrast modern dance with "contemporary" dance, a kind of dance (associated with Merce Cunningham) that accepts the ideals of modern dance but rejects its constraints and admits into its practice all kinds of movement; and one might add "postmodern" dance, an eclectic stage practice in which dance as such is interwoven with bits of film or theatrical business or anything else that comes along, essentially a generic "theater" art with a dance core; and "experimental" dance, in which the audience appears to be challenged to guess how what is going on could possibly be called dance. That sounds like a reactionary way to look at experiment, but one does need to make provision in one's scheme of expectations for performances that deliberately occupy the borderline between what is accepted and what is not accepted as dance. Such performances have to be approached with different expectations from those that are appropriate to what I have called "postmodern" and "contemporary."

Whatever one's schema, it might well come furnished with ideas, in relation to each category, about what to look for, what to congratulate yourself on, and whom to associate with. I will reveal my philistinism in the following sketch.

1. Ballet. Look for technique. Pride self on connoisseurship. Associate with aristocracy or reasonable facsimile.
2. Modern. Look for expression of inner self. Pride self on dedication to art. Associate with professional bourgeoisie.
3. Contemporary. Look for artistry concealing itself. Pride self on being with it. Associate with the art world.
4. Postmodern. Look for joky allusions. Pride self on not priding self. Associate with the up-and-coming.
5. Experimental. Look for anything, including nothing. Pride self on being ahead of the rush. Associate with the studio world.

One can, obviously, simply buy a ticket to a dance performance and then sit back and enjoy the aesthetic experience, whatever it may be. But one could argue that there really is not much point in doing so; the pleasure is unlikely to repay the expenditure. There is little point in seeing a ballet, for

instance, unless one grasps two things: the extreme nature of the demands placed upon the body, both in terms of the initial preparation and deformation and in terms of the continually rigorous regime; and the prevailing belief that the body is thus *ennobled* by grace and strength. The reason why this double ideology is essential is that it is unlikely to be evident, since the effect of the training is to make itself invisible, and to look at what is going on as a merely pretty flouncing around can result only in facile wonder or boredom. The preparedness for a rigorous intensity and a willingness to accept that as spiritually justified are what one has to bring with one. In a way, as I insisted above, that is part of the presumption of intense seriousness that is required by the idea of art as such; but it is something more, a devotion to the refinement and exaltation of human corporeality.

But is it necessary to accept such ideologies, with their counterparts in other dance forms? Does not cultural literacy require precisely that one not be an acquiescent victim of any such doctrine? Perhaps one should say that to appreciate an art form one must grasp and internalize its ideologies in this way, but also one must distance them and hold them in relation to each other and to more neutrally sociological views. The balletomane, who as a dance lover is wholly occupied by the ideology and lore of ballet, is certainly not a paradigm of cultural literacy. But literacy does not preclude devotion and partisanship. It requires only that one be sufficiently aware of alternatives to be able to take up a position with regard to them.

Art dance is sometimes accessible through studio performances that are in effect open only to the initiate and attendance at which represents a claim to informed good will, but for the most part it is a theater art presented at public concerts. And the presupposition of any such concert is that it is open to the public—to any well-behaved person who buys a ticket. It follows that the audience at any such concert constitutes a hierarchy, and artists and managements as well as audiences know this and allow for it—such knowledge is an essential ingredient in cultural literacy. An audience includes novices, chance comers, regulars of all degrees and varieties of knowledgeability, veterans, critics and connoisseurs, devotees, fanatics. Most of the audience are aware of this and have a fair idea of whereabouts in the hierarchy they stand. How could it be otherwise? Surely we all know that in all walks of life, political, social, familial, professional, and avocational, we have to work our way into contexts of action and understanding by familiarization, observation, and questioning. Arts organizations, like other organizations, sometimes provide informational support systems—programs, booklets, lectures, and so on—to facilitate the process, but not always. A school system clearly cannot duplicate these efforts in all fields. What can and should they do, beyond offering orientation in the use of such hierarchical appreciation systems generally?

People generally get to know what they feel they need to know, and

schools usually assume that students know their own culture—that is, the culture they already recognize as their own. They will grow up into it and become literate in it. Children in a multicultural society grow up into enclaves within the wider society, as they always have. The school's responsibility can only be to provide perspective. As Hirsch points out, what the schools in such a society can do is to teach a second cultural language, a language that must exist if the society is to function: the language, with its vocabulary and syntax, its data and schemata, in terms of which cultural and social mobility are possible. And such teaching must include the system of expectations that the media promote. Such teaching must be alienating, because what it exists to provide is the possibility of change. It provokes hostility if it presents its offerings, not as a second cultural language, but as what should have been the students' first cultural language from the start. One of the few advantages of the school system I grew up in, which wasted my youth in teaching me the dead languages of Greek and Latin and the vanished lifestyles of those who spoke them, is that no one could possibly suppose that what one was being indoctrinated into was the first cultural language of any extant social group.

The schools, I take it, have a double task. One task is that of imparting and endorsing the official culture, the imperial culture. The other task is that of promoting a perspectival vision in which the imperial culture and all the provincial cultures are seen in some vital relation to each other. A superficial reading of Hirsch's study suggests that he thinks that the second task has been pursued to the neglect of the first, so that what results is a false perspective or no perspective at all. What I have said about the absence of dance from the imperial vision, and about what cultural literacy about dance might imply, will have suggested that a lifetime in the ivory bastille has left me with misgivings. Let us have the three R's, but let them not be rigidity, wrongheadedness, and arrhythmia.

# Jan Gossaert's *St. Luke Painting the Virgin*: A Renaissance Artist's Cultural Literacy

CLIFTON OLDS

Sometime between 1520 and 1530, the Netherlandish artist Jan Gossaert produced an unusual version of a not-unusual subject: Saint Luke painting (in this case drawing) the Virgin.[1] The painting, now in the Kunsthistorisches Museum in Vienna, shows the Evangelist kneeling at a prayer desk that now serves as an easel, his right hand guided by a solicitous angel as he works on a silver-point drawing of Mary and the Christ Child. The fact that Luke has removed his shoes indicates that he occupies sacred ground, although we are hard pressed to identify it. The setting is a peculiar and rather cramped hall or court, its architectural details reflecting Gossaert's familiarity with current trends in Italian Renaissance design, but providing us with little information about the nature or function of the interior. In an arcaded niche directly behind the kneeling Evangelist, a circular and colonnaded pedestal supports a sculpture of Moses holding the tablets of the law. The subjects of Luke's drawing—the Virgin and her Child—hover in a brilliant cloud suspended above the floor and are attended by five putti, two of whom prepare to place a crown upon the head of Mary. As impressive as is the setting, the scene is remarkably intimate, the modest and deferential artist laboring to record an apparition that floats just before his eyes.

Although St. Luke's activity as an artist is not recorded in canonic literature, his painting of the Virgin was mentioned in Greek texts as early as the sixth century and in the Latin West by the twelfth century.[2] It was popularly believed that this portrait was extant (scores of Byzantine or Eastern European icons have been identified as the work of Luke) and that the type of Madonna commonly known as the *hodegetria* was based on this illustrious prototype. Thus credited with being the first Christian artist, Luke became the patron saint of painters—painters who saw to it that images of

*Clifton Olds* is Edith Cleaves Barry Professor of Art History at Bowdoin College. Among his recent work are *Winter*, coauthored with Donald Hall. He has written a number of articles on art history and is a past contributor to this journal.

St. Luke painting the Virgin adorned their guild halls as evidence of the legitimacy of their art.[3]

It was a legitimacy that often had been called into question, particularly in the early years of the religion. As heirs to Judaic tradition, many early Christians believed that the commandments of the Old Testament God were as binding upon them as upon the followers of Judaism, and one of those commandments—the first or the second depending upon one's reading of the decalogue—forbade the making of images ("You shall not make for yourself a graven image, or any likeness of anything that is in heaven above, or that is in the earth beneath, or that is in the water under the earth . . ." *Exodus* 20:4). Allegiance to this prohibition may explain why few if any Christian images can be dated before the third century A.D., and even after such images began to appear around the shores of the Mediterranean, opposition to their creation continued. It reached a climax in the Iconoclastic Controversy of the Eastern Church, a fundamentalist movement that insisted not only upon a literal interpretation of the Mosaic prohibition, but also upon the destruction of images already created.[4] The Latin Church experienced nothing like this officially sanctioned iconoclasm, but it has always harbored influential voices ready to condemn—to one degree or another—the creation of art. Among the early fathers of the Church, men like Origen, Tertullian, and Augustine were particularly opposed to imagery, fearing that the mere creation of an image led directly to idolatry. Tertullian put it in the most succinct terms when he stated: "Both the making and the worship of an idol are forbidden by God. Insofar as the making of a thing precedes its worship, so far, if the worship is unlawful, the prohibition of its making logically precedes the prohibition of its worship."[5]

Rebuttals to this charge were numerous, and they usually focused upon one or more of three tenets: (1) that Judaic Law is not necessarily binding upon Christians, (2) that idolatry is synonymous only with the *worship* of images, not with their creation, and (3) that imagery is of practical value in communicating with those unable to read. More than one early Church father emphasized the didactic efficacy of imagery, but Gregory the Great put the defense into its most memorable and widely quoted form when he held that "to adore images is one thing; to teach with their help what should be adored is another. What Scripture is to the educated, images are to the ignorant, who see through them what they must accept; they read in them what they cannot read in books."[6]

This argument was to be repeated by churchmen as illustrious as St. Bede and St. Bonaventure and to be given scholastic dignity by St. Thomas Aquinas. Faithful to his Neoplatonic antecedents, Aquinas argued that our knowledge of universals is based upon our observation of concrete par-

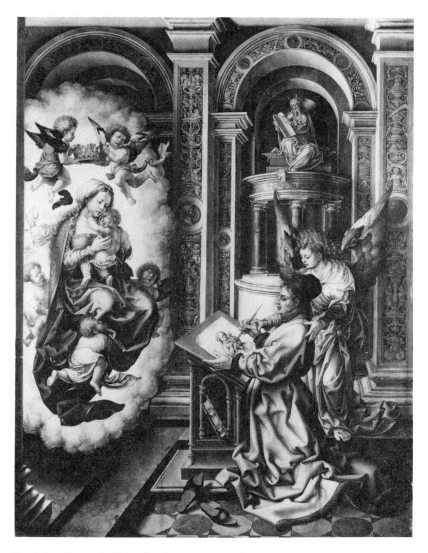

Fig. 1 Jan Gossaert (Netherlandish, c. 1478-1532), *St. Luke Painting the Virgin* (betw. 1520 and 1530). Oil on panel, 43 1/8 x 32 1/4 inches (24 x 30 cm.). Vienna, Kunsthistorisches Museum. Reproduced with permission.

ticulars and that through the perception of physical things and the images of things we may come to understand superior levels of truth: "It is natural that we attain the intelligible through the sensible because all our knowledge derives from our senses."[7]

Considering the long history of this controversy and its potential threat to the livelihood of those who produce images, it is understandable that theologians and artists alike should call attention to Luke's creative activity. If this contemporary of Christ, this close friend of Paul, this divinely inspired writer of the Gospel, should find it permissible to paint a picture of the Virgin, then certainly such an activity was sanctioned by God. As Aquinas put it: "The Apostles, inspired by the Holy Spirit, gave to the Church those teachings which they did not record in words . . . wherefore St. Luke is said to have painted the likeness of Christ which is in Rome."[8]

A painting of St. Luke at his easel thus became the aesthetic counterpart of Gregory's *apologia*, a visual rebuttal to the argument that such an act leads directly to idolatry. Displayed prominently in the Guild Halls of St. Luke, pictures like that of Gossaert essentially justified their own existence. But the attack on imagery was to be mounted again in the sixteenth century, and this is the context in which Gossaert's Vienna painting takes on additional significance.

In 1522, Andreas Bodenstein von Karlstadt, one of Luther's most militant followers, published his *Von Abtuhung der Bylder*, an ardent attack on religious imagery, setting in motion a wave of iconoclastic sentiment that eventually would result in the actual destruction of art.[9] Simply stated, Karlstadt believed that the law of Moses was normative for the Christian world and that the second commandment meant exactly what it said. Although Luther did not share Karlstadt's views, other reformers did: Ulrich Zwingli began his attack on images in 1523, and his sermons led to the official suppression of religious art in Zurich in 1524.[10] An outbreak of iconoclasm also struck Strasbourg in that same year. These were isolated instances—it would not be until the last third of the century that northern Europe would experience the wholesale destruction of its religious art—but artists active in the 1520s must have been worried by this resurgent iconoclasm. Albrecht Dürer, in the dedication to his *Unterweisung der Messung*, published in 1525, notes that at that moment the art of painting was under attack and "is said to serve idolatry."[11] He then goes on to defend religious art in terms not unlike those employed almost a millennium earlier by Gregory the Great.

Although the specific date of Gossaert's *St. Luke* is impossible to determine, its style suggests that he produced it sometime in the 1520s, or in other words in the decade in which religious art was coming under attack from reformers whose writings must have been known in the Netherlands (Karlstadt's treatise was available in printed copies by the end of 1522).

Gossaert was at that time employed by the house of Burgundy, until 1524 by Philip of Burgundy and thereafter by Philip's nephew Adolph. As staunch Catholics (Philip had been named Bishop of Utrecht in 1517), Gossaert's Burgundian patrons must have been concerned by events occurring in Germany and Switzerland, and it would be surprising if Gossaert did not share their concern. Although his painting of the Evangelist was undoubtedly produced for a Guild of St. Luke and not for his noble employers, it must certainly be considered the work of an artist working in a Catholic world and familiar with the traditional defense of religious imagery. It is in that light that one must consider the iconographic peculiarities of the work.

Some years earlier, probably between 1512 and 1515, Gossaert had painted the same subject on a panel now in the National Gallery of Prague.[12] Although this earlier version was innovative in its use of Italianate architecture and pagan sculpture, Gossaert's interpretation of the Evangelist and the Madonna followed a tradition that harks back to Rogier van der Weyden's famous St. Luke in Boston, where Mary assumes the earth-bound posture of the Madonna of Humility and where Luke labors unassisted to record her image. Aside from the question of whether Luke could actually have seen and painted Mary and her Child, these earlier works present us with a straightforward image of an artist and his model. In the Vienna version, however, the event is clearly more miraculous than mundane. The Madonna is a vision, not a living presence, which explains why Luke's eyes are upon his drawing and not upon the apparition: he sees her inwardly. And his effort is directed by a higher power, an angel who actually guides his hand.

It is difficult not to see these departures from the traditional rendering of the scene as specific responses to the growing threat of iconoclasm. Against the charge that the creation of a work of art is both idolatrous and arrogant (arrogant in the sense that the artist is challenging the autonomy of the Creator) artists of the Renaissance held that their talent was a divine gift and that their efforts were in the service of God, not in competition with Him. Leonardo da Vinci, although not a religious man in the orthodox sense, saw the art of painting as "the grandchild of nature and related to God."[13] As early as 1512, Dürer, as if anticipating the acts of the Protestant iconoclasts, wrote that "those who suppress the arts extinguish noble genius . . . it is a great misdeed to destroy great and masterly works which were invented with much trouble, work, and time given by the Grace of God."[14] That the Grace of God is active in Gossaert's Vienna painting can hardly be denied, since the Evangelist has been granted a vision of Mary as well as divine assistance in recording that vision. In short, the act of painting becomes not only a devotional exercise, but a genuine revelation.

As if the miraculous elements in the Vienna painting were not enough to

prove God's sanction of the artist's role, Gossaert has also included a detail that speaks directly to the question of whether Mosaic law forbids all imagery. The sculptured figure of Moses holding the tablets of the law might seem an almost perverse addition to a painting that defies the Judaic ban on image making, but a close examination of the figure reveals that Moses is pointing to that area of the tablets where one finds the first commandment, and it is on the definition of that commandment that the arguments for or against imagery are often centered. From the earliest years of Christianity, there have existed two interpretations of the structure of the Decalogue. One (often called the Philonic) assumes that the first commandment insists only on loyalty to one God, the prohibition against image making thus constituting the second commandment. A second interpretation (the so-called Augustinian) maintains that the verse beginning with "You shall not make for yourself a graven image" actually belongs with the first commandment and that the second simply warns against taking the name of the Lord in vain (this division requires a splitting of the verse on covetousness in order to maintain the number ten). While arguments about these divisions may seem overly subtle, the question of whether the prohibition against image making was important enough to deserve its own commandment was crucial to any debate on the subject. Those who considered the ban on imagery to be simply part of the general warning against polytheism could maintain that the Lord was selective in his prohibition, that only those images that were intended as objects of worship were forbidden. Those who granted the ban on images separate status as the second commandment thereby made it absolute.

As one might expect, the Roman Church held with the Augustinian view, as did Luther, who in contrast to Karlstadt did not oppose religious art. Calvin, on the other hand, favored the Philonic version, which gives the ban on imagery special status. The degree to which this doctrinal division was being discussed in Gossaert's day is difficult to determine, but it seems very likely that the Moses of the Vienna panel points to the first commandment in order to remind us that there, and *only* there, does one find God's admonition about image making, and that in that context He refers only to the images of false gods.

Gossaert's painting thus becomes a powerful defense of the artist, whose gifts are obviously God-given, whose hand is guided by an agent of the Lord, whose vision is truly visionary, whose profession can boast of a saintly Evangelist, and whose obedience to Mosaic law does not preclude the creation of works of art. As a response to those who preached the abolition of religious imagery, it makes an argument that would echo throughout the years of the Counter-Reformation.

There is, of course, a built-in danger in using the term "cultural literacy" to describe Gossaert's understanding of the religious and social issues of his

day, since "literacy" implies knowledge expressed in words. In that sense, all iconographic interpretations of works of art are, to one degree or another, speculative, since the verbal translation of nonverbal messages is inescapably flawed. If we broaden the definition of literacy to include an intuitive comprehension of cultural patterns and pressures, however, we enlarge the horizons of interpretation and at the same time do justice to the complexity of the creative process. If we can say nothing else than that Gossaert's *St. Luke* "fits" the intellectual pattern of early sixteenth-century thought, we have at least enriched our understanding of the painting and the pattern as a whole.

## NOTES

1. The painting is on panel, and measures 43 1/8 x 32 1/4 inches. Jan Gossaert, who also called himself Mabuse, was born in Maubeuge around the year 1478. He is recorded as a member of the Antwerp Guild of St. Luke in 1503. While in the employ of Philip of Burgundy, he worked in Middelburg and Utrecht and accompanied Philip on a trip to Rome in 1508. After Philip's death in 1524, Gossaert worked for a number of other noble patrons, including Adolph of Burgundy and the King of Denmark. He died in 1532. The best survey of his life and work is still Max Friedländer's *Die altniederländische Malerei* (Berlin and Leiden: 1924-37), English trans. H. Norden (New York: Frederick A. Praeger, 1967-76), vol. 8.

2. For a review of the literature, see D. Klein, *St. Lukas als Maler der Maria, Ikonographie der Lukas-Madonna* (Berlin: 1933).

3. The subject appeared in Byzantine manuscripts as early as the eleventh century and in Western art as early as the fourteenth. See R. Goffen, "Icon and Vision: Giovanni Bellini's Half-Length Madonnas," *Art Bulletin* 57, no. 4 (1975): 487-518, esp. 505-9.

4. The Iconoclastic Controversy lasted from 726 until 843, although brief periods of tolerance interrupted the prohibition and destruction of images.

5. *Quinti Septimi Florentis Tertulliani de Idolatria*, chap. 3, trans. Caecilia Davis-Weyer in C. Davis-Weyer, *Early Medieval Art*, Sources and Documents in the History of Art Series (Englewood Cliffs, N.J.: Prentice-Hall, 1971).

6. Davis-Weyer, *Early Medieval Art*, p. 48.

7. Thomas Acquinas, *Summa Theologica*, I, q. 1, art. 9. For medieval attacks upon, and defenses of, imagery, see J. Philips, *The Reformation of Images: Destruction of Art in England, 1535-1660* (Berkeley: University of California Press, 1973), chap. 1; J. Gutmann, ed., *The Image and the World: Confrontations in Judaism, Christianity and Islam* (Missoula, Mont.: Scholars Press for the American Academy of Religion, 1977).

8. *Summa Theologica*, III, q. 25, art. 3.

9. See R. Sider, *Andreas Bodenstein von Karlstadt, The Development of his Thought, 1517-1525*, Studies in Medieval and Reformation Thought, vol. 11 (Leiden: E. J. Brill, 1974). Iconoclastic sentiments mark a number of protoreformation movements, including the Wyclifite and Hussite heresies, but these had little effect on the arts. In spite of the many verbal attacks on imagery found in medieval literature, outright destruction of Western religious art before the sixteenth century was at worst only sporadic and local.

10. The best survey of the fate of art in the German Reformation is C. Christensen, *Art and the Reformation in Germany*, Studies in the Reformation, vol. 2 (Athens, Ohio: Ohio University Press, 1979). See also the early sections of D. Freedberg,

*Iconoclasm and Painting in the Revolt of the Netherlands, 1566-1609* (New York: Garland Press, 1988).

11. See Christensen, *Art and the Reformation*, p. 203, for Dürer's response to the threat of iconoclasm and the meaning of his *Four Apostles* in Munich.

12. See E. de Johngh, "Speculaties over Jan Gossaerts Lukas-Madonna in Prag," *Bulletin Boymans-van Beuningen Museum*, Rotterdam, 19 (1968): 43-46. Although this painting poses its own iconographic problems, they are not relevant to this interpretation of the Vienna picture.

13. J. Richter, ed., *The Notebooks of Leonardo da Vince* (New York: Dover Publications, 1970), I, 327.

14. H. Rupprich, *Dürers Schriftlicher Nachlass* (Berlin: Deutscher Verein für Kunstwissenschaft, 1956-69), II (1966), 112-13.

# Context, Criticism, and Art Education: Putting Meaning into the Life of Sisyphus

MARCIA MUELDER EATON

According to E. D. Hirsch, Jr., in his very influential and proportionately controversial book *Cultural Literacy: What Every American Needs to Know*, a certain level of "background information" is required before anyone can even minimally participate in communication and transactions that take place within a culture.[1] Thus, to the extent that an American culture exists, every American who wants to engage effectively in his or her society "needs to know" certain things. Hirsch provides a list of these things in this volume and, with Joseph F. Kett and James Trefil, provides thumbnail sketches for each item in a subsequent volume, *The Dictionary of Cultural Literacy*.[2]

Hirsch represents a growing body of educators and theorists who believe that institutions and practices, and their products, cannot be properly studied in isolation but must be viewed contextually. One movement in art education, Discipline-based Art Education, also exemplifies this general attitude. Claiming that adequate art education goes beyond simply teaching people how to produce objects, DBAE adherents urge inclusion of aesthetics, history, and criticism in art curricula. There are things one "needs to know" in order to appreciate artistic objects and activities, they believe.

Because historical, aesthetic, and critical activity does play a large part in most adult experiences of art, I am inclined to agree with theorists who argue that these disciplines have much to contribute to elementary and secondary art education. I have recently developed theories of art and the aesthetic that I believe have important implications for art education. In this article I will describe my own aesthetic views and show how historical context and criticism are crucial for an understanding of aesthetic objects and experiences. Finally, I will suggest ways in which my theories figure in *education* generally, where 'education' is to be understood as that which

*Marcia Muelder Eaton*, Professor in the Department of Philosophy of the University of Minnesota, is the author of *Basic Issues in Aesthetics, Aesthetics and The Good Life*, and *Art, and Nonart: Reflections on an Orange Crate and a Moose Call*. She has also published several articles in aesthetics and philosophy of art.

provides for a meaningful life. Along the way, I shall have something to say about the role of programs like that proposed by Hirsch.

Understanding my definition of 'art' is, I believe, easiest if I say a bit about how I came to it. In 1971-72 I spent a sabbatical year teaching at the University of Copenhagen. Early in my stay I learned that an exhibit at the Louisiana Museum had created such an uproar that it was removed before it was scheduled to close. Some "artists" (at least that's what they called themselves) slaughtered and cut up a horse, put the pieces in jars, and displayed them in the museum. This dramatic incident and the public interest it aroused convinced me that the question "What is art?" is the most important issue in contemporary aesthetics—especially if this discipline is to contribute practically as well as theoretically to society. That is, answering the question is important not just for academic reasons but because it says things about what our culture values. It has serious implications for public policy—about, for instance, the sorts of activities public funds should be used to support (and I include here questions about educational policy).

I began my own search for the answer to "What is art?" with the assumption that not all artifacts are art—that not everything that is created by a human being is an artwork.[3] I was also drawn to contemporary institutional theories of art.[4] These theories maintain that an object by itself is not an artwork, but that established institutions are required to give artistic status to an artifact. A person cannot be a knight without being dubbed one by someone in authority who performs certain actions within an appropriate context. Nor can someone become a wife or president or out at home plate without institutional sanction. Similarly, art is what a complex set of institutions called the "artworld" (including museums, concert orchestras, publishers, commissions, schools, etc.) says is art. Just as not just anyone can turn me from an unmarried to a married woman, not just anyone according to institutionalists can make an artifact art. But who has the authority—and what conditions are required to create the authority and to make the institutional "dubbing" successful? These questions were not, I thought, satisfactorily answered by existing institutional theories. (They are, incidentally, questions that can be intelligently discussed by secondary students who usually know a great deal about at least one art world, viz. the music industry. Several of the questions raised in this article can be topics of classroom discussion. One does not have to have all the answers to talk about the issues.)

What is right about institutional theories, I thought, is the claim that in order to become *art*, artifacts must be treated in special ways. But it is not enough to dub or point to something and say, "That's art." More is required. What, I asked myself, do people *do* when they think something is (or is about to be) an artwork? One obvious answer is, "They *talk* about it." One special treatment of artifacts is recurring, repeated, nearly endless *dis-*

*cussion*, particularly when the object identified as art is also described as "great." Indeed works are presented or displayed in ways that invite and permit discussion.

So my strategy was to look at these discussions (all kinds—articles in professional academic journals, newspaper reviews, program notes, letters to the editor, travel guides, etc.) to try to see if there was anything special about them. If there were, an answer to "What is art?" should be forthcoming. That is, one could articulate a definition by filling in the blank in:

X is an artwork if and only if in discussions of x we find _____.

The blank, of course, would have to be filled in with something unique. That is, artworks could be distinguished from nonartworks only if discussions of art included mention of things that were *never* included in discussions of nonartworks and if discussions of artworks *always* mentioned that thing. Only in this way would the definition present necessary and sufficient conditions for something's being an artwork.

So I spent a year looking at discussions of things people had identified as works of art—and learned that there is no way of filling in the blank that yields a way of distinguishing artistic artifacts from all the others. There are several recurring topics; reference to subject matter, the life of the maker, formal properties, creative intentions, and historical context are the most common. Writers report that a sculpture says something about motion, that the maker wanted to be a pilot, that the lines curve gracefully upward, that the work was commissioned by an aircraft manufacturer, or that the sculpture was produced just after the first flight of the Concorde. (Below I include these various topics under the term 'information about the history of production'.) But none of these taken separately or even taken together constitutes a set of necessary and sufficient conditions. Freeways and shopping malls as well as paintings and symphonies can be (and are) discussed in terms of form, content, and context.

But it occurred to me that if there was no unique answer to the question "What do people talk about when they discuss works of art?" there *is* a unique answer to the question "Why do they talk about certain things when they discuss works of art?" It is not the *content* but the *goal* of discussion that makes the important difference. When artifacts are discussed as works of art, the goal is to bring the viewer or listener to perceive aesthetic features that might have been missed if the viewer or listener had been left on his or her own.

When told that Frans Hals was bankrupt and forced to paint the directors of almshouses where he lived, we look for signs of this in the faces of his portraits of regents. Told that something was painted at the beginning of Picasso's blue period, we look more closely at the coloration and perhaps

ask ourselves what effect it has. Told a sculpture is composed via repetitions of right angles, we look for them. Told that a set of drawings was produced during a period in which women were idealized, we look at the treatment of the female figure more closely. And so on. (My examples here are from the visual arts but can easily be extended to the other arts.)

These considerations, then, yielded the following definition:

> X is a work of art if and only if x is discussed in such a way that information about the history of production of x brings the audience to attend to features considered worthy of attention in aesthetic traditions.

One of the things that this definition has in its favor is the fact that it does not foreclose the possibility of creativity and change. Different cultures will consider different things worthy of aesthetic attention. In one period color will be most important, in another line. Recognizable representation of natural objects mattered for a long time and then ceased to matter. There are signs that it has begun to matter again. The definition also explains why we keep art objects safe, display them properly, and struggle to preserve them. Only then can one properly attend to them. Artifacts that fail to get discussed properly—thoroughly and attentively—fail to achieve the status of artworks.

As with all definitions of complex objects, this one contains several terms that deserve more lengthy discussion.[5] 'Artifact' and 'history of production' clearly need more attention than I can give them here. For purposes of this discussion, I want to concentrate on the concepts most closely related to the subject of this paper: *aesthetic* and *tradition*. Which features of an artifact are its aesthetic features, and what role does context or tradition play in determining them?

The answer to the first of these questions comes, I think, by asking what happens when one has an aesthetic experience. One delights in properties of something—a property or feature that is located *in* an object, person, or event and that we have come (learned) to value. (Notice that the class of aesthetic objects is broader than the class of artworks. The former includes things like sunsets or human faces or rock formations that are not artifacts and therefore are not works of art.) Thus I define 'aesthetic feature' as follows:

> An aesthetic feature is an intrinsic feature traditionally considered worth attention, i.e., worthy of perception and/or reflection.[6]

These features can be both sensual and abstract. In our culture we delight in things like color that we can perceive directly and in things like subtle depictions of human relationships that require mental reflection. The fact that these may not be directly obvious to us explains why there are discussions of art. Left on our own we may miss the repetition of right angles or

the slave/master relationship between two figures. If one fails to notice such features, there is no way that one can delight in them. Information about context (history of production) often makes perception possible. Unless one knows the parts of an ancient Greek temple, it is unlikely that one will notice all of them and the way they relate to one another. Some knowledge of laws of perspective is required before one can assess the way volumes are organized about a particular vanishing point. The function of soup cans and urinals in contemporary American culture must be understood before the artworks in which these everyday objects function can be fully apprehended.

'Delight' here is not a wholly satisfactory term. It suggests, perhaps, too shallow a view of aesthetic experiences. Not all of these experiences are "delightful" in the sense of being joyful. Indeed sometimes works of art may be depressing—may cause us thoughtfully to reflect upon life's deepest pains and problems. Works may cause sensual pleasure and reflective pain, and vice versa. When we experience pain, however, I believe that there is still something that we value *positively* in the experience—the way the artist has manipulated the medium, for example. Therefore I have chosen a positive term, but the reader should understand that 'delight' is meant deeply.

Many people are initially put off by the heavy role that tradition plays in my theory of art and the aesthetic. In contemporary culture, traditions are often viewed with suspicion—as elitist or restrictive or enslaving. The fact that the history of Western art has to such a great extent been in the hands of economically or politically powerful white males causes many people to want to reject "traditions."

Communication, nonetheless, requires shared traditions. As I intend the term, however, 'tradition' refers to what the philosopher Ludwig Wittgenstein called "forms of life." Forms of life are interests, goals, activities, values, rituals, institutions, etc., that communities share. They develop and are learned and passed on by way of language. I prefer the term 'tradition' to 'form of life' because it connotes something that I think is essential, namely, history and historical context. Values and interests are enmeshed in language which comes to us with a history. This is not to say that traditions are stable or static. As individuals and their environments alter, so does what they do and what matters to them, and this is reflected by changes in language systems. But change does not occur overnight. Meanings must change gradually or communication would be impossible. If what I meant by 'chair' or 'good' or 'beautiful' suddenly shifted totally, no one would understand my utterance "That is a good and beautiful chair." Chairs have indeed changed over the years, and chairs in a culture geographically remote from ours may look and feel quite different. But if we are to communicate the need for a chair, there must be some shared tradition. Similarly, the

meanings of 'good' and 'beautiful' change but remain rooted in forms of life or traditions that are brought to the present from and with a past.

Within a culture—a language group that shares traditions or forms of life—people learn what matters. In some cultures there are no words for snow, in others over twenty. Clearly this is a factor of varying physical environments. People also learn what matters aesthetically—that is, they learn what sorts of things are valued and delighted in. Terms like 'balanced' or 'linearly composed' are not universal; they figure only in language communities with special traditions. When we learn a language, we learn how its speakers interpret, categorize, and respond to their world.

We must not just think of cultures or language communities as gross entities—for example as English speakers or French speakers or Chinese speakers. Within these large communities there are a multitude of subcultures. Individuals belong to many at the same time. You can belong to the community of American speakers of English, and this group has different traditions (reflected in its specific language) from those of English speakers of English. At a microlevel we have subcultures consisting of families or small groups of friends. The special words and phrases used by one's own family indicate our special interests, values, customs, experiences, and pleasures. An outsider will not "get" everything that the insiders say to one another. Families have their own *traditions*, and it is in this sense—not the domineering-white-male-wealthy-politically-powerful sense—that I use the word. There are native American traditions, black traditions, female traditions, rural traditions, etc., as well as those more socially and economically dominant.

Within each tradition, some artifacts will be identified as works of art, namely those that are treated in ways that draw attention to their aesthetic features—the features in things that are (traditionally) considered delightful. Before we can understand which and why some are distinguished as artworks, we must know a great deal about a group's history. To the extent that histories cross—black and female traditions are not completely separate from white or male traditions and vice versa—understanding the history of one group will require understanding the history of others. If we are blind to others' traditions, we run the risk of only dimly comprehending our own.

Having learned something about another tradition since I first articulated my definition of 'work of art' I have revised it. The reader will notice that in the statement of my definition above I said that artifacts must be *discussed* in certain ways. In the last paragraph I used the term *treated*. This change seemed to me to be demanded when I learned that certain native American cultures do not *talk about* their artworks at all; indeed to do so would be to commit a sacrilege. For this group, artworks are sacred and are kept apart and revered—to discuss them would in a sense be to sully them.

They are, however, treated in special ways; otherwise there would be no way to distinguish artistic from nonartistic artifacts—no way to know that one is to perceive and reflect upon intrinsic properties.

Art is at the heart of human forms of life. It reflects and is reflected by historical, social, political, economic, and religious contexts. Thus it cannot be adequately comprehended without consideration of its context. The language used to discuss art (or the rituals constituting an analogous special treatment of art) is historically determined; even as it changes it carries its past with it. This is why history (and here I use the term to indicate attention to context broadly construed—history of production) is so crucial a part of art education. Understanding why an activity is worth pursuing or why an object deserves and repays attention demands a knowledge of an individual's or group's traditions. This can only be obtained from a study of context.

Attention to context is also essential for art criticism, which, I believe, is in turn essential for adequate education in the arts. Here I would like to use three "stories" to introduce my theory of criticism. The first two are personal and suggest the difference between good and bad (or not-so-good) art. The third comes from our culture's traditions and will lead directly to my general view.

1. Most weeks for me, as for us all, are hectic and stressful. By midday Friday I am eager to get home where, whenever possible, I relax in the following way. I pour myself a stiff drink of Scotch and watch "Dallas." Both activities, drinking and watching this TV program, are fairly mindless—exactly the sort of thing that serves well at week's end. The obviously contrived plot and flat characters of "Dallas" dull one's senses in much the way the alcohol does. Both are just what I want.

2. One summer when my son was a camper at the National Music Camp at Interlochen, Michigan, I attended a rehearsal of the high school choir. The practice had been going on for some time, and the young people (juices flowing as they inevitably will at that age) had become a bit fidgety. The director, Melvin Larimer, tapped the stand and said, "People, we are singing Bach, and he deserves your respect and attention." I was impressed with the way that his remark brought the students back to the business at hand. Essentially I think that the difference between good art and bad art lies in this: good art demands and repays sustained attention, no matter what the tradition. Bad art is mindless and dulls the senses; good art is mind-full and stimulates the senses. (Consider the difference between 'anaesthetic' and 'aesthetic'.)

3. The third story is the myth of Sisyphus. Readers will remember that in Greek mythology Sisyphus was doomed to spend eternity repeatedly pushing a heavy boulder up a long, steep hill only to have it roll down again as soon as it and he reached the top. Probably because it provides so poignant

an image of human life (a lot of us feel like Sisyphus nearly every Monday morning), several writers have attempted to answer the question "How might one give meaning to the life of Sisyphus?" If we can answer this, perhaps the rest of us will have a chance for a better life—and be able to enrich the lives of others as well. My own answer to the question is derived from my theories of art, the aesthetic, and criticism.

But first I want to mention two other philosophers who have considered this question. The most famous is probably Albert Camus. Reflecting on the Sisyphus-like character of many human lives led Camus to say, "There is but one truly serious problem, and that is suicide."[7] The absurdity of human life, Camus worried, seems to dictate death. "A man is talking on the telephone behind a glass partition; you cannot hear him, but you see his incomprehensible dumb show: you wonder why he is alive. . . . Likewise the stranger who at certain seconds comes to meet us in a mirror, the familiar and yet alarming brother we encounter in our own photography is also the absurd."[8]

Camus's response, one that I find hard to accept let alone live by, is that Sisyphus' life is meaningful when he heroically accepts his fate—is conscious of the fact that "his rock is his thing,"[9] and hence is superior to the rock and to his fate. "One always finds one's burden again. But Sisyphus teaches the higher fidelity that negates the gods and raises rocks. He too concludes that all is well. The universe henceforth without a master seems to him neither sterile nor futile. Each atom of that stone, each mineral flake of that night-filled mountain, in itself forms a world. The struggle itself toward the heights is enough to fill a man's heart. One must imagine Sisyphus happy."[10]

Well, his way is not enough to fill this woman's heart. Nor has it solved the problem of how to put meaning in Sisyphus' life for some other writers. Richard Taylor suggests two other ways of doing it.[11] First, we might inject something into Sisyphus' veins that makes him feel good. (This, or course, is like drinking Scotch!) If Sisyphus *feels* good, what difference will it make to him what he is doing? If the meaningful life is the happy life and if we have a happy-drug, then all lives can be meaningful. Taylor's second alternative is to give Sisyphus a purpose, to provide his rock-pushing with a goal. Tell him that he is helping to build a temple or a road or increasing his upper body strength.

The injection view provides meaning from the inside, as it were; the goal view provides it from the outside. The trouble with both ways of solving the problem is that neither allows for a way to distinguish between lives. On the internal view, pushing a rock uphill, nursing the sick, playing the violin, raping and pillaging all yield equally meaningful lives as long as the doers have the right injection. On the external view, as long as there is a goal, building temples or muscles, exterminating rats or Jews, again all lives

are equally meaningful.

What we want, in the first place, is a way of making us feel good about our lives. We do not want to be told, for example, "There is meaning to your life even if it makes you miserable." This "grin and bear it" view may prove correct—but it is hard for our culture and generations to accept it. In the second place, we want a way of evaluating, even ranking, lives.[12]

It is beyond the scope of this article—and the author's abilities—to provide an overall answer to questions about *the* meaning of life. I do, however, have a way of putting some meaning into the life of Sisyphus—one that will make him feel good sometimes and one that will allow him and us to identify the richer moments of his (and our) life. We shall provide him with aesthetic experiences.

Combining my definitions of 'art' and 'aesthetic' and my observations about *Dallas* and Interlochen, we can derive the following points:

> 1. In discussions of art, information about context (history of production) draws the viewer's attention to certain intrinsic features of things.
> 2. The features to which attention is thus drawn are considered worthy of attention in some aesthetic tradition(s).
> 3. Aesthetic traditions are those which identify intrinsic features that yield delight upon perception and reflection.
> 4. Objects whose intrinsic features repay sustained perception and reflection are aesthetically valuable.

These points taken together provide a theory of criticism and suggest a way of putting meaning into Sisyphus' life, i.e., yield suggestions for at least one way of thinking about art education. Instead, that is, of injecting him or giving him a goal, we shall invite and teach him to take delight in intrinsic features of his environment considered worthy of perception and reflection. Art education can do at least two things that will make the life of Sisyphus (who obviously here is intended to represent our students) richer. It will invite him to attend to intrinsic features that repay attention and it will help him to identify those features: the view from the mountain, the shapes made as light falls on the rough surface of the rock, the harmonies created by the colors of the trees, path, and sky, the ideas and feelings communicated by the rhythms of stepping and breathing. Thinking of criticism and education as inviting attention and pointing to what is worthy of attention has been described aptly by Susan Bernick who calls criticism a "helping profession."[13] She discusses it by way of analogy to therapy—bringing a client to a point where he or she can adequately and successfully take over.

Both invitation and identification are complex activities that deserve analysis and investigation. Let us begin with a brief discussion of what the activity of inviting entails.

Invitations are issued when one person (A) wants another (B) to share in

an activity that A believes will give delight to B. (A would not *invite* B to be tortured, for example.) This means that A takes on certain responsibilities. Responsible inviters cannot renege on invitations. He or she must consider B—the sort of person B is, what she enjoys, what his capacities are, and so forth. Invitations can be casually or formally extended, can be issued for casual or formal affairs. A responsible inviter will do the things that may be necessary for B to get delight. A will tell B what to bring or wear if that is relevant. A must consider what sort of food, for instance, will give B pleasure. A ten-year old will probably not consider the offer of liver and brussels sprouts much of an "invitation."

But A must do more than consider B's pleasure. A must treat B with *respect*. A must realize that B is capable of enjoying more than just standard or "lowest common denominator" fare. Even a ten-year-old who comes from a hamburger tradition can broaden his or her horizons—can come to enjoy sharing in a taco or pizza or sushi tradition. If B is treated as a cretin or as a glutton whose only goal is to gorge, that is probably what he or she will be. When people are not invited with respect, they do not typically give respect. "Dallas," unlike Bach, does not treat one as capable of very much. It is not surprising that it does not repay sustained perception and reflection.

Responsible inviters will thus consider what B does enjoy and is capable of enjoying. Teachers as inviters have a clear opportunity for doing this. Ten-year-olds are probably not ready to enjoy certain intrinsic features of objects—subtle adult relationships, for instance. That does not mean that they are not capable of attending to others—to the shape of a human hand or a suspenseful battle scene or tensions between friends. They are also quite capable of being introduced to other traditions. They can easily see and delight in the differences between Egyptian and Greek treatment of the human body, for instance. (The popularity of the song and video of The Bangles' "Walk Like an Egyptian" shows how sophisticated teenagers' conception of style can be.) Our invitation to Sisyphus must take account of what he might take pleasure in, where he is, and so forth. But we must not be too quick to say, "He'll be too tired to enjoy anything very subtle or sophisticated." As a human being he is capable of a great deal, and we should at least provide the opportunity for him to enrich his life.

But how can we *decide* just what to point to, what to serve, on the dinner analogy? Here there are at least two things that should be done, I believe. First, we must *provide* Sisyphus with a tradition. Second, we must *introduce* Sisyphus to other traditions that he may benefit from learning about and from.

Since traditions are shared by language communities, providing a tradition amounts to teaching a language, or, when learners already share part of a language, teaching amounts to extending it or making more of the same language accessible. When I was an elementary student in a public

school in a small city in Illinois, most of us shared a tradition—white, middle-class, Christian, western-European heritage. We believed that we had melted together in the same pot. Occasionally there were eruptions, as when a Jewish classmate asked why a man in a picture had a moon around his head. But the assumption was that the main goal was to pass on more of that tradition—more about Western science, art, literature, and so forth. The Jewish child was "assimilated" by being taught that, since the man was Jesus, the moon was a halo. No attempt was made to teach us any details from the Jewish religion or iconography.

The situation has changed radically. More students speak radically different languages; Spanish is the most obvious one in the United States. Moreover, we are increasingly aware of the fact that even sharing a gross language like English is only superficially to speak the same language—to share traditions, that is. Within English-speaking communities there are both extreme and subtle differences between traditions shared by speakers of street and establishment English, white and black English, female and male English. The myth of the melting pot is no longer even an ideal; traditions clash because, with good reasons, people want to preserve their traditions, not be assimilated into someone else's.

This, of course, creates enormously complex problems for teachers. How does one decide what to teach? Having decided to invite Sisyphus to enrich his life, which language or languages should we give him? Which things should we point to in the effort to insert meaning into his life?

Recently there has been a great deal of criticism of schools in the United States for turning out people who are culturally illiterate. The most controversial book, Alan Bloom's *The Closing of the American Mind*, accuses us of becoming a nation which is, in my terminology, traditionless.[14] Another book, this one from a different tradition, suggests the dangers of a society which loses traditions. Nien Cheng, in *Life and Death in Shanghai*, claims that one of the things that contributed to the Cultural Revolution in China was the ignorance of traditions of people educated under Mao.[15] She discusses in particular the total lack of aesthetic sensitivity which marked the Red Guard.

Bloom is a better reporter than problem solver, I think. He does identify a failure in our society of the passing on and making accessible of traditions. He rightly worries that ours is a culture that admires and rewards innovation for its own sake and in which what matters is not the past but what is new. In fact the past is looked upon as threatening, for it "keeps me from being me, from doing my own thing." We no longer have heroes, Bloom asserts, but are urged to just "be yourself." Modeling oneself after another's role is viewed as restrictive and demeaning.

Bloom's way out of the situation, however, is neither very realistic nor appealing. Essentially I think he would like us to be able to return to the

good old days in Illinois. His suggestion is that we simply go back to extending one tradition. E. D. Hirsch, who shares many of Bloom's views, even provides us with a list of things from that tradition that matter most. Broadened to include the *Judeo*-Christian, it is still essentially white, male, western European, middle-class, and middle-aged. Even within this community there are glaring gaps. Physics, but not biology, is represented. There are no sports items on the list. (These gaps are filled in the *Dictionary* that followed Hirsch's first book; even so, while some sports personalities can be found, e.g. Babe Ruth and Jesse Owens, there are still none of the important terms from sports that color many conversations, e.g. 'home run' or 'end run'.) No list can be expected to be complete. America is a pluralist culture, and no one can say what everyone in it needs to know.

Nonetheless, if we are to help Sisyphus, we have to start somewhere, and to his credit, Hirsch has at least made some choices. It is undeniably better, I believe, to do this than to tell Sisyphus to do his own thing. One strategy for deciding what to point to might be to let Sisyphus in on the things people in power hold dear. (This is essentially what Hirsch's list provides.) When people ask me why I talk almost exclusively about male philosophers in my classes, I do not simply explain that the most readily available material was written by men. I also insist that if one wants to know about the most influential philosophers, one must study these men. 'Most influential' is only another term for 'powerful': knowing about these men is one way of getting power.

But one need not stop with finding out what the powerful say or prefer. As we pass on critical abilities (a part of my own tradition that is nonnegotiable), we teach people to take what is good and throw out the rest. One does not have to accept everything that Plato or Kant said as gospel truth. One can choose for oneself to use some or reject it all. The same is true of Milton or Mozart or Monet or Mao or Machiavelli or Marx or Mohammed. Informed choice is only possible when one is informed. As teachers we cannot avoid choosing what we think is best based upon our own traditions. We can also ask other traditions to send us their best and try to make it accessible to ourselves and our students. When students are taught aesthetic and critical principles, they are more apt to make informed choices about what to use and what to reject and to justify their decisions. They may even teach teachers about "mistakes" in the canon!

Learning a tradition is not something that can be done overnight, obviously. A language like English with all its complex and subtle connotations is never fully mastered. And some people argue that we can never step out of our own shoes and see the world through someone else's eyes. Some deconstructionists argue that others are radically Other. We can never comprehend what another person means, they claim, for interpretation is always doomed to be misinterpretation. I think this is false—though I

would agree that we must always be aware that there are limits to how much one can know about another's interests and intentions. Still, we can with work come to know something of the Chinese or African or medieval or Baroque world view. With *work*. This involves discovering things about the contexts in which the products of these places and periods were conceived and created.

The fact that there is so much to learn can be paralyzing. Hirsch argues that before we can start trying to get into other shoes we had better fully understand what it is to be in our own (where "our" is for him, of course, rather narrowly construed). It may be that one must be able to speak a language fairly well before one can learn another, although there are children who seem to learn two languages more or less simultaneously. But could one learn three or four? Learning theory is still in its infancy; it is not clear when courses in cultural pluralism are best introduced. How much does one need to know about art that adheres strictly to laws of perspective before one can understand how Cézanne used and abused those laws? Or how native Americans depicted three-dimensional space? How much must we learn about western European culture before we turn to the East—or to urban Black American street traditions? I do not know the answers to these questions. I do believe, however, that in both extending one's own and in approaching other traditions it makes sense to concentrate on the best.

But what is *best*? Again an answer to this, or at least an answer to what is "aesthetically better," can be found in the four points stated above.

X is better than y if and only if sustained attention to x yields more delight than sustained attention to y.

Choice of what to point out to Sisyphus is based on what we think deserves and repays sustained attention. If I had a chance I would be more likely to give Sisyphus a Vermeer than a Rockwell to look at along his path, Coleman Hawkins rather than Elvis Presley to listen to. Some television, certainly some Scotch, repays sustained attention. There will undoubtedly be times when Sisyphus wants to watch "Dallas" and drink beer, and that's all right. But we must not conclude from the fact that he once asks for these that they are all he will ever enjoy.

There is only one way to decide when or if something is valuable: give it sustained attention and see if that attention (perception and reflection) is rewarded. It is also essential to remember (and this brings us back to the requirement of responsible inviting) that we may be wrong. Not everything that delights us will repay the sustained attention of everyone else. Sisyphus may not like landscapes or color relationships. He may even have some suggestions about things that will enrich *our* lives, things that only someone from his tradition is likely to have noticed and reflected upon sufficiently.

We may need to make choices between traditions as well as between works to point to within traditions. Not all traditions are equally good, equally deserving of attention or respect. For one thing, not all traditions give respect to human beings generally. Some are elitist, limiting, oppressive, or restrictive of creativity; they may simply be boring. If the goal is to provide for a life that repays sustained attention to intrinsic properties, it is also to challenge, liberate, and empower. Art will contribute to a meaningful life when it is viewed not as a frill—an activity at the periphery of a community's forms of life—but as an integral component of it. By insisting that context and criticism be parts of art education, art is given a core position within that community. Information concerning history of production and judgments about what is worthy of attention put artworks where they belong—at the center of human experiences and values.

NOTES

1. E. D. Hirsch, Jr., *Cultural Literacy: What Every American Needs to Know* (Boston: Houghton Mifflin, 1987).
2. E. D. Hirsch, Jr., Joseph F. Kett, and James Trefil, *The Dictionary of Cultural Literacy* (Boston: Houghton Mifflin Company, 1988).
3. Marcia Muelder Eaton, "Art, Artifacts, and Intentions," *American Philosophical Quarterly* (1969): 165-69.
4. See, for example, George Dickie, *Art and the Aesthetic: An Institutional Analysis* (Ithaca, N.Y.: Cornell University Press, 1974).
5. Marcia Muelder Eaton, *Art, and Nonart: Reflections on an Orange Crate and a Moose Call* (Cranbury, N.J.: Associated University Presses, 1983).
6. Marcia Muelder Eaton, *Aesthetics and The Good Life* (Cranbury, N.J.: Associated University Presses, 1989).
7. Albert Camus, *The Myth of Sisyphus and Other Essays*, trans. Justin O'Brien (New York: Alfred Knopf, 1955), p. 5.
8. Ibid., p. 15.
9. Ibid., p. 123.
10. Ibid.
11. Richard Taylor, *Good and Evil: A New Direction* (New York: MacMillan, 1970), pp. 264-68.
12. David Wiggins, "Truth, Invention, and the Meaning of Life," *Proceedings of the British Academy* (1976), pp. 331-78.
13. Susan Bernick, unpublished manuscript.
14. Allan Bloom, *The Closing of the American Mind* (New York: Simon and Schuster, 1987).
15. Nien Cheng, *Life and Death in Shanghai* (London: Grafton Books, 1986).

I am indebted to the following for many of the points made in this paper: Ruth Wood and Richard Jackson, University of Minnesota; Local Arts Leadership Institutes, 1986 and 1987, University of Minnesota; Changing American Values Discussion Group, University of Minnesota; Owen, Laurie, Ciarin, and Caitlin Muelder, Galesburg, Illinois.

# Cultural History and Cultural Materialism

RONALD BERMAN

I've been asked to cover a specific topic for this special issue, the interpretation of Shakespeare from the perspective of cultural history. I'm going to ask certain questions intended for both Shakespeareans and common readers. The first is, *Can interpretation ever be final?* This question matters more to students than one thinks. No one has yet been able to assign an absolute meaning to Shakespeare's text. Interpretation changes naturally enough with time. But this may not be as much of an opportunity as it sounds. Works of art last longer than explanations for them. They last better too. The work can at times be revalued, but the fate of criticism is worse, it goes out of style. The disparity between the fate of art and that of criticism may account for some of the anxiety of intellectual life.

My own sense of the matter is that part of the job of criticism is to reject implausible explanation. As the man said about waiting for the Messiah, it's steady work.

I've taken a first example from the late seventeenth century which discloses how far critics and producers will go in reinterpreting the text. The question is, *What does one do with plays whose original values no longer obtain?* Suppose, like the histories, they take monarchy seriously? Or, like *The Tempest*, one of their prime values is virginity? Do they entertain us like, say, Pharaonic relics which have the power momentarily to impress, but which can communicate nothing of their original imperatives? Emptied of their content, they are filled up with what we provide, Egyptian motifs on wallpaper. But people once died gladly and in great numbers for what we now perceive as themes in a text.

Great efforts have been made to modernize the text, efforts which began in the same century as their original production. Criticism early demanded

*Ronald Berman*, Professor of Literature at the University of California, San Diego, and a former Chairman of the National Endowment for the Humanities, is the author of *A Reader's Guide to Shakespeare's Plays, America in the Sixties, Culture and Politics, Advertising and Social Change,* and *How Television Sees Its Audience.* Professor Berman is a frequent contributor to this journal.

that the text conform to the audience. It became important, as the Enlightenment began, just before 1700, to resolve ambiguities. Elizabethan tragedy was not morally intelligible. It did not have distributive justice for good and for evil. Because of that, it implied a world without design. Poetic justice—distributive justice—was a way of seeking metaphysical order.

Toward the end of the seventeenth century *King Lear* was rewritten with its famous happy ending. There were certain reasons for this, one among them the rise in popularity of sentiment and sensibility—the editor of Nahum Tate's version of *King Lear* says that the playgoer experienced a "sense of benevolence" when he "pitied virtue in distress."[1] But there were other and probably more compelling reasons. Three generations after its first staging the play was thought to be behind modern times. Too many of its events depended on pure accident. Cordelia's death was evidently a matter of bad timing. The issue of it being good metaphysics was no longer in doubt—in the Newtonian world, consequences were foreseeable. The "rules" of literary criticism began to be taken seriously when the "laws" of motion were discerned.

Edmund must have seemed as "motiveless" to Tate as Iago was later to seem to Coleridge. Shakespeare's text instructs us to accept Edmund's resentment, just as it tells us to accept the hidden duality of Goneril and Regan. It does not give us a biography of these things, although some interesting rationalizations are provided by these characters about themselves. Gloucester's eyes are torn out because the capacity to take pleasure from such an act underlies normal appearances: it has nothing to do with Elizabethan justice. We simply discover, as we watch, that beauty and intelligence may love torture.

In Tate's version, Edmund is given a full set of intentions, and his crimes become much less totemic. One of his great motives is simply that he wants to rape Cordelia, to

> . . . enjoy
> This Semele in a storm. 'Twill deaf her cries.
> Like drums in battle, lest her groans should pierce
> My pitying ear, and make the amorous fight less fierce.
> (III.ii.121-124)

But Cordelia, who deserves neither to be raped nor executed, ends by marrying Edgar. Lear retires to a monastery. The play concludes with the lines "Whatever storms of Fortune are decreed/ . . . truth and virtue shall at last succeed." The play was successful, and it dominated the stage for over a century. Samuel Johnson was unwillingly convinced of its philosophical merits, although he felt far more deeply for the original version. As we can see, instruction sometimes supersedes text. It is, as Charles Gildon observed in 1710, the audience that matters: "The King and Cordelia ought by no

means to have dy'd, and therefore Mr. Tate has very justly altered that par-
ticular, which must disgust the reader and audience to have virtue and
piety meet so unjust a reward."[2]

With this in mind I will turn to much more modern examples, and to
other questions. *How does dramatic history imply actual history?* We begin
with the text, let us suppose the plays about Henry V. We would ideally
like to have two sets of information: the first in reference to the early fif-
teenth century which the plays depict; the second in reference to the late
sixteenth century in which the plays are staged. A good job has been done
on setting and sources in a book (*Shakespeare and the Shapes of Time* by David
Kastan) which deals with personal motives and royal prerogative. The critic
sees that at the siege of Harfleur the king is far more ideologically engaged
than he is in the pages of the principal source, Holinshed. Shakespeare has
added something to the source, something which may be a commentary
upon both character and, possibly, politics:

> Shakespeare's procedure here is, to say the least, unusual. He sup-
> presses Holinshed's mention of the plunder of Harfleur, replacing it
> in the play with Henry's order for leniency. Yet equally unmindful of
> his source, Shakespeare places the savage threats in Henry's mouth
> instead of following Holinshed's account of the chivalrous conduct of
> the English before the city. The effects of these manipulations of the
> source seemingly cut in two opposing directions. On the one hand,
> Henry's order to "use mercy" works to confirm his own account that
> he is "no tyrant, but a Christian king" (I.ii.242) but the speech at the
> city's gates suggests precisely the reverse. Both the brutal speech and
> the merciful treatment of Harfleur must be viewed together, however,
> and both may be seen as behaviour consistent with a man supremely
> confident of his moral authority. The terrible threats are not evidence
> that Henry "does not see the horrors of war feelingly," but evidence
> that he does not see the moral complexity of this war at all.[3]

It may be that the late sixteenth century is saying something about the early
fifteenth and in the process making a profoundly political observation.
Within the bounds of probability our understanding of Elizabethan pre-
rogative may shape our understanding of the text. But there are bounds to
probability—because there are infinite ways to interpret a text does not
mean that all of them are right. Without an awful lot of evidence we will
not be able to demonstrate that Henry before Harfleur implies the relation-
ship of the Elizabethan state toward its subjects.

When the author changes a source we have direct evidence of his inten-
tions. When we ponder the meaning of that change we are on a second level
of abstraction. It may well be that Elizabethan politics are being suggested
through Lancastrian politics. But there is a third level of even more argu-
able abstraction which we enter through historicism or cultural mate-
rialism, the principal "adversary" modes right now of seeing literature as

criticism of life. As in psychoanalysis the text is found to be doubly indicative, in what it says and also in what it does not say. And, whatever meaning is inferred, the assumption is that the text is primarily useful for its bearing on something else, some social fact or relationship or essence. As *Cultural Literacy* puts it, "The flaw in the current view is not that the sociological observations are wrong . . . but that the inferences drawn from them are unwarranted" (p. 115). One presumption is that the text exists in a dialectical relationship with politics—not with theology, which might seem to us a more practical choice, given the thrust of the age and the intellectual disciplines which theology then governed. Hence political realities like the power of monarchy or the colonization of the Americas are to be found within dramatic texts—the function of the text is to comment on them. Sometimes the act of commentary is tricky, at least in its interpretation. If politics are mentioned, there is no particular difficulty. But if they are not specifically mentioned they have to be discovered through a code—for example, through the relationships of men and women. Such relationships are presumed to have internalized political meanings. So we have not only to find meanings but to discover codes.

A natural place to begin study of this issue is with the question *Can it be said that the politics of a play imply the politics of its audience?* I think that it can fairly be said that historicism and cultural materialism put the worst face possible upon interpretation: that is to say they find in the history plays indications of the illegitimacy of all government which does not conform to guilt and victimization. Whenever authority acts in Shakespeare, no matter how conventional or how much that action is determined by circumstances, it is seen to offend against age, race, class, or gender. There is always a victim in cultural materialism, and the source of victimization is never nature. It is authority—generally conceived of as a translation of the authority of our own age.

For example, one critic tells us that at the end of *The Second Part of King Henry the Fourth* authority "assumes an austere air of harshness through exorcising the vitality in the spirit of its victims." The meaning is that the banishment of Falstaff is done by a power inherently disposed to punish the merely existential. Law is not in the equation, only the victimization of something called "vitality" which belongs to all of us. We are threatened, not Falstaff. Thereafter,

> the loss in the integrating function of the national experience makes the pragmatic clothing of the Tudor idea of authority appear rather seamy. There is, then, a kind of logic when Shakespeare, in *Julius Caesar, Hamlet,* and his problem plays, transposes the issue of authority onto a level where the political problem, once it is detached from English history, is more deeply absorbed in character and action and completely expressed by them.[4]

Somewhere in the middle of the first sentence Lancaster has quietly become Tudor. The most difficult leap of interpretation of all, from the text of a play about the early 1400s, has been made without evidence to the politics of a world vastly different, much more modern, with entirely different concepts of constitutionality.

It might in addition be pointed out that the ending of *The Second Part of King Henry the Fourth* is not harsh and by no means exorcises the "vitality" of the victims of the state. The play has an Epilogue which says plainly that "if you be not too much cloy'd with fat meat, our humble author will continue the story, with Sir John in it, and make you merry with fair Katherine of France." The play ends with a promise of marriage and a sequel; with a dance and with prayer. It doesn't look to the objective viewer as if "vitality" were being exorcised but rather ("We bear our civil swords and native fire/ As far as France") as if it were being *asserted*. Possibly the critic does not approve of the way in which "native fire" (not a bad equivalent for vitality) is being manifested, *but that is the form in which the text has placed it.* The play is full of vitality asserted, as the next one will be, but in the form of military heroism, not appetite. There are many glozed-over assumptions in the passage cited: not only that the play is really about Elizabeth's England but that Elizabeth's England became (along with Shakespeare's plays) progressively more "seamy" (whatever that means) over the next few years; that the plays cited are melancholy because of the political climate during the years they were written; and finally that politics can in fact be "detached" from history and applied to character and action. In fact, that it can be "completely expressed" by them. One of the fundamentals of cultural materialism, as predictable as its Marxist interpretation of economics, is its insistence on seeing any individual activity or state of mind as if produced by external causes. And the causes are always political, although other causes—genetics, accident—might seem equally probable.

Sometimes Occam's razor is needed more than others. To account for Hamlet's despair or Brutus's dejection we go to the text, not to a theory about the diffusion of political anxiety into psychological anxiety. If Shakespeare had wanted to say that Elizabethan instability was responsible for the state of Roman or Danish character he could easily have done so, far easier than such explanation is now driven to provide. The superstructure of theory becomes ever more rickety: first, cultural materialism states that character in Shakespeare's plays is divided or withdrawn or otherwise psychologically afflicted because of politics. Then, realizing that the Elizabethan state was politically undeveloped—that it had extremely slight contact with most of its citizens and almost no apparatus for *governing*—the definition of "politics" has to be changed. It becomes something much more vague, "power." "Power" is politics without agency, law, stipulation, limitation, or statement. In other words, an idea as risky to use as "worldview"

or "spirit of the age." It is in fact a regression to use this kind of nomenclature at all.

*What are the specific meanings of "power" and "political"?* The word "power" is often used to describe relationships within the plays, but little attention is paid to its tactical form, "policy." Statements like the following have served to diffuse the idea of politics into psychology. Instead of being truly historical, i.e., tracing the text to party or governmental statement and action, historicism very quickly becomes amateur psychology. It moves to a far easier field, finding "power" relationships refracted in all human relationships:

> Power's condition of possibility ... must not be sought in the primary existence of a central point, in a unique source of sovereignty from which secondary and descendent forms would emanate; it is the moving substrate of force relations which, by virtue of their inequality, constantly engender states of power, but the latter are always local and unstable. The omnipresence of power: not because it has the privilege of consolidating everything under its invincible unity, but because it is produced from one moment to the next, at every point, or rather in every relation from one point to another. Power is everywhere; not because it embraces everything, but because it comes from everywhere.[5]

The above is from Foucault's *The History of Sexuality*, a master text for cultural materialism. Its assumptions may not be as persuasive when examined as when stated. It proceeds from the definition of self as largely responsive; our attitudes are determined by things to which we react. These things are uniformly political. Finally, nothing is idiosyncratic—there is a reason for everything.

That phrase about power being "everywhere" is a flat rejection of intellectual autonomy. But it is common in the new historicism to conceive of the mind as victimized by its circumstances. And yet—can it be said that within any functioning polity the limits of power are unconfined? No modern state has succeeded in imposing its authority beyond a certain level of assent. In fact, the reverse has happened; that is to say failure to assent has resulted in limiting the pretensions of power. This has been a strange decade for Marxism: socialist governments invoke *glasnost* while literary critics in the West refuse to accept the gift. It seems more strategically useful to think of intellectuals victimized by culture than to recognize that power is demonstrably not everywhere.

But of course critics on the left are not concerned with the reform of actual political systems. Their quarrel is with the West and with psychological experience. The passage from Foucault is representative in that it accounts for human resentments in political terms. In fact, resentments, frustrations, dissatisfactions of all kinds have been dignified by the new historicism, dig-

nified by redefinition. If we do not like the relationships of men and women we entitle ourselves to describe their historical connection as unjust and to argue that logic and justice can only be served when history has been changed. And if we want to find examples of injustice we turn to literary texts. They are, essentially, frozen examples of political relationships. Oscar Wilde never looked better or wiser than he does now.

There are of course several ways of looking at psychological experience. In *Civilization and Its Discontents* Freud denied historical causes for biological facts. A good deal of Freud's medical practice went into his conclusion that "we shall never completely master nature; and our bodily organism, itself a part of that nature, will always remain a transient structure with a limited capacity for adaptation and achievement."[6] Dissatisfactions may well have historical causes, but only paranoia sees power everywhere. As Freud judges, dissatisfaction proceeds from birth. It is automatically generated by human relationships, especially sexual relationships. But the new historicism is so firmly based on the fallacies of Marxism that it shares the least convincing of its dogmatics: that if our ideas and institutions were perfect there would be no unhappiness or resentment.

*Can the plays be read as if they have anything to do with political realities?* Within limits. But (to take again an example from the new historicism) if the critic has a heavy investment in the delegitimizing of the modern state he will see politics in drama also as unjust. *Macbeth* has become a favorite exemplum. In one essay the victory of Duncan's army over the rebels in Act I causes this conclusion: "Violence is good . . . when it is in the service of the prevailing dispositions of power; when it disrupts them it is evil. A claim to the monopoly of legitimate violence is fundamental in the development of the modern State; when that claim is successful, most citizens learn to regard State violence as qualitatively different from other violence and perhaps they don't think of State violence at all (consider the actions of police . . . )."[7] This is an especially useful citation because of the extent to which it deals with, or tries to deal with, political science. As to the first point the text contradicts the critic: we are informed that Duncan's cause is in fact good. To call monarchy as constituted by the text one of the "prevailing dispositions of power" is to ignore the "justice" (I.i.29) of his cause. This is an important term, and I will be returning to it. It is of course connected to the statement that there has been a particular "development of the modern State," a development allowing for "legitimate violence."

I don't think that this critic means "force" when he refers to "violence"— he means to gloze the distinction between, say, rebellion and the act of putting it down. But he also means that there is an identity of interest between crime and police action. Without wasting too much time, the issue might be looked at in these two ways: first, that what he calls the "development of

the modern State" has nothing to do with the acceptance of unlawful violence. The question was posed very early (in the debate between Socrates and Thrasymachus in Book I of Plato's *Republic*) as to whether mere "strength" can ever be employed by the state. The answer was of course that the state proceeds not from power but from justice. I do not know of a single political theorist in the "development of the modern State" who defends a monopoly of "violence." Second, when the critic says that "most citizens" are indifferent to state violence he plainly means most modern citizens. Since the Nuremburg Laws it has been almost superfluous to argue the opposite: we know now, as Shakespeare's audience knew in their own time, that Natural Law prohibits such indifference. The "justice" appealed to in *Macbeth* (I.ii.29) derives directly from political theory: it is that which makes force different from violence.

A final note—citizens under Tudor government had much more to fear from private than from public "violence." The magnificent new *History of Private Life* by Philippe Ariès and Georges Duby has a wealth of information which confirms the historians of fifteenth- and sixteenth-century England: the "exploitation" of the populace "became increasingly a private affair" with the expansion of private wealth, arms, and perquisites.[8] The reason Elizabeth was obeyed was that she protected people from the arbitrary and lawless powers of private jurisdictions. Monarchy freed the populace from feudal impositions—and from the unregulated aggression of knights, lords, gentry, mercenaries; even from the injurious acts of religious orders.

The essay cited above claims that the state (both modern and Elizabethan) is indistinguishable from its enemies; that it relies on violence rather than force; that its historical development is towards tyranny. There are illustrations of Elizabethan arrest, suppression, and torture. And part of the thesis is that Macbeth is an advanced form of James I. I don't want to go into a dissertation on law *circa* 1600, but the reader should be referred to G. R. Elton's *England under the Tudors*. In precisely the period that the critic above cited finds the state characterized by violence and torture Elton reports on the growth of barriers to state powers.[9] Executive power did not control chancery, king's bench, common pleas, or exchequer; nor could it control the various councils and commissions whose business it was to supervise power by law; nor did its writ extend to the widest and most direct agency of law, the justices of the peace. The first thing to be recalled about Elizabethan government is that there was very little of it. National government was for the majority an abstraction—the exercise of power took place in parish and shire. In fact, a certain renunciation of power was involved, according to Elton: "Under the strict, active, and intelligent privy council of Tudor times local government by local men was a success. It exploited local

knowledge and loyalties in the interests of the state, a thing no centralized bureaucracy could hope to achieve, and it provided a training in self-government which was in the end to express itself in the self-reliance and skill of the parliamentary opposition. The Tudors preferred to enlist the abilities of the gentry even at the cost of foregoing a despotism they neither needed nor wanted."[10]

Domestic and foreign relations were congruent. Here is another historian, J. C. D. Clark, on the facts of army and finance: both Elizabethan and Jacobean England was "a State weak in relation to foreign powers and a State prone to *rebellion* and civil war. A weak militia and a monarchy starved of funds were related phenomena. The extreme military and financial fragility of the Elizabethan regime is only now coming into clear focus."[11] It might be concluded that the conflicts, feuds, and disloyalties of Shakespeare's plays are the actual realities of the political regime. And yet an extraordinary amount of criticism concentrates on the progresses and spectacles of the court as if these things—theatrical in themselves—could be politically operative. Very little of the new historicism covers acts of Parliament; it focuses unremittingly on what it believes to have been the powers of the executive.

There is another question at this point about the issues of the plays—*Are they in fact our own issues, or the cause of our own issues?* Here is a statement about the direct effect of linear imprint and its arrangement. The subject is the dramatis personae or list of characters:

> In preparing the texts for general readers and in teaching them to students, do we not underestimate the power of our ranked and sex-divided lists of dramatis personae to put characters in their places, to make us see male leaders as most important, women as less important, commoners as featureless?[12]

The above assumes that sex, rank, and condition are the most fundamental of human designations, in fact the only designations worth critical attention. The text (whether only the dramatis personae or the play it introduces) is to be valued solely in regard to its equities. It is clearly possible for a bad play attentive to a good cause to be better than a good play which is not so observant. There are supporting arguments invoked, for example, that the transformation of our ideas about "sex, race, class" is the real object of criticism.[13] In fact, anything which intrudes between text and transformation is an evil, especially freedom of thought in students: our "class structure and a semi-noxious tradition of excessive individualism allow teacherly goals of student self-empowerment and critical awareness to supplant needs for genuine political and collective action among student groups with interests in common."[14] I believe a fair translation of the above would read something like this: we should disallow interpreting the text in

any way but one. The function of criticism is to eradicate dissent. The critic will tell us what to think—and he devoutly hopes to be empowered by some agency which will prohibit the teaching of evil ideas and protect the rights of good causes. It is a Marxist idyll: asserting virtue by force.

Cultural materialism fails because it is neither political science nor literary criticism. Here, in summary, are four reasons to doubt it: (1) It denies the use of alternative methods of inquiry which remain in the realm of "noxious" or hateful intellectual freedom. (2) It believes that literature has no independent existence but serves only to mirror other and more important things. The text is generally "about" something external to it. *The Tempest* is about colonialism, *Macbeth* is about absolutism. (3) The matter of method: if a play depicts political activity then it reflects the actualities of its audience. If it does not mention political activities they are nevertheless to be found within the relationships of its characters. Men and women, for example, enact in little the victimization of the realm under arbitrary power. In any case, no matter what, they enact the fundamental inequities of sex and class relationships. A play with no visible political references is said to resist the powers of the Queen—but the same conclusion is to be drawn if it does have political references. (4) The central weakness of historicism is that it does not know history. It draws on a private stock of Marxist academics who ignore the main body of historical research. Monarchy is overinterpreted, Parliament ignored; the operations of shire and parish government which stabilized the realm seem not even to be known.

We might ask, as a final question, something stated and then answered by Freud: *How has it happened that so many people have come to take up this strange attitude of hostility to civilization?*[15] In part, according to *Civilization and Its Discontents*, because guilt has become so embedded in our attitudes; in part because of the complex aggressiveness of social relations—and in part because of the institution of education itself. The educational world makes false demands of the real world. It sees the world of politics and economics as if it were far simpler than it actually is. And it resents having to come to terms with it.[16] Under a "false psychological orientation, education is behaving as though one were to equip people starting on a Polar expedition with summer clothing and maps of the Italian Lakes."[17] In this book Freud's great concern was that the complexities of reality would be disguised by the demands of the ego—that "ethics" and "virtue" would be invoked as an act of aggression against culture.

NOTES

1. Nahum Tate, *The History of King Lear*, ed. James Black (Lincoln: University of Nebraska Press, 1975), p. xxviii.
2. Ibid., p. xxvi.

3. David Kasten, *Shakespeare and the Shapes of Time* (Hanover: University Press of New England, 1982), 67. The "horrors of war" citation within this passage is from Robert Ornstein, *A Kingdom for a Stage* (Cambridge, Mass.: Harvard University Press, 1972), p. 189.

4. Robert Weimann, "Society and the Uses of Authority in Shakespeare," *Shakespeare, Man of the Theater*, ed. Kenneth Muir (Cranbury, N.J.: University of Delaware Press, 1983), p. 194.

5. Cited by Edward Pechter in an important essay on the criticism of Shakespeare, "The New Historicism and Its Discontents: Politicizing Renaissance Drama," *PMLA* 102 (1984): 297.

6. Sigmund Freud, *Civilization and Its Discontents*, ed. James Strachey (New York: W. W. Norton, 1961), p. 33.

7. Alan Sinfield, "*Macbeth*: History, Ideology, and Intellectuals," *Critical Quarterly* 28 (1987), p. 63.

8. Georges Duby, "Private Power, Public Power," *A History of Private Life*, 2 vols., ed. Philippe Ariès and Georges Duby (Cambridge, Mass.: Harvard University Press, 1988), vol. 2, p. 21.

9. G. R. Elton, *England under the Tudors* (London: Methuen, 1985), p. 417.

10. Ibid., p. 419.

11. J. C. D. Clark, *Revolution and Rebellion: State and Society in England in the Seventeenth and Eighteenth Centuries* (Cambridge: Cambridge University Press, 1987), p. 54.

12. Charles Frey, *Experiencing Shakespeare* (Columbia: University of Missouri Press, 1988), p. 107.

13. See citations by Frey, ibid., p. 188.

14. Ibid., p. ix.

15. Freud, *Civilization*, p. 34.

16. Ibid., p. 72 ff.

17. Ibid., p. 81.

# Contextualism and Autonomy in Aesthetics

LUCIAN KRUKOWSKI

This article is about different theories of art, specifically, theories that disagree about how artworks relate to the circumstances of their origins and use. The main question at issue is how these circumstances influence—or should influence—the ways we "think" about artworks. Such thinking concerns not only how we interpret works, e.g., how we discover their meanings and assess their value, but also how we come to know that they are artworks in the first place. The theories that I describe are distillations I have made out of a broad literature. My goal here is not a survey of that literature; rather, it is a codification of what I take to be an important controversy in recent aesthetic theory. The philosophers whose works I use to describe the various sides of this controversy could accuse me of being procrustean in so categorizing them. Here too, my aim is not to give a general account of their ideas, but to show how some of these ideas underlay the conflicts I describe. In the last part of this article I redirect my comments to another area—that of general education. I take up E. D. Hirsch's recent works on "cultural literacy" to see if his proposals can be fitted into the aesthetic controversy I describe and, if so, on what side these proposals would fall and what might be said about them from the vantage point of the opposing side.

I

On the one side of the controversies between current aesthetic views are found what I call "autonomy" theories, which have in common the thesis that artworks form a unique class of entities that is distinguished by certain "intrinsic" aesthetic or artistic properties and that we learn to understand

*Lucian Krukowski*, Professor of Philosophy, Washington University, is the author of *Art and Concept; A Philosophical Study* and has published numerous articles in the *Journal of Aesthetics and Art Criticism*. He has also contributed an essay to *The Reasons of Art* and articles to *Synthese, Bucknell Review,* and this journal. His paintings have been widely exhibited and are included in several major collections.

and appreciate these entities through the "internal" relationships that unite them in a historical tradition. On the other side are the theories that I label "contextualist," in which we find the counterargument that there is no specific set of properties through which artworks can be identified and that traditions of art are consequences—not determinants—of our efforts to identify and evaluate artworks. Instead, contextualist theories maintain that the term "art" is an honorific designation which is coherent only within specific contexts of theory and use and that different specifications need not be consistent with one another.

When we first consider these opposing views, the "autonomy" theories may seem less controversial, for they articulate the appreciative practices that we associate with the great traditions of art and the masterworks located within them. Contextualist theories, on the other hand, if not more unfamiliar, seem more unruly, for the theoretical discontinuities they propose are much like the conflicting demands made upon us by art of our own—modern—period. These first perceptions—that the contrasts between theories mirror contrasts between generations, cultures, appreciative preferences, even styles of art—may indeed be justified. But we know that fitting a theory together with a historical practice makes for a fickle relationship, one that dissolves the moment either theory or practice is found wanting by the other. A better way to proceed—the one I take here—is to examine and contrast the theories themselves in terms of what is philosophically important in each. This emphasis makes the various references to artworks more credible and justified.

I began by noting that autonomists do not much bother with ontological questions, that is, questions about what kinds of things artworks really are and what distinguishes them from all the other things in the world. For autonomists, the unique identity of artworks is a given, buttressed by a long scholarly history of placing them into specialized categories and a still longer history of institutional practices through which they are physically isolated and conserved. The questions that are of greater concern for autonomists are largely normative; they are questions about the validity of criticism and the proper cultivation of aesthetic appreciation. On the other side, contextualists find that historical guarantees of continuity are not relevant to much contemporary art in that, for the more radical movements, doctrinal interest lies precisely in destabilizing the ontological security of the earlier traditions. In practice, this interest marks a shift from the creation of unproblematic works such as are found at the center of each art realm, to the possibility of creating new works that test the stability of the borders— borders between realms and between art and nonart. For autonomists, the appreciation of artworks is concerned with the sensory enjoyment of their "intrinsic" aesthetic properties. Contextualists, as they do not admit that

there are any such specialized properties, direct appreciation toward the concepts through which artworks gain and lose their status as art. It is through these concepts, they say, that a work's consequential properties are defined. Such defining shows that only certain properties, out of all those that an artwork may possess, are aesthetically consequential. Some such properties may be sensate, others not—none are intrinsic. But, for contextualist theory, it is their specification that determines the nature of appreciation for works of that type.

## II

With this overview in place, I move to a more detailed discussion of each theory. I begin with the autonomist position. One philosopher whose concept of art leans heavily on the notion of intrinsic aesthetic properties is Monroe Beardsley, and I consider him a major proponent of autonomy theory.[1] Even for Beardsley, however, autonomy does not mean total separation. For example, he would agree with the thesis that art reflects the social context in which it occurs and that we can learn many things about artworks by exploring these contexts. However, he minimizes the *aesthetic* importance of this information and asks us to believe that art—as art—is historically continuous, internally consistent, and self-referential. His emphasis on the autonomy of art relies on a distinction he makes between artistic properties that belong directly to the work and others that are part of its history of interpretation. He identifies this distinction through the terms "local properties" and "regional properties," the former being concrete, directly observational properties such as color, shape, pitch; the latter being generalized, interpreted ones such as strength, richness, subtlety. In this regard, Beardsley is somewhat of a philosophical reductionist, for he holds that regional properties are elaborations of local properties, that there is a consequential—if not causal—bond between them. Although he may agree that this distinction between property types can be found in other sorts of things, Beardsley considers the distinction central to the task of defining art. For it is in artworks that these "aesthetic" properties are most purely exhibited, and it is through our experience of them, in their varieties and configurations, that we come to enjoy the particular pleasure that Beardsley reserves for the appreciation of art. It is not altogether clear, however, how he distinguishes the properties that only artworks have from the more common "aesthetic" properties found in many other things. He may consider the former to be "distillations" of the latter, to be so "graded," e.g., through increasing focus and magnitude, that in their most "complete" form they belong to all and only artworks and thereby act as determinants for that realm. There is a problem here, common to autonomy theories, of showing

precisely how "aesthetic" turns into "artistic." It is a problem of some importance because of that viewpoint's insistence—as its name indicates—on the autonomy of art. However, as I remark above, distinguishing the realm of art from other realms is not a major concern for Beardsley. He is able to view the distinction as a historical "given" because he locates it in the hermetic context of art history rather than the diffuse one of social history: it is in the relation of artworks to each other that their properties become explicit and our judgments about them justified; it is through ongoing experience of these properties that we come to learn what particular works mean and how good they are. Beardsley also maintains that our interpretations of artworks—our assessments of their meaning and value—are historically cumulative and corrigible. Artworks do not mean "anything we want them to," although, at any particular time, we may not know everything they mean. As much as artworks have distinct properties, they have definite meanings. These meanings are "in the works themselves," although it is through our sequential efforts of analysis and paraphrase that these meanings come to light. The best works resist easy explication because their properties—and, correspondingly, their meanings—are rich, complex, and many-tiered. For Beardsley, appreciation is *our* response to the gradual unfolding of artworks as *they* respond to historical scrutiny. With regard to new works, those unfamiliar ones about which we are as yet uncertain, it is the insights provided by these traditions of art that inform and correct our reactions and indicate which new works warrant our attention.

To sum up this discussion of Beardsley's viewpoint, I want briefly to note how another of his arguments, the familiar bipartite one on the "intentional fallacy"[2] and "affective fallacy,"[3] fits in here. In the first part of the argument, Beardsley states that artists' intentions apropos their works have no privileged role in interpretations of these works. Indeed, because intentions as such are private and essentially unknowable, they should have *no* role in such interpretations. Statements and records of intentions, on the other hand, simply join the other empirical data that we consider in our attempts at understanding and evaluation. In the "affective fallacy" argument, Beardsley moves from the first to the third member of the "artist-artwork-spectator" triad and denies that the spectator's or critic's response to a work has ontological force. He denies, e.g., that artworks have infinitely malleable natures, that they are whatever "we" and their changing interpretations take them to be. The summary point of concern here is Beardsley's attempt to establish the autonomy of the concrete work: its primacy over both the conditions of its origin and changes in its interpretation. For him, what a work "is" is an objective matter, one that is independent of what it was "meant to be"; further, what we "take a work to be" can elucidate, but not deny, what that work "is."

## III

When we turn to the other viewpoint under consideration, the one I call "contextualist" theory, the main difference between it and the "autonomist" viewpoint rests precisely in the contextualist denial that there are specifically artistic properties that both identify artworks and guide our appreciations. The effect of this denial is more radical than first appears, for the contextualist concern is not primarily with meaning or value, but with ontology—how the status "artwork" is achieved and lost. It is clear, for this viewpoint, that if artworks cannot be identified through an examination of their unique properties, then the other considerations—meaning and value—also do not depend on any such properties. As I point out above, autonomists would agree that our interpretations and evaluations of works change over time, but they regard these changes as cumulative, as refinements of our perceptions and judgments which continue to approach—if not reach—a work's actual meaning and value. If, however, we *equate* works with their uses—with the varieties of their interpretations—we need not regard these uses as either cumulative or enduring. We could argue instead, as contextualists do, that something becomes art within a context in which the dynamics of "artmaking" are understood in specific ways.

An argument of this sort is offered by the philosopher Arthur Danto who calls such a context an "artworld."[4] Artworlds, according to Danto, are proper parts of the real world and need be alike only in that they share a "concept" of art. Further, such concepts need only agree in certain respects—only enough to link them with their neighbors and maintain a continuity in the chain of worlds to which the term "art" is applied. Thus, artworlds may differ from each other in regard to judgments about what things are counted as art, under what conditions something is accepted as art, and what uses are made of the things so accepted. Such differences are not seen as corrosive to theoretical completeness, only as denials that an aesthetic theory must be of the sort that *all* of its variants share a common thesis. It is sufficient, according to the chain analogy, that such sharing occur between immediate neighbors—even if each shares a different thesis with the neighbor on either side.[5]

In contrast to autonomy theory, Danto holds that we must distinguish ontologically between the thing we perceive and the thing we take as an artwork—that perceptual properties are no guide to the status "art." This move gives us two entities where previously we had one, and two may be one more than some of us had expected or wanted. The difficulties here are compounded when Danto asks us to suppose that we are faced with a number of objects, all of which look "exactly alike," and yet only some of which are artworks. This is his famous example of nine perceptually identical red squares whose contextual identities range from *The Israelites Crossing the*

*Red Sea*, to *Kierkegaard's Mood*, to a minimalist *Red Square*, to a square that is painted red.[6] Evidently, why some are art and others are not, and why those that are art are all different works, is based on something we cannot discern—at least, not by "merely looking." There is need then, in this theory, for recourse to some form of independent knowledge that provides the nonperceptual differentia between art and nonart. Here, the contrast between the two theories we are considering becomes more pointed. Evidently, if perceptual differences don't count, we must set aside one of the things we value in artworks: the pleasure accorded us by their sensual qualities. Nevertheless, we may agree to suspend judgment and follow this argument further. What is it then, under this theory, that *does* identify artworks? If we view an artwork as a complex entity consisting of both perceptual and nonperceptual components, and the theoretical task we have is to identify the relationship that holds between these components: Of two lookalikes, if only one is art, in what does its "artness" consist?

One well-known proposal on this score is that artworks, rather than being identical with their objects, are "embodied" in them. This concept of embodiment is found in the writings of the philosopher Joseph Margolis who uses it to distinguish between "cultural" and "natural" entities in a variety of realms.[7] We may, for example, consider "human being" to be a natural kind of entity identifiable through biological criteria. But human beings are also considered to be "persons," which is not a biological classification. Yet, there are (all too many) examples of humans who have been labeled "nonpersons" and treated accordingly. Less extremely, we recognize that the term "citizen" applies to only some people in a given society, but we also agree that there should not be any perceptual differences (race, sex, ethnicity, etc.) that distinguish citizens from noncitizens. Rather, this status is attained through participation in a certain cultural ritual: requirements are fulfilled, promises made and accepted, ceremonials undergone, and documents completed. Once achieved, of course, such status does engender differences: in privilege, freedom and complexity of function, opportunity. Actually, this is true for both citizens and artworks. Using the concept of embodiment in the realm of art offers a way out of the dilemma posed by our lookalikes: some are "embodiers" and thus art, and others are not and thus "merely" objects. We may not be clear about how a particular embodiment relation occurs, but if we accept the "fact" that, however inscrutable, there is *that* difference between these entities, we are then free to find other differences—certainly, other ways of treating them—that stem from this first difference. The embodied work, e.g., deserves appreciation and evaluation relative to art-historical traditions while the mere object has only its transient history as an artifact; the embodied work calls for the kind of scrutiny of qualities its indiscernible counterpart does not. So the term "embodiment" gives us an invitation to invent, embellish, associate; it ser-

ves to make any commonplace unique and suggests novel strategies to make use of a work's newly acquired status.

But the consequences of this distinction may not be entirely welcome. Once we have fragmented the traditionally unified entity "artwork" by dividing it between embodied and embodier, we cannot suppose that this division is only conceptual and that these components always remain seamlessly united in any actual instance.[8] If we press the duality that we have now established, we can imagine a new host of strange and disturbing entities: "pre-embodied" and "disembodied" works, such as are seeking or have lost their objects; perhaps more extremely, "unembodied" works, those that reject all reification and presume to exist solely and adequately as ideas. While one set of reflections may lead us to entertain artworks that are purely "mental entities," on the other side—that of the "object"—another conundrum awaits. If objects may sometimes be embodiers and sometimes not and if there is no way to tell "merely by looking" which they are or when they are, then all objects may be potential—worse, "possible"—artworks. There may, in fact, be no class of phenomenally distinguishable objects which has exclusive claim to the status of art. Here we face the disturbing conclusion that anything can be art.

A retreat from these rarified climes—if a retreat is called for—brings us back to the autonomist claim that the point of appreciation is "pleasure," a pleasure valued precisely because it is of a distinctly aesthetic kind. It is the "look" or "sound" of artworks that pleases us; not all looks and sounds do the job, nor do all things provide the proper kinds. Autonomists argue that the better the work, the more complete and unambiguous is its function as a source of aesthetic pleasure. This thesis depends on the practical institutions of art: galleries, museums, etc., as they isolate and preserve those works whose value is established, and it depends on the theoretical institutions: art-historical scholarship, connoisseurship, etc., to establish these values. The realm of art, under autonomy theory, is characteristically distinct. It is a realm of preferred objects that are of a particular kind: they have a certain intrinsic value, they require a special mode of attention, and they engender a unique kind of response. Autonomy theory, in short, is an aesthetics of the "masterpiece."

When we compare this theory with the contextualist view that the realm of art is essentially open and ubiquitous, we are also led to infer that, for contextualists, appreciation is—or should be—about something other than pleasure. Actually, contextualists deny, as they deny the categorial distinction of aesthetic properties, that there is any such thing as a distinctly *aesthetic* pleasure.[9] Therefore, it would follow that the question of artworks pleasing us is not constitutive for the realm of art, nor is its answer an adequate guide for our aesthetic responses. In the contextualist view, the function of art is essentially cognitive. Artworks press our beliefs about them by

resisting the categories we fashion for them; they thus force us periodically to discard both beliefs and categories for new and "better" ones. Contextualists view this theoretical position as applicable to all of art, but they also agree that it has special relevance for that period of art which directly bears on the theory's own formulation. In contextualist theory, the history of Western art is interpreted as an ongoing series of challenges directed by artworks against institutional attempts at their codification—whether by church, court, state, or the museum-gallery enterprise. The challenges that artworks present to these institutions occur through innovations in form and content which cannot be accounted for by the extant aesthetic terminology and appreciative practices. While contextualists may see this as a way of construing the history of art in general, there is also no doubt that the overt antagonism they describe between art and its institutional codification belongs to recent art history: to "modern" art, or that part of modernism which has made radical change the overt center of its program.

When Danto states that the distinction between art and nonart is something "the eye cannot descry,"[10] then evidently some artworks have somewhere primed the theoretical pump by masquerading as nonart. As we know, recent art history is full of examples of these kinds of works: minimal art, environmental art, pop art, dada, happenings, appropriation art, etc. These names all identify contemporary "styles" or "movements" which have in common references to things and events that "ordinarily" are not counted as art. Our response then, if it is to be adequate to these works, if, that is, we do not dismiss them out of hand, must be an "extra-ordinary" response: it must show a willingness to enlarge, suspend, or abandon our held concept of art in the face of these works' radical self-presentations. As our "willingness" in this regard becomes more practiced, what we in fact abandon is our dependency on categories: between art and nonart, between aesthetic appreciation and other forms of attention, and—hardest of all—between good and bad art. I state above that autonomy theory is an aesthetic of the masterpiece. According to my account, then, contextualist theory is less concerned with erecting a transcendent scale of aesthetic value than with plotting the ways in which artworks transform belief. Masterpieces are not needed for that. Of course, even here, artworks can be valued for their effectiveness in creating such transformations, but this is a cognitive value located in the historical dynamics of the event rather than in the enduring properties of the work. One consequence is that contextualists tend to deny that the institutional reverence and protection given artworks has any *theoretical* justification. If artworks are more like interesting ideas than precious objects, they can be pondered, quoted, argued with, refuted, rejected—all without prejudice. Together, these responses function as "appreciation" for contextualists—their alternative to the "aesthetic pleasure" criterion of the autonomists. Value, here, is located in novelty, disvalue in

boredom; artworks can be appreciated and yet be expendable, disposable, replaceable.

## IV

From an autonomist point of view, the contextualist viewpoint may seem crass—even barbaric. After all, we are being asked to set aside our hard-won sensibilities for a dubious theoretical conceit, to admit that history teaches us very little, and to denigrate precious objects that we greatly prize. Upon reflection, however, others of us may find this viewpoint to be, if not quite benign, then prescient of our own time. There are, after all, many more artists in the work force these days, and many more artworks for consideration, than there once were. An autonomist aesthetic, then, that sees much of its task as the culling out of masterpieces from the commonality of artworks, could come to be regarded as atavistic, unworkable, and—even—undemocratic. A contextualist might argue that when artworks lose their individual ambitions for immortality, they have more of a collective chance at being noticed in the present. Who was it that said that, someday, everyone will be famous for ten minutes—or was it one minute?

## V

The difficulty of choosing between the promises of immortality and the satisfactions of the present is not only faced by artists and their chroniclers. It also shows up in the field of general education, especially when such questions as the following are asked: What should our children know that will equip them for the world they face as adults? Although this is a question that can be asked at any historical juncture, it has—or has been given— particular urgency in the light of the reputed failure of our current system of public education to give a satisfactory answer. In this last section, I comment on a recent proposal where the solution that is offered, upon analysis, seems clearly to belong to one side of the autonomy-contextualism debate I discuss above. My remarks are limited to a brief analysis of the general values upon which this proposal seems to be based.

E. D. Hirsch, Jr., has presented the provocative thesis that too many Americans suffer from a lack of "cultural literacy," that is, they lack adequate knowledge of the specifics—historical, technical, aesthetic—that constitute their culture.[11] His thesis itself has the virtue of specificity in that he presents us with a fairly comprehensive list of the minimal requirements for the achievement of such literacy. To argue with this thesis—to ask why we need know these things and not others—is primarily to question Hirsch's construal of what we and the world should be like. In the contrasts between aesthetic attitudes that I present through my "autonomy-contextualism"

schema, I also point to some values said to underlie the world of art that are compatible with one or the other attitude. My suggestion here is that Hirsch's thesis is also most compatible with one side—the "autonomy" side—of this schema.

"Autonomy," as an aesthetic position, purports to free art from the manipulations of the moment by transferring its need for justification to the enduring traditions of its historical past. Freedom, here, is identified with understanding how things locate within that tradition. Our ability to make such discriminations among past works gives us, so the theory goes, the ability effectively to discriminate between things in the present. Note, however, that the two abilities are not quite equivalent: a finely nuanced familiarity with past traditions is tantamount to understanding the many different ways artworks can be valuable, while that ability brought into the present is used to distinguish between those works that are worthy of attention and those that are not. The premise is that aesthetic value, however various its traditional compliants, is constant enough to identify deserving works in the present. But this second distinction is a way of selecting out those works that are compatible with that tradition and discarding those that are not. The justification here is premised on the constancy—and continuity—of value through time.

I believe that when Hirsch talks about culture, he has something like the above in mind. For us to know what he wants us to know gives us the ability to make our present continuous with certain things we (should) value in our past. This reliance on continuity, to be sure, can be theoretically enfeebled if we include things that are repetitive or irrelevant, but it does serve to protect us from the threat of the destructive and disjunctive.

Actually, Hirsch's model is not an ideal; it is based upon a segment of our present society. His cultured individual is here among us, is the best of us—only would that there were more. In referring back to the discussion on aesthetics, we find that this double reliance on tradition and acculturation also underlies the standards upon which Beardsley bases our capacity for adequate appreciation in art.

I grant that this analogy between aesthetics and the crisis in education is somewhat forced. Hirsch, after all, is concerned with the grave problems of our incipient decline as a competitive culture and our growing social polarization. Beardsley wants only to protect and enhance the richness of our aesthetic enjoyment. Reasons for bringing the two together could be given, of course; Schiller famously did so in arguing that aesthetic and social values are interdependent. But I shall not pursue this here.

If one goes along with the above analogy, the other side of my schema—the viewpoint I call "contextualism"—can be used as a criticism of Hirsch's position. Contextualism locates its values in a "counterhistorical" view of

present affairs and, accordingly, it contains a strong element of skepticism about the normative claims of traditions—particularly those traditions that presume to be "dominant." Hirsch, given his program, is not a skeptic in these matters. The contextual view does not entail searching the past in order to legitimize present choices; it makes what past it needs out of the preferences of the present. Of course, one must always make some past or other—as many, in fact, as changing interests dictate—but there is no reason to believe that any so made contain the values through which the present can learn what it really is—and thereby prosper. The direction, according to contextualism, is actually the reverse: the present teaches the past what it is—but not "really"—and there is no promise of prosperity. In this alternation of making and unmaking boredom is a continuing threat, and the escape from boredom becomes a central value. Avoidance of boredom is the value contextualist aesthetics offers as a replacement for the autonomist value of beauty. Reapplied here, we may ask if there is a like replacement that contextualism might offer for Hirsch's "Dictionary"—the work in which he and others actually compile the basic requirements for cultural literacy.[12]

When confronted with Hirsch's list of requirements, it is difficult to argue against them without first checking to see—if only in passing—that one's own proficiencies are up to snuff. That such "checking" does not bore us reveals our own complicity with his thesis and, so, Hirsch has us there. But we know that the students with and for whom Hirsch is concerned may very well be bored. Let us suppose here, just suppose, that an "anticultural dictionary" could be devised in which would be found the things that are known by those who, in Hirsch's terms, are culturally deprived. We could all devise our own versions of such a dictionary but, arguably, it would contain all that one needs to know to survive in the culture of its origins—but it would not be, whether by intent or indifference, an enabling guide to the culture that Hirsch values. It also would be a dictionary about whose contents Hirsch, you, and I know very little. We would likely fail the test.

I state above that contextualism is a skeptical position, and thus the challenge posed by my "alternative dictionary" is not to be interpreted as a new romanticism—as a sentimentalization of the disenfranchised. But it does say that whatever "alternative worlds" such a dictionary would identify are not self-evidently ones that need replacing. This value has to be argued for. Certainly, our own lack of mastery over—and perhaps fear of—the contents of such worlds is not a sufficient argument. Autonomists might insist here that a world literate in the way that Hirsch envisions is self-evidently valuable when compared to what the alternatives would be. Contextualists, unwilling to admit such a notion of "self-evidence," might regard this argument as stemming from an alternative illiteracy.

134    *Lucian Krukowski*

NOTES

1. Monroe C. Beardsley, *Aesthetics* (New York: Harcourt, Brace, and World, 1958).
2. Monroe C. Beardsley and W. K. Wimsatt, Jr., "The Intentional Fallacy," in *The Verbal Icon*, ed. W. K. Wimsatt, Jr. (Lexington: University of Kentucky Press, 1954), chap. 1.
3. Monroe C. Beardsley and W. K. Wimsatt, Jr., "The Affective Fallacy," *The Sewanee Review* 57 (1949): 3-27.
4. Arthur Danto, "The Artistic Enfranchisement of Real Objects: The Artworld," *Journal of Philosophy* 61 (1964): 571-84.
5. This notion of sharing properties through "linkage" is found in Wittgenstein's theory of games where he indicates that we understand the concept of "game" even though there is no single property common to all games. Rather, the status is achieved through the sharing of pertinent property with a "most similar" game.
6. Arthur Danto, *The Transfiguration of the Commonplace* (Cambridge, Mass.: Harvard University Press, 1981), chap. 1.
7. Lucian Krukowski, *Art and Concept; A Philosophical Study* (Amherst: University of Massachusetts Press, 1987), chap. 5.
8. Joseph Margolis, *Art and Philosophy* (Atlantic Highlands, N.J.: Humanities Press, 1980), chaps. 1 through 5.
9. George Dickie, "The Myth of the Aesthetic Attitude," in *Philosophy Looks at the Arts*, ed. Joseph Margolis (Philadelphia: Temple University Press, 1987).
10. Danto, "The Artworld."
11. E. D. Hirsch, Jr., *Cultural Literacy* (New York: Random House, Vintage Books, 1988).
12. E. D. Hirsch, Jr., Joseph F. Kett, and James Trefil, *The Dictionary of Cultural Literacy* (Boston: Houghton Mifflin, 1988).

# Aesthetic Literacy: The Psychological Context

MICHAEL J. PARSONS

What kind of interpretive background do children need to be able reasonably to understand art in today's world? What knowledge and skills will enable them to deal meaningfully with contemporary art? And hence how should we structure the art curriculum?

These questions are asked in the context of the recent flurry of national reports and books about the quality of American schooling. A number of these have been especially concerned with literacy. Are most Americans literate? If not, are the public schools responsible? What should we do about it? E. D. Hirsch[1] seems to have raised expectations somewhat by switching the discussion from functional literacy to cultural literacy. It seems that a "literacy movement" has arisen as a successor to the "excellence movement" in the discussion of public schooling. We hope that it will prove to be a continuation of, and not a deflection from, the attempt to raise the intellectual level in our schools from that brought about by the back-to-basics and competency movements of the previous decade. And so it seems reasonable for art educators to put their question in terms of aesthetic literacy: What should people know if they are reasonably to understand art, and what should the schools teach about it?

Hirsch divides the curriculum in general into two parts: the extensive and the intensive curriculum (pp. 127-28). The extensive curriculum consists of items we need, he says, to be acquainted with if we are to be literate. 'Acquaintance' means knowing enough about the item to fit it into an appropriate category and to have a set of standard associations with it. The intensive curriculum by contrast consists of a few cases that are studied in detail and understood in depth. These cases provide the categories with which we will interpret the items in the extensive curriculum.

The obvious suggestion in art education is that we should have students

*Michael J. Parsons* is Chair, Department of Art Education, The Ohio State University. He is the author of *How We Understand Art* and of numerous articles that have appeared in the *Journal of Aesthetics and Art Criticism*, this journal, and other education and art education publications.

study a few exemplary artworks in depth and should teach about, in a more superficial way, an extensive number of others. This seems in itself an innocuous proposal, especially if the distinction between extensive and intensive is not drawn too sharply. For the two are in a two-way interaction. The extensive curriculum avowedly depends on the intensive curriculum for the interpretive schemes with which it is understood; and in turn the works in the intensive curriculum will derive part of their meaning from their place in an art history tradition, their social context, and from the more general similarities they may have with other works—an awareness of most of which would be gained through the extensive curriculum.

But if the distinction between the extensive and the intensive aspects of curriculum seems innocuous, one can expect controversy over its application. Hirsch thinks that the context of the extensive curriculum should be relatively fixed for students in public schools across the nation, whereas the content of the intensive curriculum may vary considerably more. I find that decision less obvious. Before we have agreement on a list of artworks that everyone should know about, there are prior questions that will be raised. Should the items on the list be drawn only from the traditional Western fine-art tradition? Or should they also represent the artistic traditions of different subcultures within the United States? If so, which subcultures and in what balance? And what about other cultures across the world? And what about folk art and popular art? A basic unsettled question is how far the curriculum should reflect the art and culture of the community in which it is taught and how far we should have a nationally standardized curriculum that everyone should study. These are old chestnuts, of course, though not the less difficult for that. They are philosophical, social, and political in character and will engender controversy probably more in connection with art than with other subjects.

But my focus here is not the extensive curriculum. I am more interested in the intensive curriculum and in the way it is taught. To lay out the extensive curriculum in detail is not the most important concern in educational reform, though it is what many reformers currently focus on. To think otherwise seems to me to miss more than half of the problem, a miss of which Hirsch himself is only in a formal sense not guilty. The more important concern lies with what he calls the intensive curriculum.

A developmental point of view shows why it is more important. Such a point of view requires us to consider the students' own understanding of the artworks that make up the curriculum. It requires us to consider what students take those artworks to be, to look for the actual values and assumptions that students read into them and take from them. We should not suppose that the meanings of artworks for children can be defined in advance by an adult standard. In fact they may vary considerably. We need to

look at students' actual interpretations, because what the actual curriculum is depends on them as much as on the choices of curriculum planners such as those imagined by Hirsch.

I differ with Hirsch somewhat on the matter of student interpretations. We both assume that these interpretations are the crucial matter and that they are primarily learned in the intensive curriculum. Hirsch, however, supposes that they are relatively superficial and rather easily controlled. His examples are famous battles and canaries, concepts that are rather simple and isolated. I assume, however, that the interpretive concepts that we are most interested in are fundamental and complexly networked. They have to do with what we think artworks are, how we respond to them, what we learn from them.

Arthur Danto[2] stresses that artworks are literally constituted by interpretations, and what he says is sympathetic with my view. He says, for example:

> . . . indiscernible objects become quite different and distinct works of art by dint of distinct and different interpretations, so I shall think of interpretations as functions which transform material objects into works of art. Interpretation is in effect the lever with which an object is lifted out of the real world and into the artworld, where it becomes vested in often unexpected raiment. Only in relation to an interpretation is a material object an artwork.

I could summarize much of what I have to say by changing a few words in these sentences thus: the same artwork may become different works of art by dint of different interpretations, and students' interpretations are levers with which artworks are lifted out of the intended curriculum and into the actual curriculum, where they become vested in often unexpected raiment.

Interpretations exist at many levels and have several varieties. What I am interested in here are the basic and constitutive kinds, those that depend on a few assumptions about what kinds of things artworks are. These assumptions are often not articulated, but have to do with what is valuable about artworks, what kinds of meanings they embody, what kinds of relations they depend on, what sorts of things we should look for in them. Such assumptions exist as a network, itself usually implicit, and this network is loosely structured in a set of interpretive patterns. A developmental approach focuses on such networks. These things run deeper than Hirsch seems to suppose and are not so easily taught. They are learned as we gradually enter the network of meanings that constitute our culture and are heavily affected by subcultural context and patterns of interaction. We have to learn, for example, that artworks can be expressive of states of mind, that the detailed handling of the medium and the form can be significant, that artworks can reflect something of their time, that their meaning is affected

by their place in their tradition and culture, that we can look at them as aesthetic objects; and such learnings relate to assumptions about reality and representation, expression and meaning, mind and communication—the sort of assumptions that can't be taught quickly or changed easily.

These things are learned at home, in the community, from the mass media, and can best be affected in the intensive curriculum, through the close study of a few examples. Inevitably the extensive curriculum will be interpreted in terms of these assumptions. Having children encounter an artwork in the extensive curriculum does not at all ensure that they will constitute it as the curriculum planner thought. What is ostensibly the same work may be different objects to different children. An example might be drawn from Picasso's *Guernica*, a likely item on most lists of what everyone should know. How this work is received differs considerably with developmental level, and hence what is learned from it differs. The *Weeping Woman* is one of a number of well-known studies for the *Guernica*, and I have found it to be a useful stand-in for the *Guernica* when interviewing students, because it is simpler. Consider the contrast between two kinds of response to the *Weeping Woman*.

One response is that it is not drawn very well. A student may see what it is meant to represent but find the drawing awkward and inexpressive. For example, Jane, an eleven-year-old girl, said this:

*What do you think about the hands?*

Well, they have five fingers and everything, but they definitely don't look like hands.

*What should he do to make them better?*

Just make them look like real hands. He even put the fingernails on the wrong side.

This response is characteristic of what elsewhere I have called stage two, a conceptual structure common among elementary school children.[3] One way to describe it is to say that Jane has not yet distinguished between *Weeping Woman* as an aesthetic object and as a medical illustration. Or one could say she has not learned yet to look at it for expressive values. Even where such a child knows that the style is deliberate and not a result of poor technique, it carries little significance. For example, Cindy, who was twelve years old, saw the style of the *Weeping Woman* as coherent and deliberate, but could only conclude it was all a mistake. She said:

I think she's got the hand backward. It can't go like this and be showing these knuckles right here.

*That's right. Why is it done that way?*

Cause it's mixed up.

*Would it be better if the knuckles were on the right side?*

No, because if everything were perfect in the picture it wouldn't be—it wouldn't have the same style as it does.

*It's a style that's meant not to be perfect?*

Yeah.

*Why would the artist do it that way?*

Maybe the artist knew—found out that he did it wrong, and then made the whole picture the same.

Cindy here suggests a theory of style that finds no meaning in it. She is perceptive enough to see that the drawing is done throughout with a certain kind of line and that it would be unfitting for the hand to be done differently from the rest. But she can see no point to this other than consistency itself and therefore suggests that it started with a mistake. This was confirmed when she said, in the same interview but of a different work:

*Why do you suppose he painted it like this?*

Because he's done so many realistic paintings he's sick of them.

This response contrasts with that of a woman in her forties, whom I will call Margaret. Margaret brought to the *Weeping Woman* a more developed set of concepts and values. She said:

Well, it's very emotional, and it's obvious. The lines, look at those tight lines, the fingers, the clenching, and the woman tearing her teeth out with that, the angles, I think the angles, the straightness, just those lines. It's amazing you can do something so simple to get that tension in there, in those lines, the pulling on the handkerchief, the feeling in these hands—give that tension and anguish.

The important difference between these responses is not that Margaret likes *Weeping Woman* where Cindy does not, nor that Margaret attends more closely to the formal elements. In fact they both look at the lines and the form quite closely. The important thing is that they interpret the lines and the form differently, and in effect they conceive the drawing as two different objects. For Cindy it is an awkward representation; for Margaret it is an intensely expressive object. And these differences are based on underlying conceptual structures that cannot be expected to change quickly. I think an important goal of art education is to lead Cindy in the direction of Margaret, and this will happen best through the close study of appropriate exemplars.

The general point I am making can be put like this. Much discussion of aesthetic literacy has to do with the contextual knowledge needed for an understanding of artworks. The first focus is generally the art world con-

text. What knowledge of art history should students have, what kinds of artworks should they study? Then there is the cultural context, the subcultural context, the international context, the social and political context. There is plenty of room in all this for discussion as to what knowledge is most desirable and what the criteria for selection should be. But my discussion has to do with the psychological context, the existing individual interpretive context. This is the context in which all choices will be, inevitably, understood by the student. Hence a listing of artworks will not by itself denote a common curriculum, even if it were nationally agreed to.

One point that emerges from the example of student response to *Weeping Woman* is that how one teaches is as important as what is taught. If the exchange with Cindy had occurred in the classroom, there are a number of different things a teacher might do in response. The most straightforward is perhaps to continue with a discussion of the *Weeping Woman*, and of other studies for the *Guernica*, talking especially about the expressive uses of distortion. One might extend this to looking at other examples and encouraging other children to talk about them and compare them. Or one could do some studio exercises having to do with ways of creating expressive faces and comparing several different versions, including, of course, realistic ones. Or one could respond socratically, asking Cindy about the criteria and values she is assuming, and whether there are alternatives, and engaging the whole class in thinking about their own assumptions. These are alternative ways of using the *Weeping Woman* with Cindy educationally. Which of them to adopt in a particular case, if any, is a matter of professional judgment on the part of the teacher and requires a knowledge both of the intended curriculum and of Cindy's own understanding. Any of them is better, because more meaningful, than requiring Cindy to remember that the *Guernica* is a famous and powerfully expressive work, done on a certain occasion by Picasso with certain preliminary studies. But all of these, including the latter, could be described as studying the *Guernica* and the *Weeping Woman*. Unless the teacher is aware of how Cindy understands the work, it is hard to see how to avoid the pitfalls of rote learning and to make the curriculum meaningful. And for this reason, *contra* Hirsch, thinking about how one teaches is at least as important as thinking about what is to be in the intended curriculum.

Back to the question of planning a curriculum and how a knowledge of typical aesthetic development can help. I will give a sketchy, but I hope suggestive, example. The sketchiness is due to the fact that knowledge of aesthetic development has not yet been used to work out something more detailed. The example has to do with the historical understanding of particular styles. I assume that any list of desirable art knowledge would include a number of historical styles, of either individual artists or of movements. For my example I will use Renoir and Impressionism, surely

likely to appear on such lists. Now a reasonably sophisticated under-standing of such a style would include a sense of the way it expresses some-thing of the artist's mind and character, and that of the group he or she belonged to and of the culture and epoch he or she lived in. It requires, in other words, a sense of historicity, of the way one's historical and cultural placement affects how one thinks and feels, whether one is conscious of the influence or not. Because a style reveals the artist in this way, it is essential-ly a historical concept.

It is clear that this developed grasp of historicity is not available to most students in the public schools. Younger children understand history as chronology, as a series of events that happened in a sequence. They can see various formal and material similarities within a group of paintings and can understand the style so identified as being due to their having been painted by a person or group of persons. On this understanding, the style reveals the behaviors of the artist. At the next developmental level (my stage three) style is understood as expressing the thoughts and feelings of the artist or artists. Paintings with the same style are similar because they are products of the same mind or minds and express the same kind of thoughts and feelings. This is to understand history as biography and seems to be characteristic of adolescence. It falls short of a grasp of his-toricity, however, because it fails to connect the expressed thoughts and feelings with the actual details of the painting and so to understand how the painting can express aspects of mind and character of which the artists themselves were unaware. It also falls short of understanding how histori-cal placement affects what styles can be said to express.

I will illustrate these abstract assertions by referring to interpretations of the style of one work, a piece of Renoir's *Luncheon of the Boating Party* that is commonly titled in reproduction *Girl with Dog*. This is a reproduction that I have used frequently in interviews, again preferring it because it is simpler than the *Luncheon of the Boating Party*.

What sense does a typical elementary-school-age child make of the style of Renoir? Style as such is not a focus for attention or interpretive meaning at stage two. The focus is on the subject matter, on what is represented rather than on how it is represented. Realism is the preferred style because it does not distract attention from the subject by obtruding the medium be-tween it and the viewer; in fact, one could define realism as any style that promotes a natural focus on the subject matter. When a style—a way of painting—does force itself onto the attention, it is not in itself seen as mean-ingful and is usually deplored. Sometimes the style of *Girl with Dog* is seen as realistic. For example, Larry, twelve years old, said this:

> I like the glass. I mean, it's not just glass like the little thing down here.
> It has, like, yellow—it has all different colors blended to make it look

like real crystal. I also like that little bit of white just in there to show the light is coming through.

*Uh-huh, I see.*

And on the dog's eye, it makes it sort of sparkle. Because if he didn't have it there, what would you think? I mean, you wouldn't know he is looking toward here.

More often, young children find the brushwork of the Renoir not realistic and therefore pointless. The brushstrokes of white on the glass and of color around the grapes on the table come in for frequent mention. They obtrude themselves on attention and are hard to interpret representationally. They are a sort of minor climax of the style, a passage where its tendencies crystallize most clearly and where differences of interpretation become most obvious. For example, Leonard, ten years old, said:

I like the bright colors, the yellow, the green, the white. It looks nice.

*Is there anything he could have done better?*

Yes; he could have painted it a little neater. The glass looks like a real glass, but it could look better.

*What would it take to make it look better?*

Not to smear everything.

And Leslie, twelve years old, also found the brushwork objectionable:

I like the painting in general, but I don't like the kind of paintings that are so harsh.

*What do you mean by harsh?*

Well, how they kind of—how they use the paintbrush. You know, like they make it all in one big brush mark.

*You can see the brushstrokes, you mean?*

Yeah.

*It would look better if it were how?*

Well, kind of soft, and all one color that's mixed properly.

The understanding of style that this kind of expectation makes possible is largely a behavioral one: style is characteristic behavior but does not express states of mind. What it reveals is what the artist did, not what he thought or felt. An account of this understanding comes from Frances, nine years old, who was talking about a different painting but had expressed the same response to the Renoir as Leslie. The conversation continued like this:

*Then why would an artist paint a painting like this?*

I don't know. I guess that's what he paints. Some artists paint trees, some artists paint lines. Depends on the artist.

*How do they decide how they are going to paint?*

I guess they just get into it somehow . . .

*Why would he want to paint it like this?*

It's his style.

*Why choose this style rather than another one?*

It's what he's used to.

*How did he get used to it?*

I don't know.

The next level of aesthetic development—stage three—contains a greater awareness of the subjective experience of both the artist and the viewer and of the painting as a vehicle for subjectivity. This makes possible an understanding in which a style expresses some characteristic state of mind of the artist, some feeling, attitude, point of view or evokes a parallel state of mind in the viewer. Leslie, an undergraduate student, expressed her sense of the style of the Renoir this way:

I love this style of painting. The girl is in love with her dog. It is nice, that soft kind of painting. It shows nice feelings. It makes me feel good.

*You like the style?*

Yes, because it is soft and not real. I don't like things very defined and sharp; well sometimes I do, but I like this. It blends things in with one another.

*Tell me more about the style.*

Well, it's soft and has feeling. You can get a lot of feeling out of it, a lot of emotions, different emotions.

*Are you responding more to the subject or the style here?*

The style. He could have picked a different subject matter and done it in the same style. I would have liked that too. We used to have one at home. The scene was like in London. It was raining, and it was done in the same style. I still like it because you could get more of the gloomy from it. . . . The thing that was great about that was he kind of made everything a greyish tone. In something that was realistic you just could not do that. That is one way I like this type of painting, this style.

Leslie here stresses the mood and feeling of the work. She understands the style in terms of nice feelings about the love of the girl for her dog and, in the case of the imagined alternative painting, the sentimental gloom of a

London fog. These are moods Leslie imputes to the viewer and perhaps to the artist and, in the first case, to the girl in the painting. These moods are, imaginatively, part of the conscious experience of individuals. This allows the style to be understood in terms of the biography of the artist, in terms of the thoughts, feelings, attitudes that the artist experienced at different times. Renoir, on this account, might be understood as a person with rather sentimental attitudes toward pets, young women, and old cities.

It is notable that Leslie, when talking about the style, hardly refers to particular details or to the general character of the paintwork or of the form: of lines, texture, shapes, space, color, brushwork. She several times says the style is soft and defines it in terms of the absence of sharp definition. She relates this very generally with sentimentality of feeling. She says nothing about art history, about the period, or about Impressionism. This vagueness is characteristic of stage three. The focus is on a state of mind experienced as if in the present, not on the qualities of the medium nor on historical matters. Style is closely related to what is expressed and is hard to talk about in detail. And since what is expressed must be grasped directly by the viewer in present experience, there seems little need for the close discussion of the details of the medium.

A further understanding of style is possible when paintings are interpreted in a more public light, because their meanings are understood to reside in the paint on canvas, rather than in feelings and ideas or in objects represented. This understanding corresponds to what I call stage four. Paintings at this level are essentially public, because the paint can be seen by anyone, and are also worth talking about in detail, since that detail is just what the work consists in. Consequently, style is discussed much more particularly, in terms of the detail of the medium as much as in terms of what is expressed, and the focus is on aspects of the medium that are characteristic and can be seen and pointed to. For example, Nora, an undergraduate, said this about the Renoir:

> What's really intriguing to me is the colors. I am looking at the contrast between the blues and the yellows, the browns. Or, what's really catching me—I really think it's kind of cutesy, mainly because of the subject matter—if I really got into it, I'm interested in how the glasses are painted. Very interesting. It almost looks like it's becrackled. To me that's very realistic, yet, at the same time, it has a really different quality. . . . Immediately when I looked at it, I totally blocked the girl and the dog out, right down to the glasses, because I thought they were really intriguing.

Nora is explicitly blocking the subject matter out of her attention and is focusing on the way the paint looks, the way it lies on the canvas. And this is significant to her somehow—intriguing, she calls it—though she doesn't

say how. A similarly detailed, but more self-explanatory, focus on the color comes from Freda, a graduate student:

> But I love the color, . . . the wonderful color! Look at that light blue in there on the table! In other words, that's a white tablecloth, but it's got every color in it practically but white, and it models the surface. Here's a lot of yellows in there, and the green with the blue; look at the glow that comes down here! And the blue in that shadow. . . .

Freda clearly assumes that the significance of the style lies directly in its elements and that these elements and their character can be seen and articulated by others. Her manner of pointing is evidence of this. The pointing presupposes a number of viewers, all of whom can see what is pointed at. The painting exists as a meaningful object in their midst, and its significance can be debated between subjectivities. In this sense, the artwork is presumed to be public in character.

This structure of assumptions is related to what I earlier called a sense of historicity—the understanding that persons can be affected by their historical epoch in ways that they are not aware of. Aspects of character and personality can be expressed in artworks, again in ways of which the artist is not aware. The consequence is that as viewers we may find qualities in a work that the artist did not intend and was not aware of. We find them by looking and talking and by pointing them out to each other. In this way, what is expressed may be more than can be grasped by one person at any one time; it may require the group to articulate it over time. These qualities of course will be expressed by the style. A style might be found pretentious, for instance, as Robert Hughes finds much of Abstract Expressionism.[4] This, as a cognitive structure, is an advance on the previous one, where only consciously experienced states of mind were conceivable as aspects of meaning. The stimulus for the advance is surely connected to the sense of the group of viewers discussing the artwork they each can see, an interpretive community which collectively can see more in the work than any individual can. In this way a fuller understanding of historicity becomes possible, and the significance of a work depends more particularly on its place in history. This sense of history, which in the end is what makes style an important educational topic, is reflected in what Frances said about the Renoir:

> Well, what's really nice is the skin tones. Renoir loved to paint flesh because it is so reflective of the light. Look at the quality of the light here! Look at this on the neck, the yellows: and even the glass is reflecting things around it. But it reads as paint as well. You can see the splash. He doesn't care about defining the form too much. This is a very early step toward establishing the two-dimensionality of the painting—maybe not consciously, but that's what he's doing—so

you're beginning to see everything two ways. . . . He's not terribly concerned with correct perspective, correct modelling. He's more concerned with putting down exactly what his eye is recording; he's recording precisely what his eye sees, not what he knows to be true.

Frances explicates here both the "realistic" qualities of color and light and also the emphasis on the two-dimensionality of the painting; in addition, she sees this as a step in the development of the dual focus in the history of art, and she says it is irrelevant whether Renoir intended this. She appears to be willing to describe the significance of the style in a way that perhaps Renoir would not have.

This brief excursus into the natural history of the understanding of a style suggests, I hope, that a knowledge of aesthetic development is necessary for curriculum planners. It suggests, certainly, that one cannot insert Renoir or Impressionism in the curriculum and expect it to be the same thing for every student. It suggests also that an explicit focus on historical styles is most appropriate in college or late high school. This is not to deny, though, that some attention might be paid to elements of style at all ages, in the course of studying other topics. And most importantly it suggests that the practice of interpreting artworks with students in appropriate ways should be a basic art activity all along.

A summary might stress the phrase "appropriate ways." A developmental approach suggests that different artworks, or different ways of talking about the same artworks, are appropriate at different levels of schooling and that a curriculum planner must be aware of this. It also suggests that how a teacher teaches will make as much difference as what works are studied. The educator needs a sense of what knowledge is most worth aiming at and also an awareness of how children's interpretive abilities develop. Any actual curriculum is the interaction of the planned content and of the students' frames of understanding, mediated by a teacher.

NOTES

1.  E. D. Hirsch, Jr., *Cultural Literacy* (New York: Vintage Books, 1988).
2.  Arthur C. Danto, *The Philosophical Disenfranchisement of Art* (New York: Columbia University Press, 1986).
3.  Michael Parsons, *How We Understand Art* (New York: Cambridge University Press, 1987).
4.  Robert Hughes, *The Shock of the New* (New York: Knopf, 1981).

# Music as Culture: Toward a Multicultural Concept of Arts Education

DAVID J. ELLIOTT

What is "music"? What is "painting"? What is "dance"? According to *The Dictionary of Cultural Literacy*,[1] music and painting (and so on) are *a priori* "fine arts." Hence, the nature of music is considered to lie in "works of art" generally and in "classics" particularly: that is, works deemed noteworthy on the basis of their "established status as enduring points of reference in our culture."[2] Thus, to E. D. Hirsch and his colleagues, the value of music and painting (and so on) is twofold: they "are not just occasions for private appreciation and enrichment . . . but also indispensable symbols of our national existence. . . . not *just* objects for private pleasure and contemplation, but essential symbols that have helped define what we collectively are."[3] Included among Hirsch's indispensable symbols of American life (posited as information that "every American needs to know") are the following: Debussy's *La Mer*, Picasso's *Guernica*, Rodin's *The Thinker*, Bach's *Jesu Joy of Man's Desiring*, Irving Berlin's "White Christmas," and "The Road to Zanzibar," starring Bob Hope, Bing Crosby, and Dorothy Lamour.[4]

To many people, Hirsch's concepts have the ring of "common sense." Indeed, people frequently conceive music, painting (and so on) in terms of products, pieces, objects, or works and will no doubt continue to do so for some time. Moreover, it would be difficult to deny Hirsch's claim that people use "art" to embody and transmit "culture": "the sum of attitudes, customs, and beliefs that distinguishes one group of people from another."[5] The proof of this lies in the fact that although every culture has something we might reasonably call "music," for example, music is not a unitary phenomenon. People do not immediately understand, appreciate, or enjoy "the music" of other cultures. On the contrary, people within cultures and between cultures frequently speak in terms of "our" music and "their"

*David J. Elliott* is Professor of Music and Chairman of Graduate Studies in Music Education at the Faculty of Music, University of Toronto. His articles have appeared in such journals as the *Bulletin of the Council for Research in Music Education*, *The International Journal of Music Education*, and this journal. He is currently writing a philosophy of music education for the Philosophy of Education Research Library and has had several compositions and arrangments published.

music. Clearly, our tendency to use music as a means of separating oursel-
ves from one another rests on the fact that "music can abstract and distill
the relatively unclear and obscure nature of culture."[6] Surely the same
holds true for all "fine arts" to greater and lesser degrees?

Given such commonsense concepts of art and culture, it is not surprising
that Professor Hirsch values arts education. For whether or not the fine arts
bring us personal joy and satisfaction, "every citizen does need an acquain-
tance with the enduring artistic works and artists of our tradition, if only
because they are indispensable reference points for our shared lives."[7] It is
on this basis, then, that Hirsch posits art as a body of shared background in-
formation that "people must be aware of in order to communicate with
other literate people in our society."[8] And it is on this basis that Hirsch also
maintains that any trend toward instituting the study of cultures outside
"one's own community"[9] or formalizing exchanges among different cultur-
al groups via multicultural education "should not be allowed to supplant or
interfere" with the transmission of "background information" about the
American "national culture."[10]

Educational common sense? It is not my intent to reply directly. Instead,
my purpose here is to make use of Hirsch's concepts of art, culture, and
multiculturalism as starting points for rethinking key questions in the
philosophy and practice of arts education. The questions I have in mind
(and, in truth, some thoughts I have in mind about Hirsch's work) are im-
plicit in the following passage by Israel Scheffler. Written years ago,
Scheffler's thoughts emphasize the central weakness of Hirsch's new varia-
tions on old reductionist themes.

> The public treasury of knowledge constitutes a basic source of
> materials for the teacher, but he cannot hope to transfer it bit by bit in
> growing accumulation within the student's mind. In conducting his
> teaching, he must rather give up the hope of such simple transfer,
> and strive instead to encourage individual insight into the meaning
> and use of public knowledge.[11]

As arts educators we might ask: (a) How does one encourage individual
insight into the *meaning* and *use* of one's own (or another person's) "art"?
(b) What *disposition* is required to understand and appreciate one's own (or
another person's) "art"? and (c) How does one encourage the development
of a "critical artistic literacy," that is, the tendency to consider that what
may seem natural, common, and universal about one's own art, or another
person's art, is *not*?

The body of this article begins with an analysis of "culture" and "multi-
culturalism" as a prelude to rethinking the nature of one "art" (music) and
one form of arts education (music education). The primary suggestion here
is that the nature of music (and, perhaps, of painting, dance, and so on) is

such that music education (and, perhaps, arts education) ought to be conceived in multicultural terms. Secondarily, the following is intended to demonstrate that the concepts rehearsed at the outset of this article are neither sensible nor "common" (as in "normal," or "agreeable") and, therefore, do not provide a reasonable basis for arts education.

## Culture

Commonsense concepts of culture too seldom consider that people are first of all members of social groups, not cultures.[12] To survive in a given time and place, a group of people must both adapt to and modify their physical, social, and metaphysical environments. Culture, therefore, is not something that people *have*, it is something that people *do*. Culture is generated by the *interplay* between a group's beliefs about their physical, social, and metaphysical circumstances and the linked bodies of skills and knowledge they develop, standardize, preserve, and modify to meet the intrinsic and extrinsic needs of the group. People actualize their shared beliefs and concepts, including an overarching sense of what is important and necessary to the group, by means of intentional actions. Properly understood, then, the culture of a social group is its shared program for adapting, living, and growing in a particular time and place.

Viewed from this perspective, the essence of a given culture does not lie solely in the intrinsic features of its inherited products, nor in background information about these products. Rather, the essence of a culture will be found in the *interplay* among a group's beliefs, informed actions (or action systems: e.g., a group's economic, legal, and educational systems/institutions), and the outcomes of these informed actions (past and present).

To these reflections we must now add Brian Bullivant's observation that one of the most important yet most overlooked aspects of cultural interplay is that between the instrumental and expressive dimensions of a culture.[13] The instrumental dimension of a culture consists in the action systems and behaviors that a group develops and mobilizes to enhance its economic, political, and social life chances. The expressive dimension includes the action systems it supports and deploys to embody and communicate its concepts and beliefs. Of course, these distinctions often blur. A group's legal system, for example, is not only a means of enforcing its moral code and protecting its members; it is both the actualization and symbolization of the group's concepts of morality, equality, justice, punishment, freedom, mercy, and so on. Hence a culture's identity or "style" inheres only partly in the objective qualities of its artifacts and its patterns of normed behavior. The roots of a culture lie in the belief system that informs the way in which these tangible aspects of culture are generated, understood, evaluated, and

categorized. Put differently, the inherent meanings of artifacts and be-haviors are mediated by concepts and expectations that are socially, histori-cally, and politically determined.

What are the basic educational implications of this concept of culture for, say, the United States? Before answering directly it is necessary to step back and consider that the United States, like other Western nations such as Canada, Australia, and the United Kingdom, may be seen to consist in a shared core culture (a *macroculture*) as well as several smaller cultures (or *microcultures*). The shared concepts and beliefs of the macroculture (e.g., a shared belief in democracy and equality of opportunity) are mediated by, as well as interpreted and taken up differently within, numerous microcul-tures. Hence, these microcultures hold beliefs that are more or less alien to the given macroculture. It is these conceptual differences that form the bases for misunderstandings and conflicts. Furthermore, the overarching beliefs of the contemporary American macroculture are not fixed, nor are they the construction of the dominant culture alone, as commonly believed. Indeed, sanitized concepts of history (like the one promulgated in *Cultural Literacy*) consistently fail to acknowledge that "the macroculture" of most nations is actually a dynamic field of struggle in which people inside and outside the mainstream of wealth and privilege compete to reshape the macroculture.

Educationally speaking, then, it seems obvious that to encourage an un-derstanding of the meaning and use of a culture (macroculture or microcul-ture) one must look deeply to the network of concepts, beliefs, and action systems from which the expressive products of a culture spring and by means of which they are perceived and interpreted. Indeed, "common-sense" notions of culture generally overlook (or purposely sidestep) the ob-vious: that what we call "art," "law," "education," and so on are *not* natural, universal phenomena. Instead, they are conceptual systems developed through the thinking-doing interplay of ongoing human prac-tices. Adding these thoughts to the insights of Clifford Geertz I suggest that "culture" is less a matter of products posited as "symbols of our national existence" and more a matter of linked networks of action/symbol systems that are socially constructed, historically maintained (or modified), and in-dividually applied.[14]

As a preliminary answer to our framing questions, then, to encourage the development of insight into the *meaning* and *use* of a culture students must be given opportunities to participate in or "live" a culture: to engage in the *interplay* of beliefs, actions, and outcomes that constitute a culture. Of course, such participation must necessarily include a *critical* examination of the sustaining human beliefs and action systems underlying a culture, with full awareness of both the instrumental and the expressive sides of actions

and their outcomes. Put differently, to develop insight into the meaning and use of culture it is not sufficient to pick the fruits of a culture, one must also look to its roots and shoots.

On this view, the process of educating for cultural understanding (macroculture or microculture) is akin to that of inducting a person into a way of life, or of engaging a person in a living, "dialectic"[15] encounter with a culture. The "guided tour" approach advocated in *Cultural Literacy* confuses knowing about things with knowing things. In other words, in addition to transmission, an education for cultural understanding ought to include student-culture *transaction* and *transformation*.[16]

In mind of this alternative to Hirsch's commonsense concept of culture we must now consider the possibility that, far from being an impediment to advancing understanding of the American macroculture/microculture complex, a commitment to multicultural education may hold America's best hope for enhancing such understanding in all children. Let me explain.

### Multiculturalism

As a descriptive term, "multicultural" refers to the coexistence of unlike groups in a common social system.[17] In this sense, "multicultural" means "culturally diverse." But the term is also used in an evaluative sense: it connotes a social ideal; a policy of support for exchange among different groups of people to enrich all while respecting and preserving the integrity of each. Thus, although a country may be culturally diverse, it may not enact the ideals of multiculturalism or "cultural democracy": it may not support equal legal, educational, and economic opportunity for all groups. For example, although South Africa is culturally diverse, few would call it a multicultural society. In other words, says Richard Pratte, the designation "multicultural" or "pluralistic" is applicable only to a society that meets three criteria:

> (1) Cultural diversity, in the form of a number of groups—be they political, racial, ethnic, religious, economic, or age—is exhibited in a society; (2) the coexisting groups approximate equal political, economic and educational opportunity; and (3) there is a behavioral commitment to the values of CP [Cultural Pluralism] as a basis for a viable system of social organization.[18]

From this perspective, the undemocratic nature of Hirsch's agenda for American education is clear. For not only does *Cultural Literacy* fail to acknowledge the full reality of American cultural diversity, it formulates a program for cultural uniformity in direct opposition to the principles of American democracy that must be operative to qualify the United States as a "multicultural" or "culturally democratic" nation. At bottom, Hirsch

seeks to neutralize the critical and liberating power of American democracy[19] by smothering the distinctive voices of minority groups under an avalanche of facts about the "classics" of Western civilization (including *The Road to Zanzibar!?*). In short, Hirsch's program for reforming American education actually threatens the essential democratic ideal he purports to uphold: "true enfranchisement."[20]

Seen from this perspective, it is not surprising that Hirsch should conveniently overlook evidence[21] to the effect that the real crisis in American education inheres in the fact that schools systematically deny some groups of children an equal opportunity for academic success by denying the burdens and disadvantages they carry in virtue of their personal characteristics (sex, exceptionality, race, and so on). Equally unsurprising is Hirsch's failure to recognize that "multicultural education" does *not* seek to "supplant and interfere" with the transmission of the overarching concepts and beliefs that define the American macroculture. On the contrary, the major goal of multicultural education is simply this: to insure that all children, "male and female students, exceptional students, as well as students from diverse cultural, social-class, racial, and ethnic groups . . . [experience] an equal opportunity to learn in school."[22] In other words, whereas multicultural education confronts the reality that the education of large groups of American students is impaired by discriminatory systems of testing, tracking, and culturally biased methods and materials, Hirsch denies this reality. In short, as part of its hegemonic effort *Cultural Literacy* deliberately underplays the impact of context (cultural, economic, curricular, environmental, social, and moral) on the organization and conduct of education.

By acknowledging and building upon the various cultural experiences that children live *with*, *in*, and *around* each day, multicultural education seeks to enhance what is "given" toward improving (a) students' understanding of the meaning and use of the American macroculture in relation to (b) students' awareness of the cultures (native or foreign) from which they come and through which they must surely navigate in the future. On this view, the goals of multicultural education are one with humanistic education: to encourage the development of insight into one's *self* and the relationship of one's self to one's culture. And on this view, the essential difference between the humanistic educator and the multicultural educator is the latter's tendency to be more acutely aware of the multicultural ideologies underlying school curricula. Indeed, many ideologies of multiculturalism exist consciously and unconsciously in the minds of educators. Unfortunately, these ideologies are seldom exposed to critical examination. Hence, although teachers may be committed to humanistic education, their multicultural ideologies may in fact work in direct opposition to their ideals.

In addition to its descriptive and evaluative senses, then, "multicultural"

can also be seen to have currency within the educational context as a concept, a reform movement, a process, and a curriculum ideology. Considered in this light, the dominant question posed by "multicultural education" is not, "What cultures should be studied?" but rather "*How* should students study the American macroculture-microculture complex?"

Taken together, these concepts of culture and multiculturalism point us away from the grim reductionism of Hirschian doctrine toward more comprehensive and realistic lines of thought about education generally and arts education specifically. The remainder of this article is concerned with pursuing these lines of thought in relation to music and music education. The first step involves rethinking the "commonsense" concept of "music as fine art."

## Music

In the case of such "classics" as *La Mer, Jesu Joy of Man's Desiring*, and "White Christmas," and in the case of every undisputed example of "music" that comes to mind, what we are presented with is more complex than a *work* of art, or a *piece* of music, or even a national *symbol*. In the same way that culture is not simply a collection of objects that people *have* but something that people *do*, "music" is a specific form of human activity. In the case of *La Mer*, for example, a human being named Claude-Achille Debussy did something, and what he did was to *make* something within the context of a specific musical practice. From the observation that "music" is necessarily (but not sufficiently) an outcome of human activity, several ideas follow.

First, it seems clear that "music" necessarily involves three dimensions: a producer, the product she or he produces, and the activity whereby she or he produces her or his product. But this is plainly incomplete since (as already noted) in any instance of human activity it is also possible to consider the context in which the doer does what she or he does. Music, then, is essentially a fourfold phenomenon: it involves a doer, a doing, something done, and a context in which the doing is done.

Now this four-dimensional concept of music is easily enriched a further four times by considering each dimension from four different directions. For example, we can look straight at the doing itself (e.g., the composing of *La Mer*) as a system of actions in isolation; or from "behind," as motivated action; or "in front," as goal-directed action; or "around," as one instance in a category of similar actions. This procedure can be repeated for the doer (e.g., Debussy), and the thing done (*La Mer*), and the context of the doing. But in the case of "the context," things get more complicated. For "context" may be regarded as something pertaining to the situation of the doer, or the doing, or the thing done, or as something that surrounds all of these.

What is the sum of these reflections? Three conclusions seem secure. First, viewed comprehensively, it seems that "music" necessarily involves several dimensions each of which has (a) natures and values of its own, (b) an inevitable link with other dimensions, and (c) a relevant context. Second, the four fundamental dimensions necessary for music are not merely linked; rather, they form a dynamic system of dialectic relationships (doers are influenced by how and what they do, as well as how their mentors, peers, and audiences respond to what they do and what they think about what they do). Third, because the dialectic relationships formed between and among musical dimensions necessarily require the intersection of contexts that are social (at least in part), one might reasonably expect these relationships to generate *concepts* and *beliefs* about what counts as "music" as well as collections of listenables[23] themselves (i.e., organized sounds to which to listen). This third point deserves a word of emphasis and explanation.

In music (as in culture), the fruits ("works") produced by a particular musical practice are inseparable from their roots (an underlying network of beliefs). For although each musical practice is identifiable in virtue of producing a set of listenables having certain objective features in common, such consistency is more than objective; it evidences the existence of a musical "style": a shared body of *beliefs, concepts,* and *principles* for making and listening to certain tones in a certain way (e.g., in terms of tonic, dominant, and subdominant relationships; in terms of ragas, and so on).[24] In other words, certain sounds are "music to my ears" (to your ears too? to "their" ears, but not to your ears?) because we are social beings who inherit and contribute to modifying a collective understanding of what shall count as music, or "tones-for-us."[25] On this view, music is neither autonomous, nor immediate, nor natural, nor nonconceptual in essence. In fact, music (like culture) is thoroughly mediated by concepts and expectations that are socially and historically determined. Let us now consider these concepts in more concrete terms.

If "music" is (in one important sense) a form of human action, then we must ask, "Is this action a manifestation of the composer's (or the performer's) character?" Surely not.

Although it is certainly true that one person may be born with the mental equipment that enables him or her to compose more easily than another, no one is born a composer (or a choreographer, or a painter). A composer does not become such merely by birth or instinct, but by developing skill and knowledge relative to the techniques, the history, the standards (and so on) that underpin composing generally, and chamber music composing (or pop song composing, etc.) particularly. Creative production by a composer, then, rests on expertise.

Now the expertise required to become a composer is not simply picked

up. It is learned informally and formally; it is developed through example and direction in accordance with rules and standards. The same is true of musical performing, improvising, conducting, arranging, and so on. All of these pursuits are ongoing human practices with histories, traditions, motives, and standards, not to mention legends, heroes, triumphs, and tragedies. Moreover, these practices are ongoing *social* practices. That is, one learns from others directly and indirectly—from practicing performers, composers, teachers, critics, and conductors who embody or share one's aspirations. Furthermore, says Alasdair MacIntyre, to enter into a practice is "to enter into a relationship not only with contemporary practitioners, but also with those who have preceded us in the practice, particularly those whose achievements extended the reach of the practice to its present point."[26] Upon entering a practice, "it is thus the achievement and *a fortiori* the authority, of a tradition which I then confront and from which I have to learn."[27] In sum, music (conceived as a dynamic system), regardless of the form or level it takes, is an ongoing social practice into which new members (potential makers, audiences, critics, teachers, etc.) are constantly being inducted.

Clearly, then, all forms of music making and music listening are embedded in specific contexts: relevant social networks of musically significant people, productions, and beliefs. Additionally, "in front" of all forms of music making and music listening are what Nicholas Wolterstorff and Alasdair MacIntyre call the "internal and external goods" to be derived from practices.[28] Furthermore, says Wolterstorff, since practitioners' values and returns shift over time, a fundamental feature of all social practices like composing music is that there is no such thing as *the* purpose of composing, let alone *the* process of composing.

In reality, then, when a composer begins to work he or she is not acting solitarily but as part of a social practice. She both depends upon, deploys, and, perhaps, transcends the techniques and standards of composing that she has come to know through her induction into the social practice of composing. Furthermore, like all practitioners, a composer takes up her practice "at a certain time in the history of that practice and at a certain place."[29]

Finally, a composer must be aware of composing her work to fit or to stretch the specific performance practices and use—practices of her time. Why? Because, practically speaking, composing for a certain musical context provides feedback necessary for the guidance of composing (performing, arranging, improvising). Thus, the goals and standards that govern the compositional process are infinitely rich and various: "They are not all so simple nor so invariantly universal as just composing an objective correlative to one's feelings or just creating an aesthetic unity."[30]

Based upon twenty-five years of empirical research into creativity,

Mihalyi Csikszentmihalyi draws several conclusions that seem to reinforce the broad outlines of our "context-dependent" portrait of "music."

> We cannot study creativity by isolating individuals and their works from the social and historical milieu in which their actions are carried out. This is because what we call creative is never the result of individual action alone; it is the product of three main shaping forces; a set of social institutions, or field, that selects from the variations produced by individuals those that are worth preserving; a stable cultural domain that will preserve and transmit the selected new ideas or forms to the following generations; and finally the individual, who brings about some change in the domain, a change that the field will consider to be creative.[31]

Thus, beginning one's consideration of the nature of music with the reductive assumption that music is simply a body of works can be seen to obviate essential dimensions of the complex phenomenon that music seems to be. More accurately, "music" is, at root, a form of intentional (and, therefore, *rational*) human action. This action is organized and deployed for the purpose of making sounds of a certain kind according to a social group's shared concepts about which sounds among all possible sounds will be selected, organized, and delineated as "tones for us."

On this basis it seems right to say that there is no such thing as "music" in the general sense, unless by "music" we mean a universe of specific musical worlds, domains, or microworlds (e.g., the jazz world, the world of choral music, and so on). Indeed, "music" in any local, regional, or national context is actually a wide array of action systems organized around specific beliefs, goals, skills, understandings, institutions (formal/informal), and standards toward the production of specific kinds of listenables for specific groups of listeners. Furthermore, each system of music makers and listeners (and in many cases, critics, historians, theorists, and teachers) is linked in a dialectic relationship of support and modification such that the beliefs, skills (and so on) that constitute a specific musical world are constantly being discussed, practiced, refined, and modified.

Thus, to understand "music" (or painting, or dance) it is clearly *not* sufficient to examine its manifestation in "works" conceived as autonomous and immediately perceptible objects. On the contrary, as Wolterstorff suggests, to encourage an understanding of "music" as a human reality "we shall have to renounce our myopic focus on works of art and look at the social practices of art . . . we shall have to look at the *interplay* of works, practices, and participants in the practices,"[32] including the network of beliefs from which these products spring and through which they are being perceived.

To facilitate this shift in perspective we require an orienting concept of music that places our traditional one-dimensional notions in balance with music's other necessary dimensions. For although our traditional ways of

conceiving music may acquit the product dimension of music (e.g., music as art, fine art, symbol, expressive form) and, sometimes, other dimensions (music as practice, community, domain, field of action, or even *Lebensformen*),[33] none of these concepts captures the complexity involved in even one "music" considered comprehensively. In short, none of our traditional concepts of music, either singly or in combination, is sufficiently integrated to provide a conceptual basis for the organization and conduct of music education.

What alternatives do we have? One possibility is obvious. I suggest that the complex network of human dimensions summed by the concept of "culture" (properly understood) bears a close logical similarity to the reality of music: a multidimensional phenomenon that not only exists within a particular web of human activity (the culture of a social group), but that is, in itself, a specific web of human activity (a music culture). Lucy Green reinforces and summarizes this proposed concept of "music as culture" in her own terms.

> Musical ideologies and practices, together with musical products, form a little social system, or musical world: a network of functions both mental and material, supporting and legitimating one another. . . . This social system does not survive autonomously, but is reproduced through a reciprocal relationship with the wider social system, of which it is only a part, divided musical practices being perpetuated materially, their divisions legitimated and maintained ideologically.[34]

What are the basic implications of this concept of music for, say, the United States context? Musically speaking, the United States, like other Western nations such as Canada, Australia, and the United Kingdom, is very much a multicultural society. It consists in a shared core of interrelated music cultures (a musical *macroculture*) as well as several music subcultures (or musical *microcultures*). The shared concepts and beliefs of the musical macroculture, and therefore its inherent musical style features, are mediated by, as well as interpreted and taken up differently within, numerous musical microcultures. These microcultures pivot on concepts that are more or less alien to the given musical macroculture. These conceptual differences are the bases for musical misunderstandings and, too frequently, musical mis-education.

Let us consider the broad implications of this concept of "music as culture" for the organization and conduct of music education.

## Music Education as Multicultural Education

If the nature of music lies in its multidimensionality "as culture," then encouraging insight into the *meaning* and *use* of one's own or another person's

"music culture" requires us to engage students in the *interplay* of concepts, actions, and outcomes that comprise the essence of a given music culture. Overall, the process parallels that of inducting a person into the way of life of an unfamiliar social group, of engaging a person in a living encounter with an unfamiliar culture, as opposed to simply leading them on a guided tour of its "landmarks." Examined specifically, the process has at least two essential aspects.

First, to "live" a music culture (a dance culture, and so on) students must participate in or *make* a music culture. To paraphrase Israel Scheffler,[35] a culture (and the expressive products of a culture) remains opaque until understood as the embodiment of beliefs, plans, and actions—as the outcome of "intelligent action in the pursuit of purpose."[36] Music *making* is therefore a key to insuring an understanding of the meaning and use of a given music culture. Through the process of music making one is obliged to "live" a music culture's beliefs about what counts as "tones-for-us," to live *in* the *inherent* meaning of these tones as "tones-for-me," and to reflect upon one's own personal response to these tones as "tones-for-them" and (perhaps/perhaps not) for me.

Indeed, the process of music making (painting, dancing, and so on) "may be taken to include not just generative procedures, but also evaluative strategies; . . . the reenactment it invites is not a *duplication*,"[37] says Scheffler, it is an involvement in the varieties of thinking (concerning one's self and others) that underpin musical artistry in general and the work of one or more artists in particular. Furthermore, the processes of artistic making have *intrinsic* value: they are not merely actions enslaved to production, but actions with standards—i.e., systematic actions, or performances—such that matters of *how* they are done (and *why* they are done in certain ways) must be a focus of our effort and attention. To view them otherwise is to obviate a key aspect of the given music culture: its traditions of rational practice to which generations have contributed and to which "particular achievements are but landmarks to further effort by contemporary men and women."[38] The centrality of the process of making music (or painting, or dancing) to the understanding and appreciation of "music as culture" (painting as culture, dance as culture, and so on) is summarized by Scheffler.

> To view past works . . . as given and unique objects rather than incarnations of process is to close off the traditions of effort from which they emerged. It is to bring these traditions to a full stop. Viewing such works as embodiments of purpose, style, and form revivifies and extends the force of these traditions in the present, giving hope to creative impulses now and in the future.[39]

Furthermore, viewing the outcomes of a music culture "as embodiments of purpose, style, and form" (instead of "given and unique objects") main-

tains the connection between the fruits of a music culture (its listenables) and their conceptual roots. An awareness of these interconnections is essential for developing complete "artistic literacy" which includes both understanding and the disposition to examine critically the beliefs underlying a specific music culture. Indeed, one's beliefs are the bases of one's understanding and experience of the products of one's own (or another person's) music culture. Let me explain.

The style of each music culture, as noted earlier, is not reducible to the objective features shared across a set of listenables. Rather, a style evidences a shared body of beliefs, concepts, and principles for constructing and listening to certain tones in a certain way: as "tones-for-us." As a result, the full meaning of the listenables of a given music culture will not be revealed by perceiving and responding to intrinsic, objective musical style features alone. Instead, one must perceive in full awareness of the socially and historically predetermined concepts and expectations that mediate such perception.

Hence, the "musical experience" of a given listenable is neither immediate nor nonconceptual as Bennett Reimer,[40] for example, suggests. On the contrary, a "musical experience" depends upon: (a) a socially/historically generated concept of which sound patterns shall count as "music," and (b) an objective pattern of sounds. Thus, for example, if (b) say, *Appa Rama Bhakti*, a piece of South Indian (*karnataka*) instrumental music, does *not* match (a), one's prior concept of music (e.g., "things" like Beethoven's *Fifth Symphony*), then the likely result will be some combination of confusion ("I can't make sense of these sounds") and rejection ("This is not music"). Such an experience would likely not be considered "a musical experience." On the contrary, what Westerners generally call "the musical experience" usually involves enjoyment, affirmation, and understanding. In a word, it implies a considerable degree of *fit* between a listener's prior conceptions and a producer's expression.

On this view, a "musical experience" is actually the result of what Lucy Green[41] describes as the interaction between our mediated perception of the *inherent* meaning of sounds and the degree to which these sounds *delineate* themselves as "sounds for us." Put differently, each "piece of music" poses several questions. For example, Are you familiar with my objective style features (inherent meaning)? and To what degree do these features match your concepts about music making and music listening (delineated meaning)?

On this view, a musical experience may be thought of as a "three ears" process: one ear processes a given pattern of sounds as tones in and of themselves (inherent meaning); one ear processes sounds as belonging to a web of socially defined (delineated or categorical) meanings ("tones for this

person?"); and one ear merges the sounds heard in these two ways to provide one's "musical experience," or not.

A style, then, is the means by which inherent and delineated musical meanings are integrated. Unfortunately, as Green suggests (and as all music educators know), people are easily drawn or repelled by the delineated meanings of a listenable: the cluster of associations and expectations its characteristic sound patterns convey to a given listener.[42] Specific characteristics of tonal patterns trigger a personal conception of their affiliations; they activate a kind of magnet field of clustered associations, expectations, preferences, and so on. These delineated meanings, in turn, penetrate the formal musical relationships (the inherent meanings) that we listen *to* and listen *for*.

Clearly, the beliefs we hold about what a music culture's style delineates are a function of the social nature of music: of what we learn to think and believe about particular music cultures and what we associate with certain sounds. In this sense, every musical style is the present sum of previous social/historical musical actions and beliefs.

In sum, although music (as a product) may seem natural and immediate, and although it may seem to be a matter of feeling alone, the power of listenables more likely inheres in the capacity of "tones-for-us" to affirm our listening "self" comprehensively: cognitively, physically, personally, socially, and historically.

Hence, an education in even one music culture is a major undertaking. Yet, even on the most conservative musical analysis, the musical macroculture of the United States encompasses a wide range of music cultures including, for example, "classical music" (subdivided into vocal and instrumental forms of such styles as Baroque, Classical, and Romantic), jazz music cultures (dixie, swing, bop, cool, fusion, avant-garde), and various pop and rock music cultures. Despite the unifying thread of tonality (and other features characteristic of the Western European musical tradition), many of these music cultures may be as incomprehensible and therefore as "distant" and frustrating to students as, say, *Appa Rama Bhakti*. Hence, even the most conservative music education curriculum is fundamentally involved in the musical equivalent of multicultural education.

How can the challenge possibly be met? In addition to applying the above principles of music making and music listening to each music culture being taught, music educators need to consider a third principle. By broadening the range of music cultures studied in a curriculum to include even one radically different music culture, music educators take a giant stride toward the goals of music education as humanistic education. How so? Because in venturing forth and "living in" the inherent and delineated meanings of an unfamiliar musical context, all students gain what only such "moving out" can provide: insight into one's "self" (musical and

otherwise) and the relationship of one's self to one's own and other music cultures. Accompanying all such risk taking, disorientation, and eventual musical "acculturation" is self-examination and the personal reconstruction of one's relationships, assumptions, and preferences. These are the challenges presented to anyone who strives for self-understanding.

Thus, to the democratic and utilitarian opportunities provided by a music education conceived in multicultural terms we must add the heightened opportunities that such a context provides for humanistic education. Chief among these is the opportunity students are given to confront their own and others' musical beliefs and assumptions and, thereby, to develop a disposition to consider that what may seem natural, common, and universal about music, is not. Harold Osborne makes the point succinctly: "The best and perhaps the only sure way of bringing to light and revivifying . . . [our] fossilized assumptions, and of destroying their powers to cramp and confine, is by subjecting ourselves to the shock of contact with a very alien tradition."[43]

Unfortunately, too many working concepts of multicultural music education prevent the realization of these opportunities because they rest upon ideologies that are not, in fact, multicultural. For example, it is common to find music educators who endorse the teaching of music cultures that are either partly or completely alien to the American musical macroculture but who still insist that *all* such music cultures be taught and experienced in terms of one particular concept of "music." Such thinking seems to run counter to logic in general and the ideals of multiculturalism in particular.

Nevertheless (and more unfortunately), such thinking has become formalized in theory. For example, the concept of "music education as aesthetic education," like *Cultural Literacy*, holds that music is *a priori* a fine art: that the nature and value of music inheres in immediate, autonomous aesthetic objects and that this "aesthetic" conception acquits the nature and value of all music. Bennett Reimer therefore declares that the music of all peoples must be approached aesthetically: "We can get the maximum benefit from all music," says Reimer, "when we remember that each piece, no matter its cultural origin, should be studied for its *artistic* [i.e., its *aesthetic*[44]] power including but transcending any specific cultural references."[45]

Given the wide influence that such thinking enjoys, it seems important to recommend that teachers wishing to encourage students' insights into the *meaning* and *use* of given music cultures give critical attention to the multicultural ideologies embodied in their curricula. To facilitate such considerations this article concludes with an outline of six conceptions of multicultural music education based upon distinctions original to Richard Pratte.[46] Five of these are often considered "commonsense" approaches to

multicultural music education. In my view, however, only the sixth approach preserves the meaning of "multiculturalism."

The "assimilationist" music eduction curriculum is characterized by an exclusive concern with the major musical styles of the Western European "classical" tradition (Baroque, Classical, Romantic). The "elevation of taste" and the breakdown of students' affiliations with popular and minority musics are a major preoccupation. All music, regardless of cultural origin, is approached in the same way: from the Western "fine-art," or "aesthetic," point of view.

The "amalgamationist" music education curriculum (Hirsch's music curriculum?) includes a limited range of microculture musics based upon their frequency in the core repertoire of the classical tradition or their potential for incorporation into new music composed in this Western European tradition. Jazz, for example, is considered an acceptable style for study by the amalgamationist because its distinctive musical features have been successfully incorporated in compositions by such "legitimate" Western composer as Ravel, Milhaud, Stravinsky, Hindemith, Copland, Ives, Gershwin, and Bernstein. Similarly, world musics are viewed in terms of their utility: as sources of new elements and formal ideas for incorporation into contemporary eclectic fine-art music, jazz, and pop music. By themselves, however, world musics are considered to have no curricular validity. To the amalgamationist, the integrity of a microculture's music, like the integrity of a person's ethnic heritage, is best broken down in the interests of transmitting the "national culture." Here, music education *in* a culture becomes music education *as* culture.

To adherents of an "open society" view of multiculturalism, allegiance to the traditional music of one's particular cultural heritage represents an obstacle to social unity and to the development of loyalty to the new secular corporate society. Under this "open" ideology, all symbols of subgroup affiliation (music, literature, clothes, laws, religious practices, etc.) are viewed as impediments to progress. Consequently, they are labelled "irrelevant" to life in the contemporary nation state. The manifestation of this ideology in music education is the "with-it" music curriculum. It places a high value on so-called musical relevance: the study of everything contemporary; the development of new musical forms as a means of "personal expression" in the context of "now" life styles. Tradition is scorned; musical values pivot on fashion.

A music education curriculum built on ethnic musics selected according to the nature of the local community demonstrates the ideology of "insular multiculturalism." In fact, this type of curriculum is not multicultural at all; it is monocultural or, in some cases, bicultural. It is one aspect of a minority community's larger effort to preserve its traditional ways of life to the fullest extent within the host culture. In this sense, it is characteristic of the

"circle-the-wagons" approach to life frequently adopted by minorities as a survival strategy. The insular music education curriculum often seems multicultural because it adds an exotic musical flavor to the conventional diet available in music programs by and for the dominant majority. Unfortunately, there is usually little critical engagement or sharing among music cultures. The social equivalent is the cultural mosaic (e.g., Canada) wherein various minority groups engage each other (and the majority) now and then and chiefly in the arena of political advocacy.

Three features distinguish the "modified" form of multicultural music education curriculum from preceding curricula: (1) musics in this curriculum are selected for study on the basis of local or regional boundaries of culture, ethnicity, religion, function, or race; (2) selected musics are approached from an aesthetic perspective; and (3) students study various musics with a concern for how they have been modified in reaction to or by incorporation into Western styles. In fact, this type of music education curriculum is a specific form of multiethnic education. The focus is on the adaptive processes undergone by various ethnic groups, the uniqueness of these adaptations, and the ongoing evolution of these cultures within the host culture. Pratte says: "The goal of multiethnic education is to make students aware of the cost of being Americanized and to extoll the virtues of cultural diversity in terms of groups being modified over time."[47]

Unfortunately, the modified multicultural music education curriculum has two weaknesses: (1) it is biased from the outset in virtue of its insistence that the aesthetic concept of music has universal validity; and (2) the music chosen for study is often limited to the music cultures of the immediate student population. Hence, this curriculum obviates the essence of multicultural education: the opportunity it provides to highlight the underlying assumptions of one's own and others' music cultures and, therefore, to flush out ethnocentric attitudes.

In conclusion, music educators (and arts educators in general) require a philosophy of multicultural education that is conservative in its concern for preserving the integrity of music cultures (dance cultures, etc.) of the American macroculture, yet liberal insofar as it goes beyond particular cultural preferences to confront beliefs systems, processes, and problems, including the shared concerns of musicians from emerging music cultures. Drawing on John Dewey's dictum that a great society must become a great community, Pratte suggests that we must educate children to look willingly beyond special interests and tackle problems as a "concerned community of interest."[48] Multicultural philosophies often promote subgroup affiliation at the expense of individual freedom beyond the subgroup. Pratte's concept of "dynamic multiculturalism"[49] emphasizes the need to convert subgroup affiliation into a community of interest through a shared commitment to a common purpose. The ideals of this philosophy hold that children must

learn how to behave in group activities that include unfamiliar beliefs, practices, and outcomes. The achievement of this form of cultural literacy will enable children to apply their talents, skills, and intelligence to shared community problems.

Music education offers an important opportunity to make the goals of dynamic multiculturalism a reality. By applying a critical perspective to a broad range of music cultures, we can create a community of interest distinguished by a dynamism that compares and contrasts concepts and practices from one music culture to another. In essence, the dynamic curriculum encourages students to develop individual insight into the meaning and use of various music cultures from the inside out and from the bottom up. This approach is desirable because it minimizes opportunities to superimpose "universal" belief systems on all music cultures. As a result, the delineated meanings that a person attaches to a given music culture are more apt to be exposed for critical examination.

The combination of the widest possible range of music cultures and a critical attitude toward their concomitant belief systems separates the dynamic curriculum from all the rest. Thus, in addition to developing students' abilities to discriminate and appreciate the differences among musical cultures (as well as the similarities), a dynamic curriculum has the potential to achieve a central goal of humanistic education: self-understanding through "other-understanding."

Indeed, if it is accurate to say that arts education functions *as* culture as much as it functions autonomously *in* a culture, then a dynamic multicultural arts curriculum offers the opportunity to develop students' appreciations and behaviors relative to the personhood of the *human beings* who generate various cultures, as well as the specific music cultures (dance cultures, and so on) that they (we) construct, maintain, and apply. I suggest that the possibility of attaining these goals—of insuring that young people achieve what *humanistic* Americans need to know—is worth any time and effort spent on behalf of multicultural education for cultural democracy.

NOTES

1.  E. D. Hirsch, Joseph F. Kett, and James Trefil, *The Dictionary of Cultural Literacy* (Boston: Houghton Mifflin, 1988).
2.  Ibid., p. 155.
3.  Ibid., pp. 155-56.
4.  Ibid., pp. 155-89.
5.  Ibid., p. 396.
6.  Bruno Netti, *The Study of Ethnomusicology: Twenty-Nine Issues and Concepts* (Urbana: University of Illinois Press, 1983), p. 159.
7.  Hirsch, *The Dictionary*, p. 155.
8.  Ibid.
9.  E. D. Hirsch, *Cultural Literacy* (New York: Vintage Books, 1988), p. 18.

10. Ibid.
11. Israel Scheffler, "Philosophical Models of Teaching," *Harvard Educational Review* 35 (Spring 1965): 138.
12. Brian M. Bullivant, "Culture: Its Nature and Meaning for Educators," in *Multicultural Education: Issues and Perspectives*, ed. James A. Banks and C. A. McGee Banks (Boston: Allyn and Bacon, 1989), p. 28.
13. Ibid., pp. 33-34.
14. Clifford Geertz, *The Interpretation of Cultures* (New York: Basic Books, 1973), pp. 363-64.
15. R. A. Smith, "Forms of Multi-Cultural Education in the Arts," *Journal of Multicultural and Cross-cultural Research in Art Education* 1 (Fall 1983): 27. Citing Walter Kaufmann's usage, Smith employs "dialectical" in the sense of "a certain kind of demanding encounter with . . . an alien culture"; the dialectical attitude, says Smith, is a "nervous wariness."
16. Cf. John P. Miller and Wayne Seller, *Curriculum* (New York: Longman, 1985).
17. Richard Pratte, *Pluralism in Education* (Springfield, Ill.: Charles C. Thomas, 1979), p. 6.
18. Ibid., p. 141.
19. Cf. Stanley Aronowitz and Henry A. Giroux, "Schooling, Culture, and Literacy in the Age of Broken Dreams: A Review of Bloom and Hirsch," *Harvard Educational Review* 58 (May 1988): 172-94.
20. Hirsch, *Cultural Literacy*, p. 12.
21. For pertinent statistics see, for example, National Coalition of Advocates for Students, *Barriers to Excellence: Our Children at Risk* (Boston: National Coalition of Advocates for Students, 1985).
22. James A. Banks, "Multicultural Education: Characteristics and Goals," in *Multicultural Education: Issues and Perspectives*, p. 20.
23. I owe this term to Francis Sparshott, "Aesthetics of Music: Limits and Grounds," in *What Is Music? An Introduction to the Philosophy of Music*, ed. Philip A. Alperson (New York: Haven Publications, 1987), pp. 33-98.
24. This concept of musical style is discussed by Mary Louise Serafine, *Music as Cognition* (New York: Columbia University Press, 1988), p. 30.
25. The concept of "tones-for-us" is derived from Sparshott, "Aesthetics of Music," p. 48.
26. Alasdair MacIntyre is cited by Nicholas Wolterstorff, "The Work of Making a Work of Music," in *What is Music?*, p. 109.
27. Ibid.
28. Ibid., p. 110.
29. Ibid., p. 112.
30. Ibid., p. 113.
31. Mihalyi Csikszentmihalyi, "Society, Culture, and Person: A Systems View of Creativity," in *The Nature of Creativity: Contemporary Psychological Perspectives*, ed. Robert J. Sternberg (New York: Cambridge University Press, 1988), p. 325.
32. Wolterstorff, "The Work of Making a Work of Music," p. 109.
33. Francis Sparshott, *Off the Ground: First Steps to a Philosophical Consideration of the Dance* (Princeton, N.J.: Princeton University Press, 1988), p. 141.
34. Lucy Green, *Music on Deaf Ears: Musical Meaning, Ideology, Education* (Manchester: Manchester University Press, 1988), p. 11.
35. Israel Scheffler, "Making and Understanding," in *Proceedings of the Forty-Third Annual Meeting of the Philosophy of Education Society*, ed. B. Arnstine and D. Arnstine (Normal, Ill.: Illinois State University Press, 1988), pp. 65-66.
36. Ibid., p. 66.
37. Ibid., p. 73.
38. Ibid., p. 77.
39. Ibid.
40. Bennett Reimer, *A Philosophy of Music Education* (Englewood Cliffs, N.J.: Prentice-Hall, 1989), pp. 81-84.

41. Cf. Green, *Music on Deaf Ears*, p. 32 ff.

42. Ibid., pp. 32-35.

43. Harold Osborne, *Aesthetics and Art Theory: An Historical Introduction* (New York: E. P. Dutton, 1970), p. 13, cited in R. A. Smith, "Forms of Multi-Cultural Education," p. 27.

44. Reimer advises his readers that in his philosophy "the words 'musical' and 'artistic' and 'intrinsic' will often be used to substitute for the word 'aesthetic' because they usually mean the same thing," *A Philosophy*, p. xiii.

45. Ibid., p. 145.

46. For another explanation of these curriculum models, see my article "Key Concepts in Multicultural Music Education," *The International Journal of Music Education* 13 (1989): 11-18.

47. Pratte, *Pluralism*, p. 79.

48. Ibid., p. 151.

49. Ibid., pp. 147-56.

# Index